Praise for Christopher Benfey's
Red Brick, Black Mountain, White Clay

A *New York Times* Notable Book of the Year

"To paraphrase Emily Dickinson only slightly, there is no vessel like a book. Especially when it's as well wrought and far-sailing as Christopher Benfey's *Red Brick, Black Mountain, White Clay,* a book about earthen vases, epic voyages, and ancestral blood. Part memoir, part family saga, part travelogue, part cultural history, it takes readers on a peripatetic ramble across America and beyond, paying calls on Cherokee potters, Bauhaus craftsmen, colonial clay-diggers, and the author's brick-mason grandfather."

—Adam Goodheart, *The New York Times Book Review*

"Strange but beguiling . . . genre-busting . . . Mixing memoir, family history, art history, and biographical portraits of American artists, craftspeople, and naturalists, *Red Brick, Black Mountain, White Clay* is a book like no other, and therein lies its many charms. . . . The result is a strange history of American craft and art—a tradition that literally has its roots in the very earth of the country—that begins in the personal and winds up in a much more universal sphere. *Red Brick, Black Mountain, White Clay* provides a new and useful way to examine American culture, where it's been, and where it might go. Call it what you will, but you can't ask more of a book than that."

—Malcolm Jones, *The Daily Beast*

"Most memoirs are mush. Given the tender emotions, fragile reminiscences, and flights of fancy that tend to flit and twirl within your average autobiography, the genre is known for its shifting, dreamlike core, not its steely spine. Christopher Benfey is out to change all that with *Red Brick, Black Mountain, White Clay,* a new family memoir that's as tough as nails." —*Chicago Tribune*

"[Benfey] spins a grand web out of his own fascinating lineage. . . . In this revelatory mosaic of lives, Benfey reclaims radiant swathes of history, traces hidden links between remarkable innovators, and celebrates serendipity, resilience, and the refulgence of art."

—*Booklist* (starred review)

"[A] lyrical but unsentimental family memoir, taking in art, memory, and time.... Lively, intelligent, and interesting—a look inside not just a single family, but also an entire artistic tradition now largely forgotten." —*Kirkus Reviews*

"Benfey's contribution to his lineage is this elegant, literary examination of the natural and historical forces that have shaped artisanal and folk art American aesthetics. An odd but pleasing book—not unlike the curios it celebrates." —*Smithsonian*

"Christopher Benfey takes us on a journey of discovery that meanders into the most curious corners of family and world history, from colonial America to Nazi Germany to Mexico, Japan, and beyond. And what a splendid cast of characters: brickmakers, Quakers, erudite scholars, famous artists, and obscure craftsmen, explorers, poets, and Mr. Benfey's own parents, whom he portrays with an amused and deeply touching affection. His prose is often delicious. This is a fascinating and charming book."
 —Stephen Mitchell, translator of *The Iliad* and author
 of *The Second Book of the Tao*

"Beautiful, haunted, evocative, and so open to where memory takes you. I kept thinking that this is the book that I have waited for: where objects, and poetry intertwine. Just wonderful and completely sui generis." —Edmund de Waal, author of *The Hare with Amber Eyes*

PENGUIN BOOKS

RED BRICK, BLACK MOUNTAIN,
WHITE CLAY

Christopher Benfey is the Mellon Professor of English at Mount Holyoke College. A frequent contributor to *The New York Times Book Review, The New Republic,* and *The New York Review of Books,* he has held fellowships from the Guggenheim Foundation, the National Endowment for the Humanities, and the American Council of Learned Societies. Benfey's most recent book, *A Summer of Hummingbirds,* won the Christian Gauss Award at Phi Beta Kappa. He lives in Amherst, Massachusetts.

RED BRICK,

BLACK MOUNTAIN,

WHITE CLAY

*Reflections on Art, Family,
and Survival*

CHRISTOPHER BENFEY

PENGUIN BOOKS

PENGUIN BOOKS
Published by the Penguin Group
Penguin Group (USA) Inc., 375 Hudson Street,
New York, New York 10014, USA

USA / Canada / UK / Ireland / Australia / New Zealand / India/ South Africa / China
Penguin Books Ltd, Registered Offices: 80 Strand, London WC2R 0RL, England
For more information about the Penguin Group visit penguin.com

First published in the United States of America by The Penguin Press,
a member of Penguin Group (USA) Inc. 2012
Published in Penguin Books 2013

Illustration credits appear on page 275.

THE LIBRARY OF CONGRESS HAS CATALOGED THE HARDCOVER EDITION AS FOLLOWS:
Benfey, Christopher E. G.
Red brick, Black Mountain, white clay : reflections on art, family, and survival /
Christopher Benfey.
p. cm.
Includes bibliographical references and index.
ISBN 978-1-59420-326-8 (hc.)
ISBN 978-0-14-312285-2 (pbk.)
1. Art and society—United States—History. 2. Benfey, Christopher E. G., 1954—
Family. 3. Artisans—United States—Biography. I. Title.
N72.S6B398 2012 2011040208
701'.03—dc23

Printed in the United States of America
1 3 5 7 9 10 8 6 4 2

DESIGNED BY AMANDA DEWEY

*Penguin is committed to publishing works of quality and integrity.
In that spirit, we are proud to offer this book to our readers; however,
the story, the experiences, and the words are the author's alone.*

ALWAYS LEARNING PEARSON

For Rachel Thomas Benfey

And is there any reason, we ask as we shut the book, why the perspective that a plain earthenware pot exacts should not satisfy us as completely, once we grasp it, as man himself in all his sublimity standing against a background of broken mountains and tumbling oceans with stars flaming in the sky?

<div align="right">

—*Virginia Woolf*

</div>

CONTENTS

Prologue:
The Mound

1.

I grew up in a placid town in Indiana, close to the Ohio border, that boasted a Quaker college, a school-bus factory, and a brown, lackluster river called the Whitewater. The river cut the town in two, both geographically and morally. No liquor was sold on our side of the river, the "dry" or Quaker side. On the opposite bank, down in the bedraggled gully known as Happy Hollow, were the ruins of the Gennett record company, where some of the classic jazz recordings of the 1920s, by New Orleans luminaries such as Jelly Roll Morton and Louis Armstrong, were pressed. A railroad was strung precariously along the river, and this, presumably, brought the unruly jazzmen to our town as they headed for Chicago. The Whitewater River, after wending its sluggish way through cornfields and limestone gorges and more nondescript small towns, dumped its murky contents into the far more impressive Ohio.

Our town was peaceful, as I say, almost officially so. Quakers opposed to slavery had come up from the Piedmont of North Carolina and Virginia early in the nineteenth century. Nostalgic for the fertile meadows and early spring of the South, they named their new settlement Richmond after their old capital city. Rich-

mond had been a major "station" on the Underground Railroad before the Civil War, when Levi Coffin, the famous "conductor" of the railroad, lived in the area, and the town had remained, uneasily, a Quaker town. Growing up there during the Vietnam War, I knew many conscientious objectors—pacifists opposed to all war who, when drafted, were allowed to perform alternative service in hospitals or prisons instead of serving in the military. I didn't know a single soldier. My own older brother had filed for CO status when he reached the age of eighteen in 1968, which turned out to be a big year in the history of Richmond, Indiana.

Like children in small towns everywhere, we complained that nothing ever happened in Richmond. And then, one hot afternoon in April 1968, something did, when six blocks of our downtown disappeared in a gray mushroom cloud. Rumor had it that local whites, wary that racial violence might spread from Chicago in the wake of the murder of Martin Luther King, had stockpiled explosives and weaponry in a sporting-goods store named, as I remember, Marting Arms. These men despised the Quakers as "nigger lovers," but a gas leak turned their own weapons against them.

I had been playing string quartets in an old office building downtown earlier that Saturday, under the tyrannical eye and ear of an unforgiving German named Koerner.

I had barely crossed the Whitewater River, carrying my black viola case as I trudged across the G Street Bridge, when the explosion occurred. I watched the cloud unfurl in the blue sky like some Cold War nightmare of unutterable disaster, the kind we were warned about, cowering under our desks, during our civil defense drills at school. Forty-one people died that afternoon and more than 120 were injured, random victims of their neighbors' fear and folly.

Several days later, as my friends and I helped in the cleanup,

there were still unexploded shotgun shells along the rubble-strewn streets. The town fathers used the federal disaster relief funds to turn the downtown into a pedestrian mall, thus inadvertently delivering the death blow to an already moribund cluster of stores and two dank and dreary movie theaters, the State and the Tivoli, where we huddled on Friday nights dreaming of distant love and violence.

2.

Many years later, when I had all but forgotten the explosion and was teaching—as I had always promised myself that I would never do—at a small college in a small town, just as my father had done before me, an unfamiliar student dropped by my office to ask if she might do an independent study with me on the Beat poets. To my surprise, she mentioned that she, too, had grown up in Richmond, Indiana. We had a long talk about every detail of the failed downtown: the terrible bookstore that didn't sell books, the more terrible restaurant that didn't sell food, and the area down by the Gennett factory on the river, which had become, she told me, something of a tourist destination for jazz fans.

I was about to turn fifty, and I had found myself surrendering increasingly to a retrospective mood tinged with a faint but unspecified melancholy. With her hair dyed pitch black, her ironic wit, and her taste for Kerouac and Gary Snyder, this messenger from the past brought Richmond back to life for me.

A week after our first conversation, I received an e-mail message from the dean, informing me that my student had dropped out of school. A few weeks later, back in Richmond, she sent me a photograph of the monument erected in memory of the victims of the 1968 explosion.

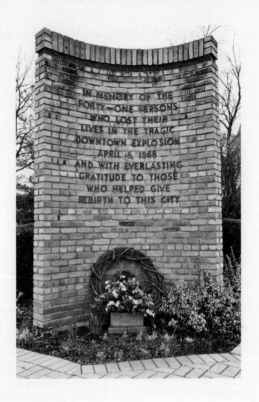

The monument, as I could see from the photograph, was a concave wall of neatly laid red brick, with gray lettering matching the color of the mortar. I could easily imagine my mother's father, a brick mason, subjecting this curved wall to scrutiny. The wall was one brick length (or stretcher) wide, and every sixth row was made up entirely of the widths (or headers) of brick laid side by side. At the top of the wall was a single line of much darker brick, the high-fired variety known as blue brick. And above this line, as a sort of crown, was a row of bricks laid vertically.

Someone had clearly given some thought to all these details, probably with Maya Lin's Vietnam Veterans Memorial in mind, though the meaning of all this virtuosic brickwork wasn't entirely clear. As for the gray lettering, the design committee must have struggled to find words for the accidental deaths of so many

blameless people, like travelers on the Bridge of San Luis Rey. They finally settled on this inscription:

In memory of the forty-one persons who lost their lives
in the tragic downtown explosion April 6, 1968
and with everlasting gratitude to those
who helped give rebirth to this city

3.

The year following the explosion was a turning point for me, as though its seismic force had shaken something loose in my own convictions. Although I had grown up on the Quaker side of the river, I had worked hard at fitting in with the "ordinary" kids, as I imagined them to be, who lived on the opposite bank. I distanced myself from the other faculty brats in my neighborhood, the sons and daughters of professors at the Quaker college. I was furtive and ashamed of my black-cased viola, and what few books I borrowed from the children's floor of the Morrison-Reeves Library—mainly fairy tales, in purple and green bindings, and books about American Indians—I read on the sly.

Instead, I played on the basketball team, more a religion than a sport in Indiana, kept my hair short, and pursued blond-haired girls with names like Rhonda.

Rhonda—how exquisite and American and sexily ordinary she looked in her pleated Scotch-plaid skirts. Her golden hair was long and straight, as though it had been ironed—perhaps it had been—and I touched it warily, like a talisman that might change me, straighten me out, when we played nervous games of spin-the-bottle at parties. My own hair, first "wavy" and then increasingly curly with a dangerous tendency toward frizz, was

to me the most alarming of the symptoms of puberty. That seemed the safest attribution, warding off some deeper cause: my Jewish ancestry on my father's side or some buried secret from my mother's Southern generations.

I tried a chemical straightener and I tried a hairnet. I slept with one hand firmly pressed against the side of my head to keep the rebellious hair in place. Something more drastic was needed. I ventured warily into the African American barbershop near the library, down the street from the Specialty Records store that sold "race records." There, as I sat nervously in the thronelike chair and listened to the banter of the barber and his cronies, my hair was cut and treated with foul-smelling potions. The results were disappointing. One day, a black teammate took me aside during basketball practice and asked, softly and affectionately, "Chris, you got nigger blood?"

The annual basketball dinner, when team members were celebrated one by one, was a mixed bag for me, part honor and part humiliation. I loved to receive the trophy and the athletic letter for my warm-up jacket, but the fathers-and-sons game that followed was excruciating. While the other ordinary dads—the police officers and grocers and insurance salesmen—mixed it up with their sons, doing trick shots and behind-the-back passes, my father stood awkwardly on the sidelines in his coat and tie and his German, Henry Kissinger accent. He could no more play basketball than fly to Mars. When my friends asked me if my father played any sport, I told them helplessly, and with wild exaggeration, that he was a mountain climber.

During the months following the downtown explosion, I went through a kind of slow-motion change, a transformation that I still don't fully understand. The pressure of starring on the eighth-grade basketball team—I was the starting center and the team captain—and the endless practices, one beginning at seven in the morning and another following the end of classes, came to

seem onerous to me. I found it harder and harder to get out of bed in the morning, and I slipped into a bottomless teenage lethargy. Abruptly, surprising even myself, I announced to the basketball coach, an ineffectual man in white tennis shoes named Eccles, that I was quitting the team.

This, it turned out, was not so easily done. Mr. Eccles called me repeatedly, coaxing and cajoling me by turns. "I am very disappointed in you, Chris," he said (he pronounced it CREE-us). "You could be a real star on this team. If you come to practice tomorrow, I promise that nothing will be said against you." And then the star of the ninth-grade team, Trent Smock, called me as well. Trent Smock was an idol of mine, and I remember thinking, well, if Trent Smock wants me to play, maybe I should play. But I stuck to my decision.

A few days later, as I was shooting baskets in our driveway with my friend Bobby Beales, Bobby allowed as how he wouldn't mind having a girlfriend. "Well, I'm all set," I said complacently, since Rhonda and I had been "going out" for almost a year. "No, you're not," Bobby said, with a cruel satisfaction that I had never heard in his voice before. "Rhonda was at the high school game last night, and she said you'd changed."

And then he added, as though he believed it too, "You're different."

4.

Leaving basketball put me in touch with another part of myself. For many years, I had indulged in survivalist fantasies. I tried to live on milkweed shoots and wild sorrel, harvested from the wasteland beside the driveway, and I studied a book by Euell Gibbons called *Stalking the Wild Asparagus.* The life that the Indi-

ans had led, close to the ground and the bare essentials of existence, appealed to me. Our ranch house—an absurd misnomer, given its modest proportions, really a couple of parallel hallways with a narrow kitchen in one and four cramped bedrooms opening from the other—was on the edge of town.

Fields opened directly beyond the row of scraggly apple trees in our backyard—planted, I firmly believed, by Johnny Appleseed himself. As far as I was concerned, the wilderness began right there. To venture deeper into the woods, my friends and I mounted our bicycles, stabled in the garage like trusty mules. We peddled down the meandering curves of Abington Pike—Doug Nicholson, Joel Barlow, Jeff Nagle, and I, Quaker renegades all—out beyond the fields and into rougher country.

About a mile beyond the sign that said, to our delight, CITY LIMITS—it always reminded me of a television show about paranormal activity called *The Outer Limits*—we found the opening in the woods where a secret path led down through stinging nettles to the swimming hole. Here, the Whitewater River abruptly narrowed and purled between great outcroppings of blue-gray shale stuccoed with fossils. Along the banks of the river and above the nettles were mulberry trees, laden with red and purple fruit. We ate them by the handful, staining our hands as the nettles mottled our legs, with stinging splotches that looked like more mulberry stains. Then, the harvest over, we were back on our bikes, flying pell-mell downhill past Curtis's farm, its stagnant pond clotted with cattails and no longer fit for swimming. Farther, around a turn in the pike and onto a gravel road, we heard the sound of rippling water: Blue Clay Falls.

We rode right in, like cowboys in a Western, our bicycle spokes flicking water into rainbows in the sunlight. The falls were no more than rapids, really, cascading over a broken staircase of low-lying shelves of shale, filled with oozing blue clay like Napoleons stuffed to bursting. Bluish, translucent crayfish—

we called them crawdads—skittered out in alarm when we poked at the clay with our toes.

The mood in the woods wove its spell: the sun filtering down through the high, wind-brushed foliage; the eerie silence except for the trickle and meander of the falls; the sense that animals and birds, invisible but near, were watching us expectantly, intruders in their lair.

Once, as we were dozing by the falls, our backs propped up against moss-bearded oak trees, Doug Nicholson, rummaging in the woods, came across a pile of *Playboy* magazines held in place by a chunk of limestone—someone's private stash of woodland joy. Suddenly, we were all wide awake, reaching over one another's shoulders to turn the pages with snickering awe. Someone ripped out a centerfold, and that was the signal. We tore the magazines to pieces in gleeful celebration.

And then, as though this, too, was part of the agreed-upon ritual, we stripped down to our boxers and slid into the shallow creek. We pried handfuls of cold blue clay from between the rocks and covered our faces and bodies with it, working it into our hair. We barely knew ourselves. Our bicycles could wait. Our families could wait. We were in another world now, hieroglyphed in blue. Our pockets under the sheltering trees should have been filled with grapeshot and pemmican.

5.

During the summer of 1969, a year after the downtown explosion, I was fourteen and getting ready to leave Indiana and basketball for good, to enroll in a progressive boarding school in Vermont. The change that Rhonda had referred to was pretty much complete. I had let my hair grow, and the incipient curls

had flourished into an Afro. I was reading books from the up-stairs (adult) section of the Morrison-Reeves Library, by Huxley and Saint-Exupéry. I was beginning to wonder what I might do with my life. That summer, I whiled away the time by helping to excavate an Indian mound in the middle of a cornfield near one of the small towns along the Whitewater River. I thought at the time that I might want to be an archaeologist.

My father taught chemistry at the Quaker college, and three students there, the archaeological team, were happy to have an assistant for the dig, someone to wield a shovel rather than a toothbrush. The undertaking seemed wildly romantic to me, and I had vague ideas about gold trinkets and bones and secret pas-sageways lurking in the mound. Each morning, the college stu-dents, a woman and two men, stopped by our house in a battered blue pickup truck. They were long-haired and easygoing, but very serious about their work on the mound. We drove out of Richmond on the old National Road and then across flat corn-fields to the roped-off site, easily discerned as a rise or swelling in the ground.

Then our long day under the hot Indiana sun would begin. The field was redolent of sweat and feed corn, and the fat flies hovered lazily over the dig. A battered transistor radio droned Top Forty songs from a station in Dayton, Ohio. Hours of pa-tient probing with blade and brush would bring to light a bit of mica or a shard of ceramic earthenware or a fragment of worked shell—the luxury goods traded by the Hopewell culture that in-habited the region from about 500 B.C. to A.D. 1000. I mainly sat and listened and watched, until some sifted dirt had to be shov-eled out of the excavated area.

The students told me that there were ancient burial mounds and monuments all over the Ohio River Valley and beyond, built by unknown tribes called, for want of a better name, the Mound

Builders. The mounds were minimalist earthworks etched directly into the landscape by visionary artists who made the world their canvas. Early European travelers in America were convinced that the mounds, some of them quite intricate in their geometry, were too sophisticated for the local Indians to have built, so they came up with the idea of a mythical people—wanderers from Wales or Phoenicia, perhaps, or a lost tribe of Israelites—who had preceded the Indians.

"May Plato's Atlantis have once existed?" the French writer Chateaubriand wondered in his *Travels in America and Italy,* as he journeyed through the colonies in 1791 in search of the Northwest Passage. "Was Africa ever joined in unknown ages to America? Be this as it may, a nation of which we know nothing, a nation superior to the Indian tribes of the present day, has dwelt in these wilds. What nation was this? What revolution has swept it away? When did this happen? Questions which launch us into the immensity of the past, in which nations are swallowed up like dreams."

6.

The year 2009, the year in which I write these words, seems impossibly far away from 1969, as impossible to imagine as growing up. I am now fifty-four, older than my father was as he stood dutifully on the sidelines of the fathers-and-sons basketball game. I can now begin to imagine what it was like for him, a stranger among strangers. At fifty-four, life, at least my life, is as much a task of recovery as of acquisition. The uncertain prospects ahead are weighed against the magnetic pull, stronger every day, of retrospect. To own one's past and the past of one's family takes

on a peculiar urgency. The archaeological impulse is a trust in the importance of origins, of beginnings.

7.

Sigmund Freud was a great smoker of cigars and a passionate collector of antique objects. He once told his doctor that his love for the prehistoric was "an addiction second in intensity only to [my] nicotine addiction." Freud's consulting room was a private museum, the glassed-in bookcases covered with statuettes and fragments excavated in Greece, Rome, and Egypt. The famous couch, piled high with pillows, was draped with an antique Persian rug, a Shiraz. Freud's hero was Heinrich Schliemann, the famous digger and discoverer of Troy. And Freud's favorite metaphor for the layering of the human psyche was drawn from archaeology. He told the patient he called the Wolf Man that "the psychoanalyst, like the archeologist in his excavations, must uncover layer after layer of the patient's psyche, before coming to the deepest, most valuable treasures." As he reminded us, *Saxa loquuntur.* The stones speak.

8.

I am searching in this book for a pattern in the wanderings of my far-flung family. But the narrative has more to do with geology than genealogy. I take my promptings from the material order of things, and especially from the clay—whether the dark, iron-rich clay of red brick or the white clay of Cherokee pottery and

fine porcelain—that is a recurring motif in the book. My own memories take up relatively little space.

The first section evokes the red-clay world in rural North Carolina where my mother grew up. The daughter and grand-daughter of bricklayers and brick-makers, she was raised on the edge of the Piedmont, where the economy is based on tobacco and red brick and where folk potteries reaching back two hun-dred years dot the country roads. The beautiful vases and bowls of the famous pottery at Jugtown, where Chinese and Japanese shapes fused with native traditions, gave her an early sense, in her own vocation as an artist, of why art lasted and what it was for. At the very moment when she prepared to leave this red-clay world, a tragic romance cracked her young life in two.

The second section moves west into the Appalachian foot-hills, to the visionary experiment in education and the arts un-dertaken at Black Mountain College. I retrace the journey of the artists Josef and Anni Albers, from their background in the fa-mous Bauhaus in Berlin to their fresh start in the New World. Josef and Anni were my father's uncle and aunt; Josef ran Black Mountain College during the 1930s and 1940s, when its tremen-dous impact on American culture was greatest and Black Moun-tain students and teachers included Robert Rauschenberg, John Cage, and many others. The Alberses taught via materials; their deepest lessons lay in the contrast of textures—brick and wood, pebble and leaf. But they also taught by example, as Anni said, by fearlessly "starting from zero." In the contours of the moun-tain roads, they discerned hidden messages, marks of home.

The third section moves farther west and further back in time, as I tell the extraordinary story of the eighteenth-century quest for "Cherokee clay." Operatives from Wedgwood and other potteries combed the dangerous North Carolina outback, riven by Cherokee fighters amid the opening salvos of the American

Revolution, looking for the silken-white clay that is needed to make fine porcelain. One of my ancestors, the Quaker explorer and naturalist William Bartram, was a tangential participant in this quixotic search. Bartram's hallucinatory travel journal fired the imaginations of the Romantic poets Coleridge and Wordsworth. "Kubla Khan," Coleridge's great opium-inspired poem, is, among other things, a dream of Carolina.

The title, *Red Brick, Black Mountain, White Clay,* names the three paths, each mapping the experiences of relatives or ancestors of mine trying—by art, by travel, or by sheer survival—to find a foothold in the American South. Heavily invested in memory, the book moves backward in time and westward in space as it digs successively deeper into the dirt and rock of the North Carolina outback.

9.

Remember the story of Hansel and Gretel. When they are led into the dark wood by their bitchy stepmother and acquiescent father, Hansel leaves a trail of white pebbles, secretly dropped from his pocket one by one. Brother and sister find their way home by following the serpentine path of pebbles. "And when the full moon had risen," as the North Carolina poet Randall Jarrell translates it, Hansel "took his little sister by the hand and followed the pebbles, which glittered like new silver coins and showed them the way."

10.

Starting out, I imagined a straightforward book in three parts, moving along a taut narrative path with a sturdy foundation of clay undergirding all. Books have their own fates, however, and research—at least the kind of research that I practice—yields to serendipity. If the destination is known beforehand, what's the point of the journey? A provisional map of the whole allows the woolgathering pilgrim to get a little lost along the way without losing his bearings completely. Meanwhile, coincidences and chance meetings confirm a certain rightness, a fit, in the meandering quest.

Midway, someone asked me, out of the blue, to write an essay about Karen Karnes, the major potter of Black Mountain College. Midway, the fact of James McNeill Whistler's North Carolina roots and his North Carolina mother—surely the most familiar mother in American art—muscled its way into the proceedings. Midway, I discovered that the uncanny parallels I had sensed between two tragic young men in my narrative, Sergei Thomas and Alex Reed, were even closer than I had suspected. One learns to trust these promptings as confirmation rather than distraction. Sometimes, the shortest path between two points is serpentine.

For me, however, the true beginning of this book lay in red clay. I began writing at the precise moment when I realized, in a flash, that the iron-rich Carolina clay that formed the bricks my grandfather laid was dug from the same hills and streambeds that yielded the earthenware pots of Jugtown.

Now is the time to stake out the area with a taut white string and dig down carefully, one layer at a time, into the mound

of memories. And when the hard work with picks and shovels yields to the more delicate probing with blade and brush, I'll sift through the red dirt and white sand, looking for shards and fragments and anything else of interest that might lie buried there.

PART I

The Bamboo Grove

1.

A geological cleavage slices through North Carolina from south to north, with sand hills on the eastern side of the divide and red clay in the Piedmont to the west. My great-grandfather John Abner Thomas lived right on the divide, in the hamlet of Cameron, North Carolina, and he made his living from both sand and clay. During the spring and summer he grew broadleaf tobacco in the white sand, and during the fall and winter he laid red brick among the farms and villages around nearby Sanford, the self-proclaimed Brick Capital, USA, where brick factories still line the perimeter of the city. Abner's own father had been a bricklayer, and he taught his son, my grandfather, to be a bricklayer as well. It was, you might say, red brick all the way down.

Abner had a double house, artfully shingled in a fish-scale pattern and painted white. You entered by the wraparound porch supported by six slim columns. There was a creaky swing for two on one side of the central door and a ceramic whiskey jug on the other, gray with pebbled salt glaze. If you touched the jug's surface, it felt like the skin of an orange. The two front parlors—living room and dining room—were for receiving guests and for show. Between the parlors was a central hallway, known as a dogtrot, which connected the front rooms to an identical struc-

ture of two rooms in the back: the kitchen and the master bed-room. Behind the house were outbuildings built of rough-hewn pine logs streaked with black pitch as if by a child's handwriting: a smokehouse, a barn for animals—pigs, cows, and a mule—and farther away, the tobacco barn for curing tobacco.

Above the front portion of the house was an attic where my mother and her two sisters, Nancy and Velma May (known as Punk), and her two brothers, Alec and John Wesley, played when they visited on Sundays. There was a chest up there filled with old dresses and suits. My mother and her sisters would pull out the dresses and try them on. Then they would dance around the attic, taking turns twirling an old umbrella like a parasol—it was the only umbrella my mother had ever seen.

When we visited my great-grandfather Abner, when he was slowly dying from diabetes, he never left his bed. Both of his legs had been amputated by then, and the rest of him, truncated, lay hidden under thick dark blankets. I was only five or six at the time, but I can still remember the dark word *gangrene* fill-ing the room like a suffocating smell. For me, the word still has the thick and cloying odor of tobacco leaves drying in the pitch-streaked barn.

2.

My mother's father, Alexander Raymond Thomas, gave up the tobacco side of the business to concentrate on brick. He attended a vocational school not far from home and learned to build the great brick ovens in which bricks are fired in Sanford and else-where. He traveled as far as Texas to lay these ovens, kilns made of bricks for making more bricks. Late in his life, he teamed up with my dashing uncle Alec, whom he had taught the bricklayer's

trade. Together they established a factory for making handmade decorative brick.

One spring—it must have been around 1960—my grandfather packed the trunk of his white Cadillac with beautiful long bricks and drove to our house in Indiana and right there laid our mantelpiece. Carrying the bricks one by one from the big-finned sedan, I knew in my hands what bricklayers have known for a thousand years: that bricks are human scale, made by hand to fit in the hand. My grandfather showed me how to get the mortar, spread with a pointed trowel like icing on a cake, just right. He was a connoisseur of well-laid brick; he would point out to me, with his stub of an index finger, the shortcomings of certain walls and buildings. Graceless attempts to hide a careless alignment of brick or a shoddy mortar job were never lost on him. He believed—believed in his fingertips—that honesty in brick was as important as honesty in any other transaction.

My grandfather referred to his missing index finger as his "trigger finger," and I always thought he had lost it in the war—I wasn't sure which war, maybe the Civil War. Later, I learned that he had lost it as a teenager while feeding corncobs into a shredding machine. My grandfather was a mason of both kinds, a bricklayer and a Mason. He wore his Masonic pin to the Methodist Church on Sundays.

3.

Arriving at my grandfather Raymond's house on U.S. Highway 1 in Cameron, North Carolina, was like some fantasy from Oz. Snaking up from the highway was a long driveway laid entirely in red brick, herringboned, like a winding signpost signaling my grandfather's profession. As a teenager, my mother had helped

to lay that driveway, couching the red brick in a smoothed bed of white sand. The driveway led up to the white frame house that Raymond had built with his own hands during the Depression, when no one could afford his services as a brick mason.

During those tough years of the 1930s, Raymond drove a truck loaded with produce from North Carolina to the Fulton Market in New York City, stopping only for gas. To stop for anything else, especially in a city, was perilous, for the crates of peaches and potatoes were fair game for thieves. When Raymond drove his truck through downtown Philadelphia, my uncle John Wesley would sit in the back with a baseball bat, threatening anyone tempted to steal a crate.

When our sky-blue Opel station wagon shifted gears for the slow crawl up the redbrick drive, my two older brothers and I knew our destination: the swing in the bamboo grove. A huge oak, big and strong as my grandfather himself, stood in the white sand by his house. Dangling from an upper branch was a thick rope holding a plank swing. At one end of the swing's flight was my grandfather's chimney, laid in the same red brick as the driveway and tapering artfully, with the stepped diagonal pattern you see in certain paintings of Vermeer and De Hooch. On the other end of the swing's swooping curve was my grandfather's bamboo grove, an exotic flourish of Asia amid the orderly tobacco rows of North Carolina.

My grandfather was a passionate fisherman, and he had planted the bamboo to supply the fishing poles he couldn't afford during the Depression. He had dammed the creek down by the Old Route 1 roadbed, a ghost road of riven macadam overgrown with weeds, and he stocked the resulting pond with bass and bluegills. When he took me fishing, a highlight of any visit, he would deftly bait the hook with a fat pink night crawler, which wriggled on the hook like his missing finger.

My mother swam in the fishing hole with her sisters and

brothers, watching out for water moccasins among the cattails along the stream. The old road was full of nooks and hideaways, inviting the resourcefulness of children. The three girls played with paper dolls cut from Sears Roebuck catalogs. They made furniture and cars from shoe boxes and pieces of paper. On the old road, there was a huge outcropping of quartz with moss and little plants growing in the cracks. There they built elaborate paper-doll houses from leaves and flowers.

Swinging on the swing in the bamboo grove, your reward for a good push off the chimney with your feet was to fly up into a spangled world of bamboo foliage and sunlight, green and gold. Then you had better twist your body immediately to get another push, or you might bruise your back against the hard brick. Between brick and bamboo—that was the journey and that was the return. You learned from the soles of your bare feet that these were two different materials, two different principles of strength: the solid red brick and the yielding green bamboo.

The swing was the source of complicated pleasures, especially if John Wesley's four daughters were visiting at the same time that we were there. They lived in Richmond also, though their Richmond was in Virginia and ours was in Indiana. On Sundays, they wore white dresses with petticoats: Theresa, Debbie, Betty, and Sharon. The petticoats were fun to watch as they floated up like unfurling blossoms into the bamboo leaves.

4.

The bamboo grove had evidently been a romantic place for my parents, as well, for they had planned to have their wedding there. If bad weather is a good omen for a marriage, my parents' marriage seemed destined to last forever. Their wedding took

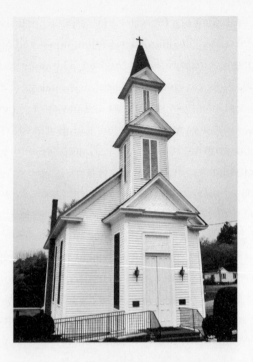

First Methodist Church, Cameron

place during Hurricane Bess, in late August 1949. They had planned to hold the Quaker ceremony outdoors in the bamboo grove. Instead, on account of the weather, they were married in the First Methodist Church in Cameron, a narrow, upright white frame structure built on New England models. It was the kind of small-town Southern church that Walker Evans had photographed in rural Alabama during the Depression. As a teenager, my mother had accompanied hymns on the piano in that church.

My father, a refugee from Berlin, must have seemed an exotic figure in these surroundings. When my mother first mentioned his Jewish background to her parents, her father asked, "Does that mean he's rich?"

If my father was a survivor of Nazi Germany, my mother was something of a survivor as well. She had been engaged to be married once before. During the summer of 1945, when the war

was drawing to a close, she had met a darkly handsome young man named Sergei Thomas at a Quaker summer camp in Richmond, Indiana. Sergei was already a leader among young Quakers, a charismatic figure who urged them to follow in the footsteps of the radical founder of the Society of Friends, George Fox. Amid the religious conflicts of seventeenth-century England, Fox had defied the king and the Church of England in pursuit of his own spiritual quest. Fox and his followers worshipped in silent gatherings, spoke only when the "spirit" moved them, treated men and women as equals, and refused to doff their hats to superiors. For their tendency to "quake" in the presence of God, they were derisively nicknamed Quakers.

At the time that she met Sergei in Richmond, my mother was a scholarship student at Guilford College, a Quaker school on the outskirts of Greensboro, North Carolina. She herself was not yet a Quaker, but a sojourn in Richmond had seemed more inviting than spending the summer in sunbaked Cameron, picking the local crop of dewberries for a nickel a quart.

My mother's maiden name was Rachel Elizabeth Thomas. She and Sergei had the same last name; their marriage must have felt somehow preordained. Sergei's exotic first name came from his mother, Nadezhda Ivanovna, who had worked as a reporter in Moscow after World War I. There she had met an operative for the American Friends Service Committee, the Quaker organization involved in relief work, named Cleaver Thomas, and they were married in the Russian Orthodox Church in her native Minsk.

Nadya and Cleaver settled first in Brooklyn, where Sergei, their only child, was born in 1925. Sergei spoke Russian with his mother. Around the time he was eight, Nadya had a nervous breakdown, and Sergei was sent to Westtown, a Quaker boarding school outside Philadelphia, where he lived with a foster family. Separation from his family seems to have brought out in Seegar,

as his friends at Westtown called him, a compensatory energy to excel. He was a star athlete in high school, playing on the varsity teams in track, tennis, basketball, and soccer. He was also the editor of the school newspaper, and he starred in the school play, Thornton Wilder's *Our Town*.

Sergei played the wise and ruminative Stage Manager, who haunts the local graveyard, commenting on the inhabitants, the living and the dead, of a small New England town.

At Westtown, two convictions crystallized for Sergei. One was the belief that war in any form was wrong. The other was that Westtown was wrong to exclude African American students. He entered Haverford College during the fall of 1942 and was soon drafted. Men like Sergei who were "conscientiously" opposed to war could either serve in a noncombat capacity in the armed forces or, if they belonged to certain approved "peace churches" like the Quakers, they could perform some form of alternative service to the country. Instead of being shipped off to the South Pacific, Sergei headed for Tennessee. There, he was assigned to work in Civilian Public Service Camp 108 in Gatlinburg, in the Great Smoky Mountains National Park. It was from the mountains that he traveled to Indiana during that summer of 1945, when he first met my mother.

After a two-week orientation at a Quaker retreat on the edge of town, Rachel taught children at a Friends meeting during the day and attended square dances and other social occasions during the evening. Once she and a friend hiked into Richmond to find some lime ice cream, her passion at the time. At some point in the two-week orientation, Rachel remembers, Sergei turned up. He was there to interview a Quaker who headed a movement called Back to the Land. Sergei was interested in this farm project. "He also," as Rachel remembered, "became interested in me!" Back at Guilford at summer's end, Rachel, as she put it,

"sort of left the summer behind." Then a letter came from Sergei saying that he was coming to Guilford College to visit her.

5.

The Appalachian town of Gatlinburg is in the heavily forested high country just across the state line from North Carolina. Camp 108, located deep in the woods outside the town, was one of the many Civilian Public Service work camps established in remote regions all over the United States during World War II. The camps were intended as much for internment as for work. They were meant to isolate men who had dangerous and subversive ideas that might contaminate the war effort.

President Franklin Roosevelt was hostile to conscientious objectors and had firmly opposed special accommodations for their views. It was only when the churches themselves—the Mennonites, the Brethren, and the Society of Friends—offered to organize and pay for the camps that Roosevelt relented. A military service bill in 1940 allowed COs to be assigned "to work of national importance under civilian direction." Beginning in May 1941, approximately twelve thousand men served in the CPS in 151 camps. Many of these were forestry camps like the one in Gatlinburg, where men living in rude barracks cleared trails, built roads and bridges, maintained campsites, and fought forest fires as smoke jumpers.

The Gatlinburg camp was run by Quakers in a former Civilian Conservation Corps barracks. The CCC was a Depression-era program of the New Deal Works Progress Administration (WPA), and the conscientious objectors at Gatlinburg took up forestry work abandoned by the WPA draftees. The Gatlinburg

camp was nicknamed Camp Rufus Jones after a well-known his-
torian of Quakerism and mysticism. Gatlinburg was actually the
second locale of the camp. It had started as Camp 19 at Buck
Creek, near Marion, North Carolina, in the woods below Black
Mountain. (Black Mountain College was a few miles away on the
other side of the mountain.) The head of the camp was Raymond
Binford, president of Guilford College. When work at Buck
Creek was under control, the men were transferred to Gatlin-
burg in July 1943.

Initially, the term of service for the CPS camps was to be one
year. After the Japanese attack on Pearl Harbor and the Ameri-
can entry into World War II, however, COs were expected to
serve, just like GIs, until six months after the war ended. During
their service, they were not paid for their work, they received
nothing for their dependents, and they had no medical insurance
or workmen's compensation.

6.

It was in the Friends Historical Collection at Guilford College
that I first heard Sergei's voice. A handsome elderly man with
white hair and sky-blue eyes was sitting at the information desk.
When I told him I was interested in the CPS camps he said, "You
can talk to me. I was in the Buck Creek Camp." When I men-
tioned Camp 108 in Gatlinburg, he told me that the men there
had produced a newsletter, which he would be happy to show
me. As I sat down to read the pile of mimeographed pages called
the *Calumet*, after the peace-pipe in Longfellow's *Song of Hiawatha*,
I discovered that Sergei had contributed a regular column called
"Chips from a Double-Bit Axe." As I read Sergei's columns in the
reading room, as quiet as a Quaker meeting, I could make out

his voice across the intervening years, the voice my mother had heard sixty years ago.

The voice was clever and full of mischief and at the same time deadly serious about things that mattered. The jokes were about the privations of camp life: the food, the distant wives, the primitive sanitary arrangements. There were also cheerful updates about the CPS athletic teams, as well as a reminder of what a gifted athlete Sergei was.

> The Smoky Mountain Soccer Club defeated the Knoxville "Royal Jay" Soccer Team at Smithson Stadium 6–0 last Sunday afternoon. The CPS team with a more solid defense and a sharper passing attack completely outplayed the home team in the second 45-minute period after scoring only two goals in the first half. Downing, Diehl, Koeppe (after a layoff of ten years), Probasco (on his first attempt at soccer), and Sergei Thomas, who scored all the goals for the Smokies, turned in good performances.

For the serious things, Sergei's voice changed to a darker register. North Carolina was a Jim Crow state, and race relations were on his mind. Sergei used a furlough during the spring of 1944 to attend the Philadelphia Yearly Meeting, where he lobbied hard for the admission of black students to Westtown. His eloquent plea carried the day. That summer, two CPS workers returned from Philadelphia and reported on the lukewarm race policy of the Friends Executive Committee. "One wonders," Sergei wrote, "if racial equality is the unquestioned practice of the Society of Friends."

Idealistic young Quakers like Sergei felt that the Society of Friends, with regard to race, was betraying its radical traditions. They wondered how the activist sect of John Woolman, who had traveled through North Carolina during the eighteenth century

urging Quaker farmers to give up their slaves, could blithely turn its back on the descendants of those slaves. The CPS workers at Camp 108 felt a sharp identification with slaves of former times. There was a movement to unionize the camp workers and to demand the opportunity, as promised in the original CPS agreement, for participation in "work of national importance" rather than the routine maintenance of recreational facilities they were engaged in.

CPS men lobbied to work in hospitals and schools instead, but their views were considered too dangerous for local populations. Eventually, in June 1942, an exception was made for mental hospitals, as isolated from ordinary society as work camps deep in the woods. The duties imposed on Quaker volunteers in mental hospitals were extreme. One untrained man would be put in charge of a ward of a hundred violent male patients for a twelve-hour shift. CPS workers were appalled at the conditions they experienced in these hospitals, which were little more than badly run and worse equipped prisons, and they did what they could to make these shortcomings public. Reform of state hospitals owed much to the work of CPS men during World War II.

The most disturbing work performed by COs was to serve as human guinea pigs in medical experiments. As many as five hundred CPS men volunteered as human subjects for forty-one macabre experiments involving various communicable diseases as well as the effects of starvation—the latter billed as an attempt to gather information for relief agencies in war-ravaged Europe. In July 1942, men at a camp in New Hampshire were ordered to wear underwear infested with typhoid-carrying lice for several weeks, then were tested with an array of insecticide powders. Others ingested water laced with human excrement to contract hepatitis, or had malaria-bearing mosquitoes placed in glass bowls on their chests.

Sergei reported that several Camp 108 workers had volunteered as "pigs" for the Atypical Pneumonia Experiment at the posh resort of Pinehurst, in the central Piedmont region of North Carolina. Instead of playing golf and watching horse races, the volunteers contracted pneumonia by swallowing infected spit. "First reports from T. Pudge White of the Holly Inn"—the luxury hotel that housed the grim government-run experiment— "tell of excellent food, rooms, public relations, and hard work for orderlies at the A-P experiment in Pinehurst."

During his final year at the camp, Sergei volunteered to go on several humanitarian "cattle boats" under the direction of the Church of the Brethren. On his ID card issued by the U.S. Navy, he is officially identified as a cattleman. These boats carried cattle and horses to areas in Europe decimated by the war. Sergei made one trip to Poland, where he saw the Warsaw ruins, and traveled twice to Trieste. My mother never forgot the names of the boats—the S.S. *Plymouth* and the *Lindenwood*.

7.

I have a photograph from the spring of 1948 that shows my mother and Sergei standing on the Guilford campus next to a huge pine tree. Sergei, taking a break from his job clearing trails in the Great Smoky Mountains, looks fit and youthful, like a young Jack Kerouac, with a plaid flannel shirt open two buttons down and a wildflower stalk in his hand.

My mother, smiling demurely, her bobbed hair framing her face, holds a sheaf of wildflowers, as gently as a baby. She looks like Demeter preparing for the fall. An ominous shadow encroaches on the bottom edge of the snapshot. On closer inspection, it appears to be the shape of the photographer's head,

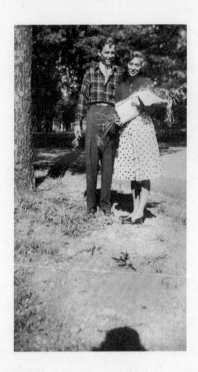

evidently a woman with hair sweeping upward. According to a note on the back in my mother's handwriting, they had just ridden their bikes out to the Revolutionary War battleground on the edge of Greensboro, where the Quaker general Nathaniel Green defeated the British under Cornwallis in the Battle of Guilford Courthouse. It was there that they collected the flowers.

I have another snapshot from the same day, dated in my mother's hand April 3, 1948, with three handsome young people taking a break on their bicycles, a white fence from a horse farm behind them and again a big tree nearby.

My mother is now wearing, it appears, Sergei's flannel shirt; Sergei is in a sweater; and Sergei's friend Brad Snipes sports a zipped-up jacket. It occurs to me that the photographer who took both pictures was Brad's future wife, Inge, who was my mother's roommate at Guilford. When these photographs were taken, Rachel Thomas and Sergei Thomas were already engaged.

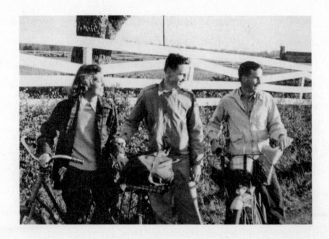

8.

The wedding was scheduled for June 13, 1948, two months after the photograph with the bicycles. Sergei and Rachel spent the weeks before the wedding preparing for their summer jobs as camp counselors at a Quaker girls camp in the Poconos. Sergei, an experienced swimmer and lifeguard, was to be in charge of the water activities. He and Tom Snipes, one of Brad's brothers, decided to take a canoe trip down the Delaware River below Philadelphia to hone their skills. The date was April 22, 1948.

The currents of the Delaware are deceptive. That spring day, when the two young men pushed off from the shore, the waters were high after a recent storm, and the current was swifter than usual. Near the pilings of the last bridge, just before the widening river enters the Atlantic Ocean, they lost control of the canoe, and it capsized in rough water. A paddle got loose and floated away. Tom Snipes clung to the canoe, but Sergei swam out to retrieve the lost paddle, letting go of the canoe. Tom lost sight of Sergei as the current by one of the pilings sucked him down.

Rachel was sitting with her friends Brad and Inge at the

junior-senior banquet at Guilford College. They were joking about what they would do after graduation, when a teacher announced that there was a telephone call for Miss Rachel Thomas. "I still remember the 'Miss,'" my mother says. Cleaver Thomas, barely audible, was on the line. "Something's happened," he said. "There was an accident on the Delaware River. They can't find his body. They haven't found Tom either." Rachel went back to the banquet table to tell Brad Snipes that his brother might have drowned.

Brad got on the phone and learned that his other brother, Sam Snipes, had located the canoe. Tom, it turned out, was okay though badly shaken. A few days later, a fisherman thought he saw a body pulled downstream in the high water. "Until then," my mother says, "I thought it was just a bad dream."

It was six weeks before the wedding. Rachel's mother canceled the order for invitations. "That was the only time I saw my father cry," she said. He hired a private plane to fly Rachel up to see Nadya and Cleaver. Cleaver and Rachel then drove to Haverford to pick up Sergei's belongings. Cleaver asked if she wanted any of Sergei's things. She took the plaid shirt. She also took his tennis racket.

The drowning cut my mother's life in two. She remembers nothing much from her sleepwalking graduation from Guilford College that May. Afterward, her parents drove their three daughters—Rachel, Nancy, and Punk—on a vacation trip to Canada, with stops at the Nabisco plant and Niagara Falls, like some honeymoon after all. That fall Rachel worked as a nanny for a wealthy family in Merion, Pennsylvania, near Haverford, and was an assistant teacher at the Haverford Friends School.

One day, about to board the Main Line train known as the Paoli Local, Rachel happened to see Tom Snipes on the Haverford platform and neither of them knew what to say. Years

later, while living alone in a cabin in Vermont, Tom Snipes shot himself.

<div align="center">9.</div>

During the fall of 1948, six months after Sergei's drowning, Rachel was introduced to a young chemistry professor at Haverford named Otto Theodor Benfey, who had arrived in the United States the previous year, after completing his doctorate in London. For a long time, I had wondered whether Sergei's death had troubled my parents' courtship. When I asked my father what it was like to have Sergei's ghost hovering around, he replied, to my surprise, that it wasn't an obstacle to their courtship; rather, it was the occasion for it. "We met through Sergei's death," he said.

Ted (the name he had substituted in England for the Prussian-sounding Otto) was in his first year of teaching at Haverford when he heard of this promising young man, Sergei Thomas, who was to have graduated from the college and whose death had left his fiancée bereft. Moved by this tragedy, Ted wrote her a note. "And then she appeared at the Haverford Quaker meeting. An older physics professor invited us both to dinner." Rachel remembers things slightly differently. Ted wrote to Nadya and Cleaver, she says, and appended a note to convey his condolences "to the fiancée."

Ted slid into the space in Rachel's life that had been vacated by Sergei. The two young men had much in common. They were born the same year; they were both Quakers connected to Haverford; and both of them had European names suggesting distance and exile and suffering. I wondered if Rachel and Ted's shared fate as survivors of trauma—Rachel surviving Sergei's

death, Ted escaping from Hitler's executioners—had brought them closer together. And then I asked again about Sergei's presence during their courtship. "The death deepened Rachel," my father answered. "There was no girlish silliness about her."

After my parents' wedding, in the Methodist Church rather than the storm-tossed bamboo grove, they borrowed a car from Renate, my father's sister, and drove up into the Cherokee settlements of the Smoky Mountain National Forest. There, in the very woods where Sergei had cleared trails and repaired cabins for Civilian Public Service Camp 108, they began their married life.

10.

I grew up with Sergei's ghost. He was frozen in time, like the freeze-frame of the photograph, there on his bike on the way to the Guilford Battleground, always young and handsome and strong, always twenty-two. For my mother, he must have stayed like that, and so he was for me. I learned to play tennis with Sergei's tennis racket, a battered green and brown Dunlop, the handle worn smooth by his hand. I was a passionate tennis player as a child, spending endless summer hours hitting the ball against a backboard at the hillside courts at Earlham College, in Richmond, Indiana, not far from where Sergei and Rachel had first met. Somehow it was conveyed to me, through my mother, I can only assume, that Sergei had been a wonderful tennis player just as, I also knew, he had been a wonderful swimmer. Looking back on that monotonous discipline, hitting thousands of backhands against the unyielding backboard, I wonder what I was really up to, and what I was thinking.

One morning, when I was twenty-one or twenty-two and a

student at Guilford College, I found my mother standing abstractedly, with a haunted look, in the kitchen. "I dreamed of Sergei last night," she said, and then she told me her dream. Sergei was back, she said, among us still. Soon afterward, I wrote a poem:

To the Man Who Almost Married My Mother

There are things in our house, souvenirs
that keep you in touch with our family.
My hand has worn smooth
the handle of your tennis racket.
A drawing you made of a porch
with overhanging branches hangs
in the hallway by the door to my brother's room.
Our mother rarely speaks of you.
Once, though, at breakfast, articulate
and bleary-eyed, she said:
"I dreamed of him last night. He was alive
and back. I didn't know what to say
to your father, who walked up and down
in the yard, while Sergei
sat in the dining-room sipping black tea
and waited for my decision.

"I wanted them both to go away.
I wanted to be alone. I woke up
frightened and relieved
that your father had already left for work,
leaving the sheets on his side mussed."

Sometimes I think that I invented
the circumstances of your death, planned

the canoe trip a month before your marriage, plotted
like a spiteful river god to twist
the currents around your boat
and suck you down.

Let's say it was a knot that I had tied
to bring me luck, to bring me
into the world, as selfish
as any child.

Today, I wonder where,
in the long-limbed reaches of the Delaware,
your vulnerable body lies hidden.

11.

During the spring of 2009, my parents planted a *Cryptomeria japonica* (Japanese cedar) in memory of Sergei Thomas. It stands in the sandy soil near the entrance of the Whittier Wing of Friends Homes, the retirement community in Greensboro, North Carolina, where they now live. There's a bronze plaque inserted in the ground, next to the tree. "In memory of Sergei Thomas, d. June 1948," it reads. "Given by Ted and Rachel Benfey." The evergreen cryptomeria is a sacred tree in Japan and is often planted at Buddhist temples and Shinto shrines. Its elegant grandeur somewhat resembles its cousin the sequoia. Its spiraling green leaves, closely packed like needles, play off handsomely against the red brick of the linked buildings of Friends Homes.

12.

Friends Homes is situated next to New Garden Friends Meeting and its adjacent cemetery, directly across New Garden Road from Guilford College. The neighborhood is the old Quaker settlement of New Garden, a prosperous farming and brickmaking community surrounded by woods, dating back to the eighteenth century. It was during those years that Nantucket whaling families, as the eighteenth-century traveler Crèvecoeur puts it in his *Letters from an American Farmer*, "cheerfully quit an island on which there was no longer any room for them." At New Garden, Nantucket whalers—those "fighting Quakers," as Melville described them in *Moby-Dick*—married Philadelphia women, forming the gene pool of so many Quakers in North Carolina and Indiana.

Among the graves in the old New Garden Cemetery are prominent Quaker names like Mendenhall—one strand of my mother's family—and Coffin and Hobbes. Here in a little brick schoolhouse, Levi Coffin taught local slaves to read. In the nearby woods, Coffin hid escaped slaves on their journey north. He established the Underground Railroad, which extended from this part of North Carolina across the Ohio River and up to Indiana. Once he was carrying escaped slaves under the false bottom of a wagon loaded with vases and straw. An official asked him what was in the wagon. "Earthen vessels, my friend, earthen vessels," Coffin answered. Because the Bible says that we are all made of clay, Coffin wasn't lying. He later settled near Richmond, Indiana, where he continued to ferry slaves to Canada and freedom.

New Garden was the most remote of the American Quaker settlements; early travelers thought of the North Carolina Quak-

ers as the Church in the Wilderness. Even in the midnineteenth century, visitors described the lonely outpost of New Garden "upon the verge of the forest." In 1845, an English visitor, James Hack Tuke, gave a vivid sense of the romantic and forested mood of the place in his description of the arrival of Friends for Yearly Meeting at New Garden, so many that "one is ready to believe that the very trees drop Friends instead of acorns":

> The shady wooded paths seem alive with the innumerable figures which are trooping down them, whilst as far as the eye can penetrate into the deeper recesses of the forest, one form after another is constantly appearing, now momentarily hid from view amidst the darker stems of the noble trees. There in the distance, a cavalcade on horseback might be seen gliding in and out, now lost amidst the thick branches, then emerging into some more open part, and thrown into strong relief by the bright sunshine. The pacing action of their tall bony horses, with high Spanish saddles and large saddle-cloths, adds not a little to their peculiar and foreign air.

13.

Near the old stone foundation of Levi Coffin's school, there are more recent graves in the New Garden Friends Cemetery. The poet Randall Jarrell is buried here. His gravestone is a gray slab of granite laid flat beneath a spreading oak tree. I used to walk through this graveyard every day, going from my parents' house a short path away to my classes at Guilford College across the street. I liked to linger at Jarrell's quiet grave.

Jarrell was entranced by the New Garden woods, the Quaker woods, as he called them. He lived near the Guilford College campus on a quiet, wooded street off New Garden Road. It was there that he translated Rilke and the brothers Grimm, wrote children's books, and composed his bittersweet poems, most famously about World War II, during which he served in the air force as an instructor.

Jarrell was a close friend of other poets of his postwar generation: Robert Lowell, John Berryman, Elizabeth Bishop. All four poets suffered from bipolar illness, alcoholism, romantic misery, despair. Jarrell died, an apparent suicide, in 1965, at age fifty-one, walking into the path of an oncoming car in Chapel Hill, where his wrist was being treated for an injury suffered in an earlier suicide attempt. His widow, Mary Jarrell, whom I got to know back in the 1970s, gave me his treasured copy of Rilke's poems.

I visited Mary again, in May 2004, two days after she turned ninety. On the walls of her apartment, in a retirement home near my parents' place in New Garden, there were photographs of Randall playing tennis. I asked Mary how fairy tales had entered their lives. I knew that Jarrell's childhood had been a painful one, and that the breakup of his parents had left him feeling abandoned and alone, like Hansel and Gretel. He wrote many poems inspired by fairy tales, and I wondered whether the woods around their house had something to do with it. "Yes, they did," she said. "Yes, they did. But it was also through Rilke."

14.

It is the fall of 2009. My mother is planning her wedding to Sergei Thomas. He has been dead for six decades but evidently not to her. A series of strokes following heart surgery has abolished the boundary in her mind between the living and the dead. She tells me that after sixty years of marriage to my father, she has decided to marry someone else.

"I wanted another life," she says.

She lies in her bed at Friends Homes, hour after hour, and plans her wedding. There is an intent, faraway look in her eyes. She reminds me of Miss Havisham in *Great Expectations,* waiting for her bridegroom who will never appear. It is taking weeks to get the details right.

I ask her where Sergei is now. She tells me that he has been living in Russia for the past year, "studying history." I ask if she has seen him recently. "We visited Nadya and Cleaver for two weeks last summer," she says. "We played tennis." I ask her about Cleaver. "A strange creature," she says. "A cranky old man." What about Nadya? "She lives in the past." In Russia? "Yes, in Russia."

A wedding is a complicated business, and my mother has many urgent decisions to make. Should it be held in Cameron in the bamboo grove? Would the Quaker meetinghouse in Montclair, New Jersey, where she and Sergei are members, be a better setting? She is leaning toward Montclair. What kind of wedding cake? Who will make it and who will order it? The bridesmaids! Who will be the bridesmaids?

One thing she is sure of. No punch will be served. Only Japanese green tea.

From time to time, my father asks her whether he should attend the wedding. "Of course," she says. In what capacity? He will give away the bride. "Thus, I have become her father,"

he says. "I have gotten older. She and Sergei remain eternally young."

During the days that follow, filled with anxiety and obsession, the plans are beginning to overwhelm her.

Where is her wedding dress, her veil?

One night, she heaves a deep sigh. She decides, abruptly and with finality, that it might be simpler, after all, to remain married to my father. Her brief career as Miss Havisham, with all clocks stopped, seems to be at an end.

Jugtown

1.

When we visited my grandparents' house by the bamboo grove, my brother Philip and I slept in a big double bed in the attic, surrounded by musty boxes filled with my mother's high school textbooks. On hot summer nights, the attic was stifling. Big trucks barreled down U.S. 1, their high-pitched approach abruptly waning to a long, tapering whine. "The Doppler effect," our father whispered, as he tucked us in for the long night. We woke up feeling feverish in the predawn hours.

There was a metal bedpan under the bed—a relic from the years when a dilapidated outhouse, down a stone pathway toward the snake-infested barn, was the only toilet. The floral design on the bedpan was meant to evoke the sophisticated delicacy of blue-and-white porcelain. We refused to use it, preferring to make the long journey down two flights of stairs and through the dark hallway to the enclosed front porch, which smelled in all seasons of ripening peaches. On one side of the porch, my grandfather had added a modern bathroom with a claw-foot tub.

Halfway down the darkened hallway, opposite the door to my grandparents' bedroom, was a little wooden table for the old-fashioned telephone, a squat lacquered Buddha in black. Next to the telephone was an earthenware pitcher, dusky orange, with

a large handle like an ear swooping down from the rim. To me, the telephone with its oversize receiver and the pitcher with its oversize handle seemed like two potbellied divinities listening to whispered words not meant for children's ears.

I knew one thing that the pitcher and the telephone had heard in the hallway; it was one of the first "grown-up things" I learned about as a child. It involved a handsome young man from my grandparents' church. He had wanted to be a pilot during the war and had wanted to marry a girl his family disapproved of. He had been doubly disappointed. The woman he eventually married instead was a stickler for the proper way to do things. Once she complained to my grandmother that her husband was seeing other women. "What do you expect," my grandmother said, "when you turn your back on him at night?" Then she pointed to her own double bed of sturdy mahogany. "That," she said, "is where marriages succeed or fail!"

I knew something else about the orange pitcher on the telephone table. I knew that it was a Jugtown pot. My parents had taken me to Jugtown, a small folk pottery a half hour's drive west of Cameron on quiet country roads, when I was six or seven years old. I had seen the harnessed old mule outside, walking around and around in a circle, turning the mill that ground the local clay, dug from the red earth nearby. I had watched Ben Owen, the potter there, standing at the turning wheel. A handsome man, he pulled a vase with his iron-strong fingers from a lump of centered clay.

One afternoon, I watched Ben Owen "milking" handles for a row of pitchers just like the one in the dark hallway by the telephone. He would take a lump of clay in his left hand and, with his curled wet right hand, gently coax an udder of clay downward. He pushed the upper end onto the rim of the pitcher, allowing the clay to bend down from its own weight, like a swooping question mark, into the graceful form of a handle. Then, he pressed

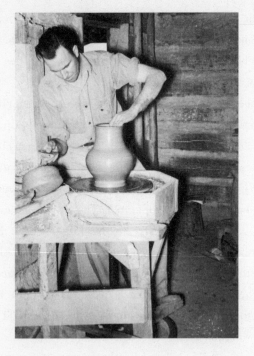

Ben Owen at Jugtown

the lower end to the pitcher with his thumb, leaving an imprint
like a signature.

2.

I had grown up with Jugtown things. My favorite cup back home
in Indiana was a Jugtown teacup, a little orange thing with a
chipped rim and a smooth handle. Our sugar bowl and creamer
were Ben Owen pots, salt-glazed and pebbled gray with cobalt
blue decorations around the rim. These were the traditional
shapes of North Carolina pottery, made in the Piedmont for a
century and more. My grandparents' pitcher on the telephone

table was glazed with orange lead and speckled with random spots of black iron that had oxidized during the long firing in the half-buried "groundhog" kiln. The glaze was known as tobacco spit. Only now, writing down the familiar name, do I see what it means: the color of chewing tobacco spat out on the ground.

A work of pottery like my grandparents' orange pitcher lives in two different worlds. It is beautiful to look at, and Jugtown pots during the last fifty years have migrated steadily from private homes into museums. But these pots were also made for use, for keeping the iced tea cold. The German philosopher Georg Simmel, in a beautiful essay called "The Handle," wrote about this double life. A pottery vessel, he wrote, "unlike a painting or statue, is not intended to be insulated and untouchable but is meant to fulfill a purpose—if only symbolically. For it is held in the hand and drawn into the movement of practical life. Thus the vessel stands in two worlds at one and the same time." The handle marks the journey from one world to the other; it is the suspension bridge from the world of art to the world of use.

If I close my eyes, I can visualize the old black telephone and the tobacco-spit pitcher sitting side by side, like an old married couple, on my grandparents' table. Both of them bring things that are far away into proximity. The telephone abolishes distance with a quick ring, a hasty grasp of the receiver, and a hurried hello. The pitcher invites a deeper, slower nearness, with the hand holding the gradually warming handle. The ear-shaped handle of the pitcher opens into other worlds and other voices, deep in the past.

3.

The story of Jugtown, as I first heard it in outline from my mother, had a certain romance. Two young dreamers from Raleigh, North Carolina, my mother's birthplace, had come up with the idea of establishing a folk pottery in the clay-rich Piedmont. James Busbee, a well-heeled descendant of Raleigh lawyers, had artistic tastes. He studied at the National Academy of Design and the Art Students' League in New York, changed his name from James to the more romantic Jacques, and pursued a career as a portrait painter. His wife, Julia, changed her name to Juliana, and worked as an illustrator. After their marriage in 1910, the Busbees became interested in folk crafts. As chair of the art division of the Federation of Women's Clubs of North Carolina, Juliana promoted traditional weaving and basketry. Jacques began collecting native pottery, especially the low-fired earthenware and more durable stoneware of the North Carolina Piedmont west of Raleigh.

One reason for the sheer concentration of potters in central North Carolina, where Busbee began his search, is the abundance of excellent potting clays. In its purest form, clay is made of alumina (bauxite), silica (sand), and chemically bonded water. But in the wild, so to speak, it is generally found mixed with other ingredients, so that different clays have different characteristics, like wine grapes grown in different regions. Clay comes in two major kinds: residual and sedimentary. A residual clay stays where it was formed; it resides there. The English word *clay* comes from the German *kleben*, meaning "to stick to or cling" and is related to the word *cleave*. The snow-white clay known as kaolin, the main ingredient of Chinese porcelain, is a residual clay and is found in the mountains of North Carolina.

If residual clays stay put, sedimentary clays travel, following

the meandering journeys of rain, river, and stream. While the Cherokee and other native peoples used residual kaolin in constructing their wooden buildings and decorating their pottery, North Carolina folk potters have preferred the more "plastic" sedimentary clays so common in the Piedmont. It is this plasticity of clay, its protean capacity to take and keep many different shapes, that makes it such a useful substance.

European pottery traditions in North Carolina reached back to the eighteenth century, when German potters settled in the Moravian communities of Randolph County, such as the town of Salem, which later joined with neighboring Winston. These potters brought with them sophisticated shapes and lively decorations applied with liquid clay (or *slip*) painted on vessels, which assumed brilliant colors when fired.

Alongside the Moravian potters, a very different tradition began to take shape during the late eighteenth century. In the small farming communities of Guilford, Randolph, and Moore County—the counties of the eastern Piedmont—there was a steady need for containers of all kinds: cups and bowls and whiskey jugs, butter churns, and chamber pots. Farmers with time on their hands could make some extra money by *turning* and *burning*, the local words for throwing pots on the wheel and firing them. The raw material, known as *mud* rather than clay, was particularly rich in the Piedmont. These local farmer-potters performed every aspect of their craft. They dug the clay from the local ponds and river bottoms. They ground it in mills powered by circling mules. They made bricks for their kilns from local clay. And they marketed their pottery themselves, taking it out on the dirt roads by the wagonload to sell to other farmers far away.

The pottery they made was made for use. The forms were dictated by their purpose; the simple glazes, made with cheap materials such as salt and glass, made the vessels watertight; ar-

tistic flourishes of any kind were time-consuming, and hence rare. Some of the earliest documented potters in Guilford County were Quakers, whose commitment to plainness and simplicity was part of their creed. The beauty of these early pots consisted of a confident but understated presence. "These guys were consummate artists," the ceramic historian Charles ("Terry") Zug III told me, picking up a whiskey jug by the nineteenth-century North Carolina master potter Nicholas Fox. "They couldn't make a crappy piece."

By 1900, local potters from a few families had been making pottery for several unbroken generations, and the old forms had survived unchanged: the jug, the pie plate, the pitcher, and the rest. But various forces were bringing this trade to an end. One was the ready availability of mass-produced containers that were both cheap and reliable. Another factor was the steady diaspora of young people moving from the country to the city. Making pots and farming on the side hardly seemed an alluring occupation for a young man with ambitions. Prohibition, and the collapse of the market for whiskey jugs, made a bad situation worse.

It took visionary outsiders like the Busbees, people with money and fresh ideas, to renew North Carolina pottery. Jacques Busbee's cultural tastes were not unusual for his time. Americans were increasingly anxious about the ravages of industrialism and the loss of intimacy with handicrafts and the land. Such worries had inspired William Morris and John Ruskin, in the wake of the Industrial Revolution, to found the Arts and Crafts movement in England during the nineteenth century. What set Jacques Busbee apart was his drive to make his dream of traditional rural craftsmen a reality.

But renewal also required potters, young people who had both the inherited skills to make the old forms and the flexibility to learn new methods. The Busbees went in search of local pot-

ters during a period when, as Zug notes, "pots were viewed as simply another cash crop like tobacco, cotton, or corn." For the Busbees, however, there was something exalted and poetic about these rural farmer-potters. Juliana liked to tell people that it was an orange pie plate, found at a county fair, that fired her interest in Carolina pottery. "It was that empty pie plate we set sail in," she wrote, "on an adventurous journey."

When they stepped down from the train in the hamlet of Seagrove during the wartime winter of 1917, the Busbees regarded the potters of Moore County as the embodiment of great traditions reaching back to the early settling of the countryside. Jacques persuaded himself that there were direct links between these local potters and the Staffordshire potteries of Wedgwood and Spode. "Some of the potters [Jacques] found had come from Staffordshire, England, about 1740," Juliana Busbee wrote. "One old potter, whose name was Sheffield (pronounced Shuffle) was a mine of information. . . . Imagine the surprise of finding his name to be Josiah Wedgwood Sheffield!"

There is no greater name in the history of pottery in the English-speaking world than Josiah Wedgwood, whose "china" dominated the transatlantic trade during the eighteenth century and after. Juliana's story was probably something of a wishful fabrication, but it shows how eager the Busbees were to establish a lineage connecting North Carolina potters with earlier traditions in England.

The Busbees tracked down two young potters, Benjamin Owen and Charles Teague, and encouraged them to develop classic Staffordshire-like shapes: pitchers and jugs, plates and saucers, creamers and sugar bowls. Initially, the Busbees and their potters were aiming for something like North Carolina Wedgwood.

4.

Then Jacques Busbee had an epiphany. He had noticed striking similarities in shape and glaze between Asian pottery in the Metropolitan Museum in New York and the North Carolina pots that interested him. Weren't these simple Southern jugs and bowls, he wondered, a kind of cultural rhyme with the ancient pottery of China and Japan? Busbee began taking photographs of pots at the Metropolitan Museum and showing them to Ben Owen back in North Carolina. Owen would then adapt the shapes to the native clays and glazes. Purists might object; it was a hybrid art that Jacques Busbee was cultivating in the Piedmont. But the alternative to such grafting was death: the end of the road for the North Carolina ceramic tradition.

"An earthy pot should contain solid firm earthy beauty," Ben Owen remarked. His aesthetic creed was a Quaker plainness:

> I avoid showy colors or any display of magnificence. Quietness, modesty of form, and harmony are elements I attempt to achieve. . . . The oriental masters have inspired me a great deal. I appreciate the quiet beauty and simplicity of form which they used to achieve balance and symmetry. The slender flowing lines are graceful, yet with strong powerful proportions, and never cease to amaze me.

Ben Owen's pots are among the most beautiful ceramic vessels ever made in the United States. White, narrow-mouthed vases that hark back in their understated grace to China and ancient Greece; ample, full-bellied, foot-tall jars in a turquoise glaze with dark purple showing through; pine-green bowls of a simple but unmistakable authority—these pots take one's breath away.

Among the dark pines and red clay of Jugtown, the Busbees cultivated an atmosphere of rustic simplicity in the log cabin they built for themselves. It was rather elegant for a log cabin, and hardly the kind of house anyone in the neighborhood lived in, but it helped to sell the Jugtown pots. The dominant style in the cabin was Japanese restraint, with rustic touches borrowed from the surrounding countryside.

My mother was invited into the Busbee home on one of her visits to Jugtown as a child. "My most vivid image is the living room," she remembered. "The sun shone in through the windows and Juliana Busbee had placed a glass vase on a table, so that when the sun shone on it one saw the rainbow. The windows had charming thin orange curtains. I can see them blowing in the breeze."

5.

I took a decisive step toward the world I had glimpsed at Jugtown—the daily toil in the pottery workshop, the simple and beautiful shapes emerging from the lump of clay, the seasonal rhythms of digging, throwing, and firing—when I accompanied my parents to Japan during the fall of 1970, when I turned sixteen. Everyone in our family seemed to be making a new start that fall. My mother, in love with purple-blue indigo, was taking a break from painting to learn the traditional Japanese techniques for dying fabric. My father, whose interests had shifted from organic chemistry to Asian alchemy, was brooding over ancient Chinese incense burners with complex geometric patterns.

With nothing better to do, my brother Stephen, four years older, and I had followed our parents to Japan with dim plans

to study Japanese and, as my father put it, "steep ourselves in Japanese culture." Japan was the boiling water; we were the tea leaves.

We moved into a Western-style stucco mansion in the town of Nishinomiya, near the sprawling port city of Kobe. Our house was in a stately row of residences built for missionaries on the edge of the campus of a Christian college. All the trees on the campus had been chopped down during the student riots of 1968, in protest against the Vietnam War and the ongoing presence of American troops on Japanese soil.

Ours was a peaceful wooded enclave, with broad lawns on one side and, across our quiet street, a cliff that descended abruptly to the hodgepodge streets of the shabby town of Nigawa, not a hundred yards away and yet entirely invisible from Missionary Row. Our cement street ended in the hills, swallowed up in a stand of impenetrable bamboo and exposed rock. There were clearings in the bamboo where students from the university met in clubs to practice the stern martial arts of karate, kendo, and archery.

One sunny afternoon in late November, two policemen knocked urgently on our door and asked in broken English if we had a television. They mentioned the name Mishima. We watched the footage together. The novelist Yukio Mishima had stormed the Tokyo headquarters of the Japanese Defense Forces and, in a screaming harangue to the soldiers, had demanded a return to the old virtues of a warrior Japan led by the emperor. Brandishing a samurai sword, Mishima cut open his own stomach, in the ritual of *seppuku*. Then an associate chopped off his head. Like some latter-day John Brown, Mishima had hoped to spark a national movement but succeeded in provoking scorn and disgust instead.

6.

For a few weeks that fall, I attended classes at the local Japanese high school, struggling to keep up with the math homework and helping out in the English class. The boys were reading "Little Red Riding Hood," an impossible title for them to pronounce. "Food," they would say. "Hood," I would patiently repeat.

Two houses down from ours, an American professor, recently divorced, lived with his infant son. He was, I think, a historian of some kind, and he had, it turned out, two keys to open doors for me. The first was his house, or rather, for us, a single room, where my brother and I spent many nighttime hours. Officially, we were babysitting, though the child was always asleep when we arrived and slept through the records we played at full volume in the book-filled living room.

That room comes back to me now as particular sounds and particular books. We were starved for music in Japan, where American music was rarely played on the radio. In the historian's house, we listened over and over again to Judy Collins's album *Who Knows Where the Time Goes*. On the shelves next to the record player were slim volumes of poetry from Grove Press and New Directions, by Gary Snyder and Allen Ginsberg, and piles of old magazines, *Ramparts* and *Evergreen*. I read Kerouac's *The Subterraneans* that fall, and it captured some of my own aching sense of loneliness and restlessness.

I remember reading a book of poems by Denise Levertov called *The Sorrow Dance*, especially a haikulike poem called "A Day Begins," which contrasted a squirrel found bleeding in the morning grass with a scene nearby of mauve irises opening to the sunlight. With these lines about opening flowers, between life and death, a door opened for me as well. It was my first encounter with Levertov and the Black Mountain poets, who

meant a great deal to me later on. It was also the first time that I read poetry in the famished way in which I have read it ever since.

7.

The second door opened for me later that winter. My father must have mentioned my interest in pottery to his colleagues at the Christian college. I had joined the pottery club at the high school and I was making pots on an electric wheel there. The historian, the same one with the records and books, had once taught a young woman in one of his classes who wanted to be a professional potter. She belonged to one of the pottery-making families in the region of Tamba, a mountainous enclave famous for its dark, mottled jars since the twelfth century. Women, long associated with bad luck in rural Japan, were not allowed to throw pots at the wheel. This young woman, however, was training in ceramics at an art school in Kyoto. It was thought that with this special expertise, she might manage to break the male monopoly in her home village of Tachikui, the last of the pottery villages of Tamba.

Inquiries were extended on my behalf, in the ritualized way in which such things are arranged in Japan, so that no one's feelings are hurt if negotiations lead to nothing.

Might there be a place at the wheel for a *gaijin,* a foreigner, in love with Japanese pottery? The surprising answer came back that indeed there was.

In the middle of February, I began the zigzag journey of trains and buses to the remote destination of Tachikui. The first change of trains was at Takarazuka, a gaudy town of neon and nightlife known for its all-female theatrical revues. From that

momentary explosion of electric light, the train entered a world of shadows, as the dim interior filled with schoolchildren awestruck at the tall foreigner hunched on the wooden banquette. This was before television was widespread in the Japanese countryside, and many of these children had apparently never seen an American in the flesh. They giggled nervously or frowned with a slight but fearful hostility.

The unfamiliar landscape spread out from the tracks. Rectangular rice paddies crisscrossed with frozen irrigation canals extended to abruptly rising hills topped with snow. Red Shinto shrines with little peaked roofs like newspaper hats jutted from the jagged hills like surveillance cameras. Nestled among the shrines were caves clotted with vines: the ruins of the ancient kilns of Tamba.

As I rode in the battered train, tugged uphill by a steam locomotive belching black smoke, I felt as though I was traveling back in time. I got off at a makeshift wooden station reminiscent of the Wild West. The last leg of the journey was in a bus, swerving dangerously around turns in the dirt road, and arriving with a flourish at the wishbone intersection right in the middle of Tachikui.

8.

For hundreds of years, the people of Tachikui have divided their work according to the seasons. During the warm spring and summer months, they farm rice in the paddies spreading toward the mountains. During the fall and winter, they make pottery in the small storehouses, known as *kura*, adjacent to their living quarters. I was to live and work with the Takeda family, who owned a small pottery along the main street of the village. A few houses

farther down the street was the much larger Ichino establish-
ment, where the best-known potter of Tamba produced his wares.
Ichino had a big modern building and a staff of assistants. He had
decisively entered the twentieth century.

The Takeda establishment, by contrast, harked back to an-
other age, when the family was the basic unit of production, and
everyone in the household had a clear job to perform. The iron
routine was unvarying, but there was a great deal of joking and
fun amid the tedium. The day began at dawn, with a raw egg over
hot rice for breakfast and a few pickled white radishes on the
side. The other meals were served from a great kettle of brown-
ish soup, which was kept simmering on the stove and to which
various vegetables and bits of fish, caught in the local irrigation
ditches, were added daily.

The pottery workplace was a tight room with a low ceiling,
made even lower by overhead racks for stacking pots. Everything
in the room, including the blaring radio and the steaming kettle
for making tea, was yellow-gray, the unvarying color of the local
clay. There were two electric pottery wheels that revolved, in
the Korean fashion, counterclockwise. Two men, father and son,
worked at the wheels, turning out pickle jars and teacups at a
rapid pace. Two women, the mother and daughter-in-law, sat
cross-legged on the floor and made lids for the pickle-jars, using
plaster molds. They pushed clay firmly into the molds with their
fingers, then cut along the face of the mold with a wire, and lifted
the finished lid from the mold with another piece of clay. A small
twist of clay, applied to the rounded top as a handle, completed
the lid.

I was invited to join the women on the floor, making lids
hour after hour through the long morning, with an occasional
break for a cup of steaming green tea. Then, in the afternoon, I
helped them load the wood-burning kiln, one of the great Tamba

noborigama, or climbing kilns, that snaked up the hill like fire-breathing dragons.

Nighttime at Tachikui is what I most remember. The village was unnervingly quiet in the thick darkness, the silence pierced once or twice in the night by a passing train. The tiny room I slept in was extremely cold. I slept on a hard futon. My feet were warmed by bricks removed from the hibachi, and wrapped in the bottom of the coverlet. If I had to get up at night, the walk to the outhouse was a long one: out of the room with its cold ta-tami floor and down a steep set of stairs, then outdoors along a stone path to the wooden outhouse. It was from this outhouse that buckets of "night soil" were carried out to the rice fields in the predawn hours and dumped there, giving, I sometimes imagined, an acrid taste to the little brown carp that floated in our soup.

9.

At the time that I worked in Tachikui, during the winter of 1970, the local ceramic production was undergoing a renaissance, thanks to the Mingei, or "art of the people," movement. There was a new demand for Tamba pots and a new understanding of the significance of the Tamba pottery tradition. I recognized the broad aims of Mingei, the recoil from industrial design and the embrace of handmade irregularities, from my visits to Jugtown. In the pickle jars and sake bottles of Tamba, the mark of the hand was as palpable, as touchable, as in Ben Owen's tobacco-spit pitchers.

The Mingei movement was founded by Sōetsu Yanagi, an urbane Tokyo aesthete who, around 1916, fell in love with the

ancient, rough-hewn pottery of Korea. He wrote an influential book, *The Unknown Craftsman,* laying out his ideas for aesthetic renewal through traditional handicraft. Yanagi soon joined forces with the formidable English potter Bernard Leach, author of the bible of modern folk pottery, *A Potter's Book.* Like the Busbees in North Carolina at exactly the same time, the 1920s, the two men went in search of traditional Japanese potters and pottery techniques as an alternative to modern industrial production.

The Mingei movement stalled during World War II and its difficult aftermath in occupied Japan, when the ravaged country placed its hopes in the revival of Japanese industry, especially the high-tech world of electronics. As in the United States and elsewhere, the sixties proved something of a watershed, with a collective revulsion in response to the nuclear age and its military-industrial complex. With renewed interest in traditional Japanese arts, Tamba, with its long tradition reaching back to imported Korean potters during the sixteenth century, was at the forefront of the revival. Leach's American wife, Janet, whom he had met many years earlier at Black Mountain College in North Carolina, apprenticed herself to Ichino at Tamba. In 1970, the year I arrived there, the distinguished American potter Daniel Rhodes, who also had close ties to Black Mountain, wrote a beautiful book called *Tamba Pottery: The Timeless Art of a Japanese Village.*

As a direct result of all this reawakened interest in traditional pottery, the Tachikui potters worked together to establish the Tamba Museum, where visitors could experience directly the extraordinary ancient pots of the region. Rhodes wrote movingly of what they found there:

The pottery of Tamba is not a very large part of Japanese ceramics as a whole. In fact, many accounts of Japa-

nese pottery barely mention it. It is not one of the more
glamorous kinds of pottery, and few examples of it are
to be seen in collections or in museums outside of Japan.
Nevertheless, it is one of those expressions in clay which
is peculiarly Japanese and one which has had an unusually
long history. It was little influenced by and had little influ-
ence on other types of pottery. Tamba grew directly out of
the social fabric; it was the product of farmers who were
close to the basic essentials of existence. It had, therefore,
a directness, an honesty, a suitability to purpose and lack
of self-consciousness, which have been the mark of the
best pottery everywhere.

When I visited the Tamba Pottery Museum, I fell in love
with a magnificent storage jar from the Kamakura Period, around
the thirteenth century. It was a foot and a half tall but it had
the authority, the rootedness, of a much larger pot. With its ru-
ined lip and its dark scars from the kiln, it had the weathered
look of a survivor. The bare clay was the dark purplish red of
Tamba, with a great swath of white-and-green natural ash glaze
dripping down the side, like a sash thrown cavalierly over the
pot's shoulder.

As I sat on the floor with the women of the Takeda family,
making the lids of modest pickle jars, or joined them in load-
ing the kiln on the hillside, I was for a few weeks a part of a
centuries-old tradition.

10.

That winter in Tamba remained an island in my past, one of those events in one's teenage years that retain a magnetic pull, even as life moves on in other directions. Then, on a recent trip south to visit my parents, it opened up for me again when I pulled into Johnny Burke Road in the red-clay hamlet of Pittsboro, a half hour south of Chapel Hill, and encountered Mark Hewitt's big pots basking in the sun.

These monumental pots—glazed in the rich oranges and juicy alkaline browns of traditional Southern folk pottery and studded with bits of partially melted blue glass—were of truly Ali Baba–esque proportions. It was a brisk spring day, and the way the planters and storage jars gathered the dark pines and the cloudless blue sky around them reminded me of Wallace Stevens's poem about the jar on the hill in Tennessee, which makes the "slovenly wilderness" surround it.

Hewitt is one of the best known ceramic artists now at work in America. Friends in New England with a serious interest in pottery had mentioned his work to me over the years; when I started thinking about Jugtown and its place in my life, they urged me to visit his workplace. Hewitt's low-lying house lies at the end of a gravel road, with a fenced pasture sloping up the hillside opposite the house. A tenant next door keeps ducks and chickens; occasionally a rooster complains in the henhouse. Down from the main house are two huge yellow-brick mounds, like whales surfacing; these are Hewitt's kilns. Alongside one of the kilns, on the day I arrived, was a row of a half-dozen pots, big enough for a man to curl up inside. As I walked down toward the kilns, shadows infiltrated the late afternoon and lingered in the boughs of the tall pines.

Hewitt, a tall and athletic Englishman of craggy good looks,

came striding out of the pottery shed to greet me. Clay was on his overalls and clay was in his bones. Although his "big-assed pots," as he jokingly calls them, have entered many museum collections, Hewitt prefers to call himself a "functional" potter, a maker of pots for use, as opposed to the "studio" or art potters whose work is intended for display. Even his outsize pots are targeted for specific purposes; he's more gratified to see a tree growing in one of his planters than to see the vessel standing empty in someone's living room. The sheer size of Hewitt's pots draws on nineteenth-century North Carolina pottery practices, when potters made large-scale whiskey jugs and grave markers; it was only later that Jugtown and other folk potteries found that smaller pots appealed to urban buyers and collectors.

Hewitt, born in the English industrial city of Stoke-on-Trent in 1955, has his reasons for being touchy regarding the traditions he works in. Both his father and his grandfather were directors of Spode, the manufacturers of fine china. Hewitt could

easily have entered the family business (both Spode and Wedgwood, its main competitor, have since hit hard times), but having grown up in the counterculture of the early 1970s, he was drawn instead to the anti-industrial craft practices inspired by Ruskin and William Morris. He liked to look at the pottery in the Bristol Museum, where he was taking classes at the university. He liked the rough-hewn Asian pots and the handmade English pots.

Then someone gave him Bernard Leach's *A Potter's Book*, with its heady combination of clear directives for how to throw, glaze, and fire a pot, and its insistence on the superiority of the clean lines and austere decoration of classic Asian pottery, and he knew where he was going. Hewitt served a three-year apprenticeship with Michael Cardew, another legendary ceramicist and the author of *Pioneer Pottery*, who had been Leach's first pupil. Cardew had worked in West Africa—in Ghana and Nigeria—grafting indigenous practices onto Leach's distinctive aesthetic blend of English slipware (pottery decorated with colorful liquid clay before firing) and Japanese simplicity.

During the time when Hewitt was working for him, Cardew happened to have a Jugtown pot in a place of honor in his living room. The Jugtown potter Vernon Owens had visited Cardew and left the little salt-glazed jug, decorated with a blue-and-brown flower painted on the side. Cardew "was famous for condemning other people's pots and he would often break them," Hewitt says. "But this little jug ended up on the big Welsh dresser that was at the center of his house in the dining room among all of his most treasured pots. It had a legitimate presence, it had passed Michael's test."

Wishing to strike out on his own, Hewitt, accompanied by his American wife, Carol, came to Pittsboro in 1983, attracted by the rich ceramic traditions and by the abundant local clay. "I was fascinated and charmed by it all," Hewitt says of the varied North Carolina pottery scene. "The potters were all different

from each other, each with incredible skills and talents, using local materials." Such regional pottery traditions are rare, Hewitt says. "They are like wildflowers that only grow in certain special soils and microclimates."

On my way down to Hewitt's, I had spoken with Terry Zug, at his place in Chapel Hill, about the blessings of working within a tradition. Zug mentioned how difficult it is for a young potter, faced with the bewildering array of national and aesthetic possibilities (from the no-frills Japanese ash glaze of Bizen—a favorite of American potters—to the playful postmodern allusiveness of Judy Chicago), to forge an individual style, or personal cohesion, as Zug called it. Working in the mode of a particular region, like the North Carolina Piedmont, narrows the number of forking paths for a versatile potter like Hewitt.

11.

I woke up early the next morning to join Hewitt for the morning's work. Duck eggs from the tenants next door made a sturdy breakfast. Pink sheaths of cloud wreathed the pines on the horizon, where the sun was rising like another giant egg. We entered the wooden door of Hewitt's workplace—"It's not a studio," he said; "studios have chairs"—a converted chicken house with a mottled dirt floor and a potbellied black woodstove in the center. A bucket of water on the stove steamed in the morning chill, with Miles Davis's *Kind of Blue* on the CD player.

It reminded me of the Tamba workspace, with its simmering teakettle. Shelves in the back were lined with drying plates, mugs, and the slim tumblers that Hewitt makes for what he calls the iced tea ceremony, an informal Southern version of the Japanese ritual. Hewitt showed me some glazes he had been ex-

perimenting with: a marbleized effect (garbleizing, he calls it) he gets from dripping liquid red clay into pools of white. He was excited about some progress he had made in reproducing the famous "hare's fur" glazes of China, much admired by tea ceremony connoisseurs in Japan.

That day, Hewitt was making identical half-gallon jugs from three-and-one-half-pound lumps of clay. He stood at one of the electric wheels, one leg thrust back for leverage, and worked fast. "It takes a long time to learn the music," he said, "to make small things very well." The apprentices arrived at eight thirty, and Hewitt gave them their marching orders. I'd already heard about one of them, Alex Matisse, from friends back in Greensboro. A great grandson of the French painter, Matisse had lasted a year at Guilford College before dropping out to pursue a career in pottery. He started feeding clay into the pug mill, a six-foot dragon of a machine that homogenizes the clay and eliminates the pockets of air that can ruin a pot.

12.

Hewitt and I had been talking about the allure of native clays and the special pleasures of making pots from them. I happened to mention that my mother was from Cameron. Hewitt looked astonished. Cameron clay, he remarked, was the basis of his current work. He went even further. Cameron clay was his *salvation*. He led me to the entry area of the shed, where expanses of local clay were laid out in various stages of preparation. He handed me a chunk of pale gray clay with a yellow tinge. "That's the Cameron clay," he said.

A few years back, Hewitt explained, he had been having

trouble firing his big pots. "You know those moments when terror sends an impulse that grabs your testicles?" he asked. "Well, for a couple of firings, at six in the morning, with the sickening pop muted by flame and smoke, I'd hear the pots opening up, as if a butcher was performing open-heart surgery on them using a meat cleaver." Clearly, he needed to find a new clay, and quickly. His previous supplier, a brick company, mentioned that they had found a promising seam of clay in a sand pit among the spindly pines and scrub oaks in the sand hills outside of Cameron, thirty miles from Hewitt's pottery.

Hewitt evoked the ecstasy he experienced in coming across the good clay he needed for his livelihood: "like stories of native peoples crawling on their knees the last few yards to sacred outcrops of hematite, or white clay, with which they adorn themselves." Driving to Cameron in his pickup truck, he was "singing a song, jumping in my seat, anxious to see this clay, get a sample, take it home, have it analyzed, make some pots, and find out whether it would be a good foundation for my clay body."

The scene at the sand pit, with its clutter of prefab offices and the roar of front-loaders and circling dump trucks, was like something out of *Mad Max*. There, in the bottom of the pit, was what Hewitt had come in search of.

A seam of clay, about twelve feet thick, was clearly visible beneath the upper layers of sand and gravel. The slightly moist clay was pink from a token stain of iron, breaking into irregularly shaped nuggets about the size of baseballs. I was in paradise. I dug my shovel in. Clay cleaves with a certain thunk; it's not got the siftyness of sand or the harshness of gravel. Too sticky and it'll stick to the shovel, like shoveling molasses; too hard and the point of the shovel will bounce back at you.

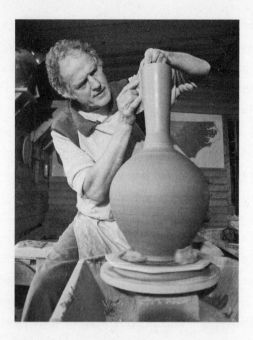

Mark Hewitt

The clay far exceeded Hewitt's expectations. "You could say that I've built my career on Cameron clay," he told me. "It's a tough and reliable clay that's as safe as houses."

After leaving Hewitt's pottery, I drove down to Cameron to see for myself. I'd forgotten how the houses on the main street, many of them antique shops now, have sand rather than grass out front. The locals sweep their yards rather than mow them. I pulled into the sand pit as a huge truck was exiting. I'd come unannounced and blundered into one of the trailers. A man in a ponytail was testing sand samples for highway standards. "Better see the boss," he said, when I told him I was interested in clay. The boss turned out to be a friendly young Englishwoman named Karen McPherson, whose office was covered with photographs of dressage horses—an immediate bond, because my wife, Mickey, is also a serious rider. She offered to drive me

down, through a mile or so of wasteland, great canyons of sand, to the clay pits Hewitt had described. "These must be the sand hills," I said. "That's right," she said. "We're getting rid of one of them."

13.

I must have chosen the hottest week of the summer to return to Pittsboro, a year or so after my first visit, to watch Mark Hewitt fire his big groundhog kiln. It was 98 in the shade when I pulled into Johnny Burke Road. Hewitt and his two apprentices were carrying the final load of pots from the workshop to the forty-foot kiln, which looked like a beached whale in the merciless summer sun. No one packs a kiln more tightly than Hewitt; multiple shelves of vases, mugs, tumblers, plates, and bowls— roughly two thousand in all—were wedged in around the huge pots that are part of every Hewitt firing.

Accident enters the potter's domain through many doors, but none is more dramatic than the wager of the kiln. So many things can go wrong in the swirling flames of a cross-fired, wood-burning kiln. "If the fire sinks, or grows too hot," wrote the French poet Paul Valéry, "its moodiness is disastrous and the game is lost." Hewitt has come to treasure the gifts of chance. Where pots touch accidentally, discolored "kisses" may form. Where bricks on the ceiling of the kiln melt in the firing, "potter's tears" may drip onto the shoulders of the pots huddled below. Quartz pebbles will blow out from the clay during firing, resulting in what North Carolina potters call "pearls." Bits of grass or twigs will flash out of the surface of the fired clay, leaving blemishes or beauty spots.

"While the fire is in action," Valéry said, "the artisan himself is aflame, watching and burning." Watching Hewitt during the side-stoking of the kiln, as he nervously eyed the temperature gauge and carefully slid another slat of wood into the flames, was like watching a ship captain responding to shifting winds. It was a more delicate operation than I'd imagined, not at all like heaving coal into a steam engine.

As he got ready to spray some salt into the chambers of the kiln, in hopes of getting the pebbly effect in the glaze that North Carolina potters have achieved for two hundred years, Hewitt shrugged, wiped the sweat from his brow, and said, "At this point, all you can do is pray." It seemed appropriate, for the anxious but hopeful mood of the firing, that the biggest pot in the kiln, a "sentinel" based on nineteenth-century North Carolina gravemarkers, was inscribed with the Nunc Dimittis, the traditional evening prayer of the Anglican service: "Lord, now lettest thou thy servant depart in peace."

14.

The traditions of British and American folk pottery have come full circle in Hewitt's work. I had often thought of Bernard Leach and Jacques Busbee as strangely parallel figures in the history of folk pottery. Both had sought to resurrect vanishing pottery traditions, one in England and the other in North Carolina. Both had looked to the spare shapes of Song China and early Staffordshire for models. And both had founded potteries to reflect their ideas, staffing them with gifted potters like Shōji Hamada and Michael Cardew and Ben Owen. And now, here was Hewitt, trained in the Leach tradition and well versed in Japanese meth-

ods, but working with the clays and glazes and techniques of Busbee's Jugtown, making pots that would outlast us all.

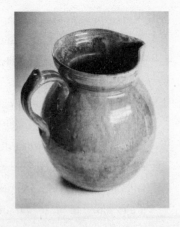

Mist was lifting from the fields early the next morning, and the great kilns lay sleeping. But Mark Hewitt was already down in the pottery shed. As I watched him trimming some dinner plates—placing them upside down on the wheel, centering them, and cutting away the yellow-gray clay to leave a clean, articulated base—I could have been back in Tamba, back in the daily, age-old rhythms of clay.

15.

A few months after my visit with Hewitt, my aunt Juanita, Uncle Alec's widow, sent me a pitcher that Ben Owen had made, the same pitcher that had sat for so many years on the table in the hallway in my grandparents' house in Cameron. It seemed to have ripened, like a burnished pumpkin in the fall, since I had last seen it so many years ago. There were mossy green shadows on its orange belly, like the bamboo grove in twilight.

I thought of the worlds its homely shape had opened for me. It had brought back memories of Jugtown, with its simple rhythms of turning and burning, and my grandparents' life of tobacco and red brick. It had taken me to a remote village in Japan. And the same rustic pitcher, with its incised lines around its strong shoulder, had taken me to Mark Hewitt's place in

Pittsboro, where new shapes and surfaces were drawn from English, Japanese, North Carolinian, and African pottery traditions.

I thought of something Hewitt had written:

> Much is demanded of pitchers. They are among the most knocked about and banged-up pots, being pulled out of larders and refrigerators, dipped in wells, put under faucets, lifted laden and heavy, poured from, dribbled, spilt, and cursed; they are vulnerable to mishandling. Pitchers are exacting to make and tougher to make survive.

This pitcher, I realized, was a survivor. I thought of the turning wheel and the turning world, the magic, alchemical transformations of the kiln. And I thought of Ben Owen making handles, thousands and thousands of handles, each handle firmly and gracefully connecting the world of art to the world of use.

The Snuffbox

1.

As a child, I was a passionate collector of postage stamps from Germany, especially those of the Third Reich—red, black, and white—which I carefully mounted, with little adhesive hinges that I licked to stay in place, in my heavy black stamp album. Among my treasures were several big red stamps of the führer, surrounded by swastikas, saluting the fatherland. These stamps exerted a special attraction for me beyond, I like to think, a child's predictable fascination with forbidden things. My father, in any case, made no attempt to prevent me from collecting these stamps, nor do I remember him expressing any particular feelings about them. These lurid stamps promised, in some obscure way I could only dimly discern, to put me in touch with a buried period of my father's life.

The shadow over my father's childhood was more easily defined than my mother's catastrophic loss of Sergei Thomas, but it was also, somehow, more elusive for me. One could say "Hitler" or "the Holocaust" or "World War II" and feel that one had somehow named the shadow, given it a label, like the carefully penciled captions in my stamp album. And yet none of those words, with their ominous and melodramatic historical weight, named *him*, the particular man with the slight build, the fly-

away hair, and the unplaceable accent (echoes of Berlin and London overlaid with Indiana and North Carolina) who was my father. He had always seemed to me not just different from the other fathers I knew growing up in the Midwest but somehow radically foreign, as though he had come from some imaginary realm.

At times, my father must have felt like such an alien himself. By the age of twenty-one, when he came to the United States, he had done a great deal of traveling, if *travel* is the right word for the wrenching displacements that external circumstances periodically forced upon him. Crossing the Atlantic Ocean for the first time in 1946, he had written of his own disorientation and momentary panic:

> Whatever was I doing here on this ship, halfway across the Atlantic, having cut myself off from one world and not yet started on another? A weird ghostlike existence I've never experienced before.

As an organic chemist by profession, trained in a hurry in wartime London, my father had a special interest in chemical bonds, those connective affinities, or valences, that are the basis of chemical combination. He loved to tell my two older brothers and me, when we were children, about Kekule's dream, in which the great German organic chemist suddenly envisioned the hexagonal structure of benzene, with its alternating single and double chemical bonds, as a snake grasping its own tail in its mouth.

My father's well-known spiral or "snail" design of the periodic table of the elements, which he first conceived in 1964 for *Chemistry* magazine, seemed to symbolize his creative and intuitive approach to the sciences. He felt unhappy with what he called the "mammoth gaps" in the first and second periods—or rows—of the traditional periodic table. Such a haphazard de-

ployment of elements neither lent itself to teaching, nor did it seem to him an adequate reflection of the relationships among the different elements. Always drawn to geometry and the arithmetic patterns often found in nature, he was convinced that a more elegant arrangement might be found for the elements and their *periodicity*—their cousinship with other elements arrayed above and below them. The result was his famous snail.

My father's interest in geometry resurfaced a few years later, during the year we spent in Japan in 1970. Designs on the surface of a bronze incense burner from the Tang era, in the imperial collection in Nara, persuaded my father that the ancient Chinese knew—contrary to the assertions of Western historians of science—the fundamentals of Euclidean geometry and specifically were familiar with the dodecahedron (twelve identical pentagonal faces) and other regular solids in which certain molecules array themselves. He traced the dodecahedron pattern, as he found it on the incense burner in Nara, to Persian pottery of the Sassanian period, decorated with "a symmetrical enclosed

three-petal flower pattern." He noted that "a number of Persians including skilled craftsmen came to China after the overthrow of the Sassanian empire by Islam in the seventh century."

But my father suspected that the Chinese were aware of the dodecahedron long before the Persian potters arrived. He discovered that the dodecahedron was also widely used in basketry and reflected that it would be odd for basket weavers making flat patterns with six strands *not* to stumble upon the form. "May one assume that some primitive man or woman, tired of always weaving six strands to create a hole, chose to weave only five, or even did so by mistake?" he wrote. "That person would very quickly have discovered that one cannot create a flat surface or tessellation with pentagons, that joined pentagons produce closed cage structures." These cage structures would be dodecahedrons.

During his tenure as editor of *Chemistry* magazine, my father vigorously defended his occasionally adventurous claims against seemingly more hardheaded objections. I remember a debate he had with the science fiction writer Isaac Asimov, who took offense at my father's suggestion that some assumptions of astrology seemed reasonable enough, because babies born during the winter were treated quite differently, bundled up against the cold, than babies born in the carefree, clothing-free summer. Asimov was convinced that modern science could not afford to yield an inch to such New Age lunacies. But my father always tried to find out what emotional needs were driving these antiscientific views. He wanted to bring dialogue, mutual understanding—"valence"—to people who disagreed.

My father's multivalent approach to things was connected, in ways that I have only recently begun to understand, with his interrupted childhood in an upper-class family in Berlin. As I have learned more about my assimilated German Jewish forebears and their abrupt plunge into homelessness and stateless-

ness, my father's eccentricities increasingly have come to seem like family traits, tendencies that I recognize, for better or worse, in me as well. I have come to feel that over the generations, our extended family has come to live with an underlying conviction about the precariousness of all merely human arrangements. Our suitcases are packed, whether we are lucky enough to be allowed to take them with us.

Two journeys promised to bring me closer to this scene of origins; on both I often felt as though I were threading my way through a disorienting maze of streets and emotions.

The first journey was an actual pilgrimage to my father's lost childhood city of Berlin, a voyage undertaken with my father and my two young sons.

The other was a journey via the library, along with various stray documents tracked down in archives and private collections. This second journey was in search of my father's namesake, the famous Sanskrit scholar Theodor Benfey, decipherer of arcane languages and the mysteries of fairy tales, who had long seemed to me an especially striking exemplar of our family traits and tendencies. This enigmatic ancestor had also decoded our shared last name, Benfey, tracing an exotic journey of family origins, exile, and restless wandering.

2.

"Just before my eleventh birthday my life changed completely." My father wrote those words to my son Tommy, who had just turned eleven, in a letter explaining how his privileged upbringing in Berlin had come to an abrupt halt in 1936. That was the year my father left Germany, for his own safety, to live with foster parents in England. He was separated from his family for

what stretched into a decade before he embarked on a new life in the United States. I had often wondered, as I grew up and then had children of my own, what these experiences had been like for my father, what balance of adventure and trauma had marked his early years. Though I knew the basic outlines of his life, I'd never had access to the texture, terrain, and emotional tone of his childhood.

The idea of getting together those two eleven-year-olds, my father and my son, prompted our trip to Berlin during the summer of 2000. That Tommy was born in 1989, the year the Berlin Wall came down, added another magic number to our journey. I wanted to see how much of my father's childhood in Berlin we could recover, to find ways for all of us to share it. I innocently assumed that it would mainly be a matter of finding addresses, old buildings, rooms.

In retrospect, I realize that there was a darker purpose to these arrangements as well. I wanted to set an emotional trap for my father, to try to rouse in him some response to what I perceived to be the trauma of his childhood, a trauma that, I felt, he had never fully acknowledged with us. Surely, I thought, to be banished from one's familiar world and adopted into another family in an unfamiliar country, with a decade-long separation from mother and father, must have been devastating. As it turned out, I was the one who stepped into the trap that I had so carefully devised.

3.

During the months before our departure, my father, living in the Friends Homes retirement community in Greensboro, North Carolina, sent a series of letters about his childhood to Tommy, who was studying immigration in his fifth-grade class in western Massachusetts. Ted explained how he had been forced to leave Berlin and his family behind because of his Jewish background. Ted's father, Eduard, had served in the Kaiser's cavalry during World War I; my grandmother had proudly shown me the Iron Cross, First Class, that he was awarded.

Trained as a lawyer, my grandfather eventually became a supreme court justice in Berlin, rising to the rank of chief justice of the supreme court for financial matters. Like other attorneys of Jewish background, he had converted to Lutheranism as a young man, both for patriotic reasons—to feel more German—and to advance his judicial career.

My father's mother, Lotte, belonged to the prominent Ullstein family. Her five flamboyant uncles—Hans, Louis, Franz, Rudolf, and Hermann—ran the House of Ullstein, the biggest and wealthiest publishing empire in all of Europe. The Ullstein firm printed the leading newspapers in Germany as well as best-selling books, with the trademark owl logo, such as *All Quiet on the Western Front*. The social prominence of the Ullstein family was clear to the philosopher Walter Benjamin, who played with my grandmother's cousins as a child in the fashionable western neighborhood of Charlottenburg. Benjamin wrote of the chil-

dren of his acquaintance: "And that it was high on the social scale I can infer from the names of the two girls from the little circle that remain in my memory: Ilse Ullstein and Luise von Landau."

The Ullsteins had been baptized as a family in the late nineteenth century. But to Hitler, who seized their publishing firm after his rise to power in 1933, they were all Jews. He had a special interest in controlling propaganda, and the "Jewish press" was one of his principal targets. The Nazis fired my grandfather from his supreme court post in 1935, when he was sixty. Ted described how his father had come home ashen faced "because at some Nazi office, when he introduced himself as Senatspräsident Benfey, an official replied, 'Sie sind nicht Senatspräsident Benfey. Sie sind Jude Benfey.'" ("You are not Chief Justice Benfey. You are Jew Benfey.")

Assimilated Jews like the Ullsteins and the Benfeys, perfectly at home in the sophisticated and easygoing world of Berlin during the 1920s, slowly came to realize that, despite their social prominence, their money, and their service to their country, there was no future for them in Germany.

The Mendl family, close friends of the Benfeys and also of Jewish descent, fled Berlin for England in early 1936, settling in the town of Watford, outside London. Uncle Gerald was an engineer; his wife, Auntie Babs, was a practical woman with spiritual leanings. They had a son my father's age, named Wolfgang, and suggested that Ted join them. So my father said good-bye to his family. He saw them briefly—his parents, his older sister, Renate, and his younger brother, Rudolf—on summer visits to Berlin.

The big event of the summer of 1936 was the Olympic Games in Berlin, where Hitler planned to put German greatness on display to the world. My father wrote to Tommy about the excitement of that summer, when his family lived only a mile

or two away from the construction site of Albert Speer's monu-
mental Olympic Stadium.

> Every day during the Games, Hitler would drive from his
> headquarters to the Stadium along a road just a few min-
> utes from the Fürstenplatz where we lived. We all went to
> the nearby Heerstrasse (Army Street) and waited for Hit-
> ler and his motorcade. And when he appeared in an open
> convertible, we all cheered like mad and everyone shouted
> "Heil Hitler!"

My father and his siblings knew nothing about Hitler's hatred of
the Jews and his threats against them. Their parents, as my father
explained, knew but didn't want to scare them.

Shortly before the Olympics began in Berlin, the German
heavyweight boxing champion, Max Schmeling, had defeated
Joe Louis to become world champion. Schmeling's victory over
his African American opponent was hailed in Germany as a sign
of the superiority of the Germanic peoples. Two years later, as
my father reported to Tommy, he again returned home for sum-
mer vacation.

> As usual I traveled in one of the big trans-Atlantic liners, it
> must have been either the *Europa* or the *Hamburg*. It had
> come from New York and was stopping in Southampton in
> the South of England to disembark passengers for Britain
> and pick up passengers for Germany. I was traveling third
> class—my family no longer had much money—but once or
> twice a friend and I sneaked into the first class area. One of
> these times we walked past a fancy lounge and in the back
> of it sat Schmeling. He was coming home after being de-
> feated in the first round in a rematch with Joe Louis.

By 1938, the time for half measures and hope was over, and my father's family prepared to leave Germany. His brother and sister joined him in England later that year. Their parents followed during the spring of 1939, and in September the war began. After a brief reunion in England, my father's parents and his siblings left for the United States in January 1940—without Ted.

These arrangements had always seemed puzzling to me. I had heard explanations. Ted, it was said, was comfortable with the Mendl family. He and Wolf were close friends, essentially brothers. He was doing well in school. He was on an accelerated track to earn his PhD in chemistry in 1946, when he was barely twenty. His parents would get settled in the United States, and he could join them afterward. As the war dragged on and the German submarines made Atlantic crossings impossible, "afterward" must have seemed forever, and Ted didn't see his family again until the end of 1946, when his childhood was long over.

4.

My German grandparents lost everything in the war, except the bits of jewelry that my grandmother smuggled into Ted's suitcase when he returned to London from vacations. But of course, they were among the lucky ones. Recognizing the danger, my grandmother had applied for an American visa. Her sister, the well-known weaver Anni Albers, was already in the United States, based at Black Mountain College in North Carolina, and could vouch for my grandparents' financial support. Other members of our family were caught in the roundup of Jews after

Kristallnacht, when Nazis smashed windows of Jewish shops and beat up Jews in the streets.

My grandfather's brother Arnold, a doctor, was incarcerated in Buchenwald, the Nazi concentration camp near Weimar. He would probably have died there if his wife, who was not Jewish, had not taken matters into her own hands. The daughter of a prominent German general, she visited the commandant of the concentration camp and demanded her husband's release. Miraculously, it was granted. My father saw Arnold in England soon afterward, and his hair was completely shaved off. Eduard's other brother, the banker Ernst, was sent to the camp of Theresienstadt late in the war and survived as well.

My grandfather Eduard got out of Germany just in time, but he didn't survive the journey emotionally. He was an elderly man with broken English, and he found the delivery jobs he performed in the States humiliating for a former judge. The quick adaptations of his much younger wife probably made things even harder for him. He hunched by the window in their apartment in Cambridge, Massachusetts, and listened to the war news. He was profoundly depressed, as anyone could tell.

When I first knew her, my grandmother, "very tall, thin as a stick," as a coworker described her, was working as the personnel manager at the Window Shop in Cambridge, a stylish restaurant and bakery on Brattle Street, around the corner from her own home on Mount Auburn Street. At the Window Shop, refugees from Germany and Austria found safe harbor, both as waitresses and as customers, while Harvard professors came to dine on Austrian delicacies. My grandfather, the former judge, was given the task of copying menus.

For me, as a young child visiting my grandmother, it was a special treat to be invited into the kitchen of the Window Shop, where I was given tastes scraped from the baking pans of all the

special cakes—the Linzer torte with its diagonal grid of crust across the top and the Black Forest cake. Her good friend Alice Broch, sister-in-law of the novelist Hermann Broch, presided over the restaurant and pampered me. Even today, when I taste the mingled ground walnuts and raspberry jam of the Linzer torte, I am transported back to the cramped kitchen of the Window Shop, filled with the odors of baking cakes and cinnamon. It was my first real window into the sufferings and displacements of the war years.

<center>

5.

</center>

My grandparents had been living in Cambridge for several years when my father finally arrived there, after the war was over. My father kept a diary of his journey to America, ten pages of single-spaced observations and experiences. I have read these pages again and again, looking for clues to my father's emotions at the time.

In the first wave of civilian voyages, after the troopships had gone home, passengers were still herded like military personnel into tightly packed bunk beds. Into one of these my father squeezed himself, along with his cello, on December 19, 1946. The cello, given to him by his uncle Arnold, was his traveling companion, as though he were some wandering musician.

After lunch on the first day on board, he suddenly felt feverish and weak. "Went to bed wondering why I should be ill now," he wrote. "Decided it was relaxation after all the excitement and worry." Then came a clue to his state of mind: "Thought this might prove to Wolf that I wasn't quite as cold and unfeeling as I seemed the last days."

My father was attentive to the young women on the ship, especially the European brides of American soldiers:

> There are about 250 on board and they are treated the worst of all passengers. The U.S. officials and nurses treat them as dirt and have no consideration for them at all. They are nine or more in a cabin, each with baby. Babies have no cots, they have to sleep in "hammocks" just like parents. One of them, I was told, fell out at night and by miracle did not hurt itself. They must do all their washing in one miserable little washroom. . . . They were told by everyone before leaving that they would be treated magnificently all through the trip. For how many of them will this be only the beginning of their disillusionment.

My father contrasted his own good fortune with the uncertain future of the GI brides and the other unlucky emigrants he encountered on the ship. "All my life has been like this," he wrote. "Will anyone ever believe in ten years time when I tell them I got my Ph.D. the day before leaving for America?" He sat on deck and read Goethe's *Faust* and looked forward to his reunion with his family.

6.

An eminent psychoanalyst once told my father that all his interpersonal problems could be traced back to a single source: He was separated too early from his parents. Abandoned like Hansel and Gretel in the forest of life, he was trying, against all odds, to find his way back home. It is a sign of my father's strength, it

seems to me, that he also traces much of his happiness in life to the same moment of separation. "My survival," he once said, in an exchange with his foster brother, Wolf Mendl, "the fact that I wasn't ended rather early in the gas chambers in Auschwitz, was purely due to the love and care and concern of my family in finding the best way of getting me out of there and Wolf's family in taking me in."

In England, my father was a gifted young student. Had he stayed in Germany, Wolf speculated, a Germany without Hitler, my father "would have been a very, very distinguished German professor, but a bit dry." Even in England, my father knew that this was Wolf's view of him. It comes across in that vulnerable moment on shipboard when he writes that "this might prove to Wolf that I wasn't quite as cold and unfeeling as I seemed the last days." What the apparent coldness masked, of course, was insecurity, and insecurity led in turn to what my father called his drive for excellence:

> When you're in your own family, you feel accepted—you don't question it—you feel that you belong. I was aware that no matter how much love I was having showered on me by the Mendls to make me feel at home, it was by choice; and so this drive for excelling is part, probably, of the drive for acceptance, and this sense of loneliness, of being apart, came to me probably somewhat earlier than for the average boy and girl.

My father experienced yet another kind of alienation with the bombing of Hiroshima. Although the research he was pursuing in the laboratory at University College, London, was supposedly "pure" chemistry—dispassionate investigations into the properties of certain molecules—he was aware that it also had potential real-world applications, such as explosives and poison

gas. And while he knew something about nuclear reactions and the possibility of an atom bomb, the actual deployment of such a weapon was a shock from which he never quite recovered. "I just walked in a daze through London, wondering what I was doing among scientists. I almost dropped science completely and went into something quite different." Instead, he developed a slight distance from professional science, the intellectual aloofness and questioning attitude that Isaac Asimov had deplored.

He had also moved toward a condemnation of all war. Wolf's mother had become a Quaker in England. She was appalled at what the Nazis had done to Germany, but she was also disgusted by what the Allies were doing to ordinary Germans during the vengeful carpet bombing of German cities as the war drew to an end. Auntie Babs was deeply drawn to mystical writings and introduced my father to Meister Eckhart and the other masters of the mystical tradition. My father called all this the matrix out of which his own pacifism grew. By the time he left England, he was a Quaker.

Growing up, I had often been puzzled by the idyllic way in which my father described his departure from Germany and his education in England. There seemed a disconnect there. I could see how Wolf was dismayed by my father's blithe invulnerability, his seeming coldness. I was inclined to agree with the psychoanalyst about the source of my father's eagerness to please (a tendency I have inherited). My desire to take my father back to Germany had an ulterior motive. I wanted to investigate the scene of the crime. I wanted to see with my own eyes where the separation had occurred, where the child had been abandoned. I wanted to probe the wound.

7.

I had been in Berlin once before, with a student group during the summer of 1977. Berlin was still a divided city then, rife with suspicion, and I remember the sensation of always being watched. Taking the subway under the Wall felt ominous, as though we were entering the underworld—would we be allowed to return? We assumed, a bit grandiosely, that our grim hotel rooms were bugged, our every movement and conversation logged in some police agent's record. People we met in the East confirmed our paranoia. A Quaker scholar I met in Dresden said that living in East Germany was like living in Hawthorne's *The Scarlet Letter,* surrounded by vigilant Puritans.

This time, by contrast, my father, my two sons, and I waltzed through customs with nary a stamp on our passports or a questioning glance from the smiling officials. We were met at the airport by the German novelist Sten Nadolny, who was writing a historical novel about the Ullstein family, to which my father's mother belonged. Together we drove into the vast and bewildering urban network of Berlin—dilapidated old neighborhoods, glittering new downtowns, skyscrapers under construction, and bombed-out spaces.

As luck would have it, we arrived on the afternoon of the Love Parade. This annual Mardi Gras–like frolic on the second Sunday in July started in 1989, when a DJ celebrated his birthday by blaring music from a truck as he drove down the Kurfürstendamm, followed by a raucous parade of friends. With no political or religious agenda whatsoever, the Love Parade had become a mob of boozy, scantily clad revelers surging up, across, and down Unter den Linden, the main thoroughfare of the Eastern sector, through the Brandenburg Gate, and into the Tiergar-

Garden of Exile and Emigration

ten, Berlin's biggest park. My father and I covered our ears, but the boys liked the relentless techno beat coming from loudspeakers, though the dyed hair and bare breasts took them by surprise. That night, back at the hotel, eight-year-old Nicholas drew pictures of spiked green hair and wrote in his trip diary, "I think they made too much of the word LOVE."

Our sturdy, unfashionable hotel was within walking distance of the old center (the Mitte, or middle) and the futuristic new skyscrapers of Potsdamer Platz. What I hadn't bargained for was the hotel's unnerving proximity to the old Gestapo headquarters, just a block away. The building was destroyed by Allied bombing, but the basement rooms, where prisoners were interrogated and tortured by the SS, came to light during recent construction. The site is now an ongoing archaeological excavation and outdoor museum called Topography of Terror.

On our first full day in Berlin, we visited the architect Daniel Libeskind's Jewish Museum. Tommy and Nicholas loved the building's fun-house effects—stairways leading nowhere and narrowing corridors ending in dark shafts. Libeskind's Garden

of Exile and Emigration, a maze of forty-nine concrete pillars topped by willow trees, was the ideal setting for a boisterous game of hide-and-seek. "This place is *cool*!" Tommy said.

Their irreverence in the labyrinth—a symbol of a tangled world in which so many children did not, in the end, find a way out—made me a little nervous until a museum official put me at ease. One message of the museum is that Jewry survives in its children, she said, and children are especially welcome there. Overhearing these reassuring words, Sten Nadolny remarked wryly, "Exile is terrible for grown-ups, but children can find fun things along the way."

8.

I was turning over Sten's observation as we took a taxi to the apartment house in Charlottenburg where my father had lived until the age of eleven. It was a lovely cream-colored stucco building of six stories, built in 1910. We rode up in a cast-iron elevator that rose beside the marble staircase, passing purple-and-pink Secession-style stained-glass panels on each landing. We knocked on the door of Ted's former apartment. A friendly couple, a lawyer and his gynecologist wife, with their new baby in her arms, invited us in. Ted noticed that the bathroom and its claw-footed tub were unchanged. Ted and Tommy stood in Ted's old bedroom talking about what it is like to share a room with a little brother.

The apartment seemed warm and comfortable, with the happy family there, but I couldn't help thinking about how suddenly Ted's life in it had ended. Looking out the window at the Fürstenplatz below, I remembered a scene that he had once described from his childhood. When word got out that he was leav-

ing Berlin, a long line of classmates had followed him home, shouting "Jude, Jude!" He ran upstairs, but they were still out there, below, screaming. Only one loyal friend stood by him during the ordeal.

If my father felt any sadness, however, he didn't show it. "I have only pleasant memories of this apartment," he said, and I realized that I had two cheerful eleven-year-olds on my hands. I was the only one feeling bereft. I had wanted to reclaim, somehow, this vanished German-Jewish world of sophistication and ease, stucco and stained glass, as my heritage, my own personal loss. My father had moved on long ago.

As we left the apartment, Ted was telling Tommy and Nicholas about the "street polo" games that he and his brother had played decades before in the park outside, with bicycles and croquet mallets, during the 1936 Olympics. Ted's father had taken his children to see the field hockey and polo matches (hence the street polo), and sneaked the kids into the Olympic Pool, even though Jews were forbidden to swim there.

The next day, we visited the Olympic Stadium. Tommy and Nicholas swam in the outdoor pool, and while they toweled off, Ted regaled them with stories of runner Jesse Owens's triumphs at the Games, and Hitler's fury that the four-time gold medalist was African American. I stared up at the diving boards, playing over in my mind Leni Riefenstahl's film *Olympia,* with its divers gliding through the air. Amid the happy scene of children swimming on a summer day, I again had that aching sense of mourning, though for exactly what, I couldn't say. Perhaps it had something to do with the sheer richness of Berlin's history, with beauty and horror so consistently interwoven. But it was also a more personal ache, centered on my feelings about my father.

That sense of unreality was compounded when we stopped at the massive dark-granite court building where my grandfather had presided as chief justice and where the Nazis had later con-

ducted show trials to condemn political prisoners to death. The main door was slightly ajar, so we walked right in. Strewn about was the apparatus of a prewar office building: manual typewriters, ancient black filing cabinets, stenographers' Dictaphones. It was as though a time machine had transported us back to 1936. Nothing had changed, I thought, nothing at all.

And then, from an office door, a stylish young woman dressed all in black briskly approached to explain that we were standing in the middle of a movie set. They were filming a crime thriller set during the 1930s.

On our last day in Berlin, we made a family pilgrimage to Benfeystrasse, a suburban street named after my father's great-granduncle, the famous scholar of Sanskrit. Then we spent the rest of the day at the Zoo, one of my father's childhood haunts. We entered through the chinoiserie Elephant Gate near the shops of the Kurfürstendamm. After visiting the flamingos and panthers, we watched a baby spider monkey learning to jump. He would leap from his mother's arms and try to grasp a low-hanging branch, miss, fall, return to his mother's arms, and jump again. It seemed, in the late-afternoon haze, a fitting image of a child's first perilous steps into the uncertain world.

This handsome city had pushed my father out into the world, and without that expulsion and his ensuing flight to America, my sons and I would never have been born. The baby monkey jumped one last time, grasped the branch firmly, and swung back and forth. I could have sworn that he smiled in triumph.

9.

On my father's writing desk, there is an egg-shaped silver snuff-box filled with paperclips. A gift from his father, the Berlin judge who liked to recite the opening lines of the Iliad in Greek, it depicts the sun god Apollo in his horse-drawn chariot, summoning the dawn from the eastern horizon. You wouldn't expect a Jewish family in Berlin to have a special reverence for a pagan god. And yet, for several generations, the Benfey family has traced its origins to Apollo.

Even when I was quite young, in my early teens, I remember hearing from my father the notion that our name was a contraction of Ben Feibisch, meaning "son of Feibisch." The Yiddish name "Feibisch," I was told, was derived from Phoebus, namely Phoebus Apollo, the Greek god of the sun. So our name, of probable Sephardic origin, meant "son of the sun."

A grandiose ancestry like this is probably best left uninvestigated. But I come from a family of philologists, lovers of words. And I suspected that the best-known philologist in our family, the nineteenth-century Sanskrit scholar Theodor Benfey, was somehow mixed up in this Apollo business. My father's namesake, Theodor taught oriental languages and literature in the Hanoverian university at Göttingen. Known for its religious tolerance, its close ties to the British crown, and its scholarly excellence in the sciences and foreign languages, Göttingen attracted many students from Great Britain—including the English Romantic poets Wordsworth and Coleridge—as well as assimilated

German Jews like Heinrich Heine and Benfey. "The town itself is beautiful," Heine wrote after being expelled from the university for dueling, "and looks its best when you turn your back on it."

Benfey was born in 1809, an exact contemporary of Darwin and Felix Mendelssohn. Though hardly as well known as those illustrious figures, Benfey had his own considerable fame in the scholarly community. At Göttingen, he was a key figure in a circle of prominent language researchers that included the brothers Grimm as well as Benfey's own teacher, Franz Bopp, the founder of comparative linguistics and the great theorist of the Indo-European origins of modern European languages. It was at Göttingen that the modern conception of languages, as belonging to families with traceable evolutions rather than, say, divine origins, crystallized.

Benfey's own linguistic skills were legendary. He had learned Hebrew as a child from his father, a Jewish merchant from a town near Göttingen. He mastered Sanskrit on a bet with a friend that he could learn the language well enough in a few weeks to review a book about it. He learned Russian in order to translate an important work on Buddhism. He published the standard dictionary of the Sanskrit language as well as an important edition of the *Panchatantra*, a collection of Indian folktales. He also prepared a scholarly edition of a Persian tale called "The Three Princes of Serendipp," the story of three brothers from Ceylon who show remarkable powers of perception during their travels. It was from this story that Horace Walpole derived the word *serendipity*, which has come to mean a chance discovery or fortuitous event.

As a Jew, Benfey was never accorded the scholarly positions or the salary that his reputation deserved, even after his token conversion to Christianity in 1848. Financial difficulties and professional humiliations (specifically, the university's continu-

Theodor Benfey

ing refusal to promote him to the rank of full or *ordinarius* professor until 1862) are running themes in the biography written by his daughter Meta. In 1859, the year in which he published his landmark edition of the *Panchatantra,* Benfey began taking in English pupils to make extra money. The most famous of these, the moral philosopher Henry Sidgwick, wrote in 1864, "Professor Benfey is a great talker, and the more I see of him the greater respect I entertain for his ability. He is not at all a man who impresses one with ability at first," he added, "but he has wonderfully quick and accurate perceptions, astonishing powers of work, unfailing clearness of head."

Sidgwick was particularly taken with Meta Benfey. "I only wish I could devote more of my time to the improvement of my German by conversation with her." According to Bart Schultz's biography, Sidgwick's sexual tendencies ran to homosexual "Greek love," and his attraction to Meta—"intelligent, enthusiastic, and not ugly"—constituted an early and confusing crisis in his sexual identity.

10.

Benfey's major scholarly contribution was in the field of fairy tales, closely associated with Göttingen because Jacob and Wilhelm Grimm taught German philology there. While the ardently nationalistic Brothers Grimm insisted on the Germanic and "peasant" origins of the tales they assembled in their collections of Märchen, Benfey, more cosmopolitan in his intellectual instincts, was struck by the many similarities between European fairy tales and mythical tales from other lands, especially Arabia and India.

Benfey's international fame rested on his bold theory, arrived at intuitively and announced in his commentary on the *Panchatantra,* that all European fairy tales had their origins in Buddhist and Hindu myths from India, and that these tales had migrated westward, via oral and written transmission, to Europe.

Benfey challenged two bedrock convictions dear to the Romantic generation of the Grimms: first, that folktales were the fossil remains of Old German myths, and second, that they were orally transmitted. "Out of the literary works," Benfey wrote in his introduction, "the tales went to the people, and from the people they returned, transformed, to literary collections, then back they went to the people again, etc., and it was principally through this cooperative action that they achieved national and individual spirit—that quality of national validity and individual unity which contributes to not a few of them their high poetical worth." Benfey noted, for example, that an Indian story about the Buddha, garbled in transmission through Arab lands, had resulted in the canonization of the Bodhisattva as St. Josaphat.

11.

Benfey's theory of Indian origins appeared in 1859, the same year as the publication of Darwin's theory of natural selection in *The Origin of Species*. The two theories have some striking features in common. Both point to a common ancestry for later variations; both argue that earlier forms—whether of species or of stories—migrate and adapt to new habitats. According to the Harvard medievalist Jan Ziolkowski, "Benfey's view of India as the reservoir of stories from which European folktales derived exercised considerable influence throughout Western Europe in the second half of the nineteenth and early part of the twentieth centuries."

While Benfey sought a single origin of fairy tales, adopting what Ziolkowski calls a model of monogenesis and diffusionism, alternative hypotheses of polygenesis were subsequently proposed. The idea of multiple origins can be based on psychoanalytic notions of universal "elemental ideas," whether derived from Jungian archetypes or Freudian family traumas. An alternative model of polygenesis was adopted by the British anthropological school, associated with Andrew Lang and Sir James Frazer and later with such works as T. S. Eliot's *The Waste Land*. "Its exponents maintained that all human cultures developed according to the same course," Ziolkowski writes, "and that, as a result, they might forge similar or even identical tales in response to similar needs, pressures, and desires."

For roughly a century, folklorists have given more attention to structural similarities among divergent tales than to their elusive origins. But there has been a recent trend toward reopening the question. In his book *Fairy Tales from Before Fairy Tales*, Ziolkowski seeks to rectify a puzzling omission in fairy-tale research: the corpus of medieval Latin texts dating from circa 1000

to 1200, many of which have an obvious bearing on the transmission of fairy tales. Ziolkowski argues that the close historical link between fairy-tale research and literary nationalism partly accounts for the omission; collectors like the Grimms were reluctant to admit that Latin, a "supranational," cosmopolitan, and literary language, might be the repository of fairy tales.

Ziolkowski has made the startling discovery that the Grimms drew freely from these Latin texts, "Germanizing" them in the process. In tracing the strange travels of one such tale, which the Grimms called "The Donkey," Ziolkowski proposes to "revive and modify for application" Benfey's "Indianist or migrational theory," which he summarizes as follows:

> From the Indian subcontinent, the tales had been transported, after the advent of Islam, first to Persia and then to the whole of the Arabic-speaking Muslim world. According to Benfey's theory, the tales eventually wended their way to the Latin West, through border zones in Spain and Sicily as well as through the Crusaders.

Ziolkowski explores three variants of "The Donkey." In the earliest version, in Sanskrit, a Hindu god is punished for his lust by having to assume the form of a donkey. Though he lives in the family of a humble potter, the donkey marries a king's daughter. He is released from his bestial form when his mother-in-law burns the ass's skin he takes off at night, when making love to the princess. The Sanskrit myth undergoes its own metamorphosis in a medieval Latin poem, in which the donkey is no longer a god in disguise but a king's son, who despite his bestial form becomes a gifted lute player and wins the love of a beautiful princess. The Grimms retained the lute—"your fingers are surely not made for that," a minstrel tells the donkey—but excised the eroticism of the Sanskrit and Latin versions.

One puzzle among the successive versions of the tale is the insertion of music making. Ziolkowski proposes an ingenious solution. He thinks that musicians were the carriers of the tale from Asia to the West, and "grafted" themselves into the story. He concludes that the Sanskrit myth "passed into regions where Hindu gods were not worshiped and where their functions in the story had to be suppressed or altered and that the carriers of the tale, the entertainers who had transported the story into their repertoires, grafted themselves and their art into the tale as a way of endowing it with a new raison d'être."

12.

Many of the fairy tales that Theodor Benfey explored are about perilous journeys. And meanwhile, according to Benfey, the tales themselves had embarked on dangerous voyages, traveling in the books and the memories of exiles on the move, wandering westward in search of better lives. It occurred to me that Benfey may well have associated such migrations with his own Jewish background, and the wanderings of persecuted Jews over the centuries. It is a bitter historical paradox that Benfey's theory of Indian—or, as it was known then, Aryan—origins of German fairy tales became part of the matrix of pseudo-Aryan mythology that buttressed Hitler's fantasies of German greatness.

But what about the supposed link—commemorated in the snuffbox—of the Benfey family to Apollo? How exactly did this particular theory of origins come into existence? Theodor Benfey's father, who belonged to the first generation of German Jews required to have family surnames, called himself Isaak Philipp Benfey (1763–1832). Isaak's father was known simply as Feistel Dotteres, sometimes Hellenized in nineteenth-century docu-

ments as Philipp Theodorus. There's nothing about Feibisch or Phoebus in any of these documents, but I found the divine ancestry in Meta Benfey's biography of her father. "In intimate circles," she wrote, "he often expressed the opinion that his ancestors must have spent a good deal of time in Greece, and might even have had an admixture of Greek blood in their veins." As evidence, according to Meta, he pointed to the many Greek names in the family: "his own name, Theodor, that of his eldest sister, Simline (= Semele), that of a brother, Philip, and of his grandfather, Feibisch (= Phoebus)." When the Jews were required to take surnames, according to Meta, Benfey's father chose the name Benfeibisch, meaning "son of Feibisch." "Luckily," Meta remarks, "the authorities thought the ugly name was too long and struck the last syllable."

Here, then, was the theory of our family name in its full blossoming. I didn't want to put too much pressure on the slippage between Feistel, the documented name of Theodor Benfey's grandfather, and this sudden emergence of Feibisch. Nor did I want to worry overmuch about how Feistel had miraculously metamorphosed (either through Meta's ingenuity or Theodor's) into both Philip and Phoebus. What fascinated me was that I had heard this Feibisch-Phoebus connection before, in a poem of migration and exile by Heinrich Heine.

Heine's poem is called "Der Apollogott," or "The God Apollo," and was written around 1849, when Heine was ill and living in exile in Paris. In the first part of the poem, a nun is sitting in her cloister room high above the Rhine and hears beautiful singing from a little boat on the river. She is astonished to see the handsome god Apollo himself, wrapped in his scarlet cloak, singing and playing his lyre to the nine admiring Muses. In the second part of the poem, he sings about his fate. Driven out of Greece (*"verbannt, vertrieben"*) like the other pagan gods, he is seeking a better home in exile. In the third part, the young nun

leaves her cloister and follows the road to Holland, asking ev-
eryone she meets if they have seen the god Apollo.

Finally, the nun comes across a slovenly old peddler trudg-
ing down the road. "Seen him?" the man replies to her query.
"Yes, I've often seen him in Amsterdam, in the German syna-
gogue." He explains that Apollo was the cantor there, and was
known as "Rabbi Faibisch, / Was auf Hochdeutsch heist Apollo"—
"Rabbi Faibisch / Which means Phoebus in High German"
(actually Yiddish). Faibisch's father, the old man remarks, cir-
cumcises "the Portuguese"—Sephardic Jews—while his mother
sells sour pickles at the market. The old man explains that Fai-
bisch has quit his job as cantor, is now a freethinker who eats
pork and roams the countryside with a comedy troupe:

> Recently he took some harlots
> From the Amsterdam casino
> And with these alluring Moses
> Goes around as an Apollo

Here was the same equation of Faibisch (or Feibisch) and
Phoebus that Theodor Benfey had found in his own name of
Benfey or Ben-Feibisch. So, where did Heine get his Faibisch-
Phoebus link? Heine scholars report that around 1850, Heine
supposedly addressed Ludwig Wihl—a Jewish poet and journal-
ist who had written a collection of India-tinged verses titled
Westöstliche Schwalben (Swallows of West and East)—as Monsieur
Faiwisch (Phoebus). But this hardly seems an explanation, as
Wihl sounds nothing like Faiwisch; rather, the anecdote suggests
that Heine saw something "Indian" or "East-West" in the Fei-
bisch/Phoebus connection.

Benfey and Heine shared some of the same scholarly inter-
ests and training. During the early 1820s, Heine, like Benfey a
few years later, had studied Sanskrit with Franz Bopp, in Göt-

tingen and Berlin, and he shared Benfey's intense interest in fairy tales. Heine's Apollo poem is suffused with the language of myths and fairy tales. Apollo's little boat on the Rhine gleams *"märchenhaft"*—"as in a fairy tale"—in the setting sun, and his song is set to the traditional meter of a folk ballad. The story of Apollo's descent into the streets of Amsterdam, moreover, bears a striking resemblance to the kind of story Ziolkowski describes in his versions of the donkey tale, in which a god assumes earthly form and becomes an itinerant musician.

Were Heine and Benfey acquainted? It seems likely that they were. The Dartmouth philologist Walter Arndt (an old family friend, since my German grandmother hired his wife to work at the Window Shop in Cambridge) sent me a report from 1995 of the discovery of an oil portrait of Heine, hitherto unknown to scholars, that had turned up in Theodor Benfey's belongings—an indication of admiration, if not necessarily intimacy. There was, in addition, at least one direct connection between Heine and the Benfey family. Theodor's eccentric brother Rudolph, a freelance writer and a socialist, was a close associate of Heine (and of Karl Marx) in Paris. Is it possible that Rudolph had shared with Heine the fanciful Greek origins of his own last name, as told to him by his brother Theodor?

13.

It slowly dawned on me that my snuffbox-inspired search for the origin of Phoebus and Feibisch resembled the quest for the origin of fairy tales. Instead of monogenesis and diffusion, could this suggestive pairing of names be an example of polygenesis? The scholar Norbert Altenhofer discovered a German novel of 1834, *Der jüdische Gil Blas,* in which there is a Rabbi Feibisch who

is linked to Phoebus. David S. Katz, in *The Jews in the History of England, 1485–1850,* mentions the Hart brothers from Hamburg, who settled in London around 1700. The elder brother, a rabbi, was known as Uri Feibush/Phoebus or Aaron Hart. "In rabbinical practice," according to Alexander Beider's *Dictionary of Ashkenazic Given Names,* "the name Fayvush and its variants were generally considered as derived from the Greek name Phoibos (Latin Phoebus), god of the sun. This erroneous etymology is also suggested by several linguists. . . ." According to Beider, the actual origin of the name Fayvush is not the Greek Phoibos but the Latin *vivus,* meaning "living" or "alive," a name that moved eastward from France and—the Sephardic hope again!—Spain.

It seems quite likely that the Feibisch-Phoebus equation was already proverbial in Heine's time and ripe for the distinctive mixture of pathos and satire that Heine brought to his Apollo poem. For Heine, and no doubt for the brothers Benfey as well, there was a close and moving analogy between the Greek gods in exile and the persecuted Jews. Heine's Apollo sings of his lost temple that stood on "Mont-Parnass" in Greece; in giving the name in French, he alludes to his own exile in Paris. Benfey's belief that there was Greek blood in his veins is typical of his Hellenizing generation of assimilated German Jews.

Of course, there was more than a little Jewish self-hatred in these stories of Greek origins and Sephardic identity, but I prefer to put the emphasis—as Benfey himself did in his scholarship—on migration and self-renewal. The truth of such origins—in surnames and fairy tales—is probably closer to Benfey's own theory of Indian origins. Names of Hindu and Greek gods traveled westward, picking up new associations and narratives. Bodhisattva became Josaphat; Faibisch merged with Phoebus.

Horace Walpole, in a letter of 1754, tried to define his new word *serendipity.* He had once read, he said, "a silly fairy tale" about the princes of Serendipp: "as their highnesses traveled,

they were always making discoveries, by accidents and sagacity, of things they were not in quest of . . . now do you understand *serendipity?*"

The god of artistic creation, of music and of poetry, carries many names and travels through books and memory, on foot or in his little boat. He travels up the river to the cosmopolitan city, where he sings to the congregation. Then he assumes a new guise, and it is as an itinerant artist, an actor, that we see him next. Both god and fraud, visionary and vagrant, Phoebus and Faibisch, he is an artist of serendipity, of adaptation and self-invention. He is still on the move.

PART II

Mexico

1.

My wife and I moved to a smaller house recently, at a time when we could foresee both of our sons leaving for college and taking the first tentative steps in their own lives. We had to dig down into the strata of belongings in the attic, sorting out what to keep and what we no longer needed. Neither of us recognized a faded blue garment bag, wedged in among quilts and Halloween costumes. It turned out to contain my serape, which I had acquired long ago on a teenage trip to Mexico. I hadn't seen the thing in thirty years. When I opened the stiff folds and slipped it on, poking my head through the slit in the center, we both laughed. I looked a bit like Clint Eastwood playing the silent man in those Italian Westerns set in Mexico.

Woven by hand of scratchy wool, the serape is simple in design. Three earth colors—gray, brown, and large expanses of off-white—are arranged in traditional Mayan motifs. There is a flourish of stepped patterning around the central opening, like tentative plans for a ziggurat. Along the base with its knotted fringes is the ancient interlocking pattern, which also appears on Greek vases and Navajo blankets, known as the *meander*, or Greek key.

I could dimly remember buying the serape, bargaining in

that shameless, exuberant way in which tourists negotiate what they consider a good price. I conceived of myself as poor in those days, the voluntary poverty of a privileged American, and I was on a strange pilgrimage of my own devising. I carried almost nothing in my blue backpack; except for books and the barest essentials, I traveled light. The serape was part of that journey, like a pilgrim's staff or a scallop shell. I bought it in Mitla, the spectacular ruins up above Oaxaca, where stones are arranged— woven, really—in a complicated mosaic fretwork resembling the geometric patterns on my serape.

I traveled alone to Mexico during the summer of 1973, when I was about to turn twenty and had spent a formless and frustrating year at a college in Indiana. My father asked me at the time why I had chosen that particular destination. I told him, with that confident manner that we never fully recover later in life, that I was going to Mexico to discover suffering. "You don't need to look for suffering," my father said. "Suffering will find you."

At the time, I assumed that this was the kind of paternal advice, drawn from Shakespeare or the Bible, that my father was accustomed to giving. "Work while it is day," he would say. "The night cometh when no man can work."

I wasn't the only teenager on the road that summer; my whole generation seemed to be in transit, looking for that utopia that had seemed in reach during the 1960s but was quickly fading. I myself wasn't looking for utopia—just the opposite. I hitched a ride as far as Albuquerque from friends in Indiana; they were driving on to California, trying to extend the endless Summer of Love. In the Albuquerque bus station, a desperate place, I remember staring at a woman in tight shorts and a bikini top, whose exposed stomach was a crater of concentric scars, as though a meteorite had landed there.

During the long, clattering bus ride through Chihuahua and

the night, the passengers would wake to floodlit towns and sweet drinks handed through the window by hawkers. Then more night, and after what seemed like many days and many nights, the arrival in the smog and traffic of Mexico City. The local headquarters of the American Friends Service Committee was my base there: a dormitory of bunks and a distant, beak-nosed man named Vaughan Peacock. It was Peacock, a project manager who had worked throughout Mexico, who told me how to get to San Damián Texoloc, a remote village in the small and desperately impoverished state of Tlaxcala.

I had an invitation from a family there. A man from my college had worked in Texoloc with the American Friends Service Committee many years earlier, trying to introduce beekeeping as a cash crop, along with more sanitary practices in the handling of dairy cows. (Neither practice had taken root.) He had remained in touch with a family there, whose name was Martínez, and they offered to put me up for a few weeks in exchange for work.

And so it was that I found myself in the brown-roofed village of Texoloc, in the high country between the sheltering volcano of La Malinche and the more distant and imposing Iztaccíhuatl. It was dry up there, all arroyos and cactus, and a spindly river that threaded between the village and the wilted cornfields—*la milpa*. There were jeweled lizards, slow-moving and poisonous, amid the stones and crags by the alfalfa fields. I lived with the Martínez family in a small house with a dirt floor and no running water. Scorpions hid in our shoes at night. Across a gravel courtyard was a concrete barn for pigs and chickens.

I liked the family very much. There was Estela, the all-suffering mother, who loved the country life and whose furtive husband had another woman and another family in a neighboring village. Their younger son, Sergio, was my age, and had had a hard time in Mexico City, spending too much money and

getting caught up in the urban life. He had become involved in the student riots that swept through the city during the summer of 1968, that near-revolution in which so many students died—no one knew exactly how many. Sergio and I played guitars, and he taught me how to sing sad mariachi tunes: "Volver" and "La Morenita."

My battered, mustard-colored copy of the poems of Pablo Neruda and César Vallejo, edited by Robert Bly, is a journal of that summer and fall, the margins and flyleaves filled with my own reflections on a single theme. "If you enjoy suffering," I wrote, "is it still suffering?" Next to lines from Bly's interview with Neruda—"I was in a very lonely situation. I was in an exciting country which I couldn't penetrate"—I have written the words "July 15, 1973 Texoloc." Above the title of one of Vallejo's poems, "I Am Going to Talk about Hope," I have written, "Suffering is hope? We will have to look further."

Did I find the suffering I was looking for? I certainly saw more death in Mexico than I had seen anywhere before. I saw a bleeding pig on the cobblestones of Texoloc, his slashed neck held open by drunken men to keep the blood flowing. I saw corpses by the highway after a traffic accident—though *accident* seems the wrong word for the random and predictable slaughter on the monotonous death trails between Mexican cities. I heard of a Texoloc man who quarreled with his brother over a woman, so they shot the woman. In the town square, a man with no arms sold breadfruit and mangos. Earlier, before the accident that maimed him, he had sold fireworks.

Mostly, looking back on that summer in Texoloc, I remember learning skills that I haven't used—couldn't even imagine using—since.

I learned to cut alfalfa with a sickle, moving down the rows on my hands and knees. Then I fed it to the pigs. As I chopped up the alfalfa with a machete on the bare floor of the pigsty, I

felt like the Prodigal Son, muscles aching and blisters on my hands and feet.

I learned to plow behind a mule, with a single-bladed curved plow that snagged in the sullen earth.

I learned to milk a cow by hand. Tío Miguel taught me, all the while making sexually suggestive jokes at my expense. The cow was called La Cubana, and a certain dark-skinned girl I knew, daughter of the vendor with no hands, was also known as La Cubana. Her real name was Elia, and she had the blue eyes of the early French inhabitants of Tlaxcala. Elia and I had led a donkey down to the river one afternoon. We had kissed and made promises that neither of us intended to keep. Somehow the whole village knew of this excursion.

One day, I slaughtered a chicken with a broomstick. I held the chicken upside down by the splayed and knobby feet and placed the broomstick over its neck and placed my feet on either end of the stick and yanked hard on the legs. *"Sí, sí!"* they told me. "That's how you kill a chicken."

What comes back to me now from that sojourn in Mexico is my father's warning. "You don't need to look for suffering. Suffering will find you." I can see now how it rhymes with the remark, attributed to the Russian revolutionary Leon Trotsky, "You may not be interested in war, but war is interested in you."

I had chosen Mexico as a destination in part because it had nothing to do, as far as I knew, with my family history. It was a place all my own, with hardships that belonged only to me. I could shed the past—how grandiose a nineteen-year-old's notions!—and start anew. What I didn't realize then and had no way of knowing (most of it was unknown even to my father) was how deeply Mexico was interwoven, like a red thread, into the white ground of our own family history. Even Trotsky, who was murdered in Mexico, played a small part in our story.

I can see now that I was retracing, in some half-conscious

way, earlier journeys, trying to feel between finger and thumb some thread of trauma and survival from those earlier generations. I wanted to know how suffering had found us, and what we had made of it. I wanted to be able to touch it, like the frayed edge of my serape, with its jagged and esoteric key design.

2.

It is an overcast morning in June 1937. The mountains on the horizon are veiled in mist. In the middle distance, a pyramid rises abruptly from the plain. A flight of stone steps leads to the first of five platforms, with a rounded mound looming above them. Three figures are walking toward the side of the pyramid, as though someone—perhaps the photographer—has asked them not to block the view. The figure in the middle is a short, heavyset woman in a dark dress. She leans on a long walking stick, one foot turned inward, as though it is painful for her to walk. Beside her and turned toward her is a tall, stately man in a linen jacket and brimmed hat. Slightly removed from this couple walks a willowy younger woman dressed in a patterned light skirt and darker blouse, a comfortable white hat, and sturdy walking shoes. She moves with a swinging motion, her loose-fitting clothes wafted by a breeze. The contrast between the two women, dark and light, is striking, almost comical.

The three figures are walking along the Avenue of the Dead at Teotihuacán, the pre-Columbian ruins an hour's drive from Mexico City. They are heading north, toward the Pyramid of the Moon. Behind the pyramid is the upper rim of Cerro Gordo; the apex of the pyramid and the notched summit of the sacred mountain coincide exactly. From the angle at which the photograph is taken, the young woman's hat and the man's hat just

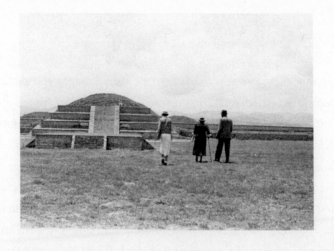

touch the top of the mountain range. There is a melancholy feeling to the scene. It looks as though it might rain soon.

The woman with the cane is my great-grandmother, Toni Ullstein Fleischmann. She is accompanied by her husband, Siegfried, and one of her two daughters, the textile artist Anni Albers. The photographer is Anni's husband, the artist Josef Albers. The stepped platforms of the pyramid resemble his Homage to the Square paintings. Among the iconic images of modern art, these arresting pictures, composed of concentric squares in contrasting colors, were inspired by Mexican adobe architecture, with its bright colors applied to sun-baked clay.

The Alberses, during the summer of 1937, were teaching art at Black Mountain College, the legendary educational experiment in the mountains of North Carolina. They were making their third trip to Mexico since their arrival in the United States in 1933. The Fleischmanns were on vacation, too, from their home in Berlin. They had not seen their daughter Anni in four years. Their younger daughter, Lotte, was back in Berlin. She was, or would be, my grandmother.

3.

On this, their first trip to Mexico, the Fleischmanns traveled in luxury. Siegfried was a purveyor of fine furniture whose clients included a cardinal stationed in Berlin, soon to be named Pius XII; Toni was an heiress—the Ullstein firm, founded by her father and run by her five brothers, was the leading publisher of books and newspapers in the world. The Fleischmanns traveled first class on the *Orinoco*, with caviar to celebrate the jubilee of the shipping line. Days passed quickly, Toni noted in her journal, with games of shuffleboard on deck, books borrowed from the ship's library (Toni chose a popular novel about Julius Caesar), and stylish parties—"in the evenings there's almost always something going on."

One night there was "a quite charming bock-beer party." Then came "a fancy-dress ball, quite charming costumes, one little French boy, maybe eight years old, was dressed as Napoleon." As the ship headed into southern waters, the stewards suddenly donned summer outfits, all in spotless white. On June 13, the Fleischmanns spotted Key West on the starboard side. That night they strolled through the streets of Havana, "all the men in white, the women very elegant, with theatrical hats. . . . For the first time we saw people dancing the rumba."

Toni was aware, that summer of 1937, that some of her fellow travelers were leaving Europe for other reasons. In first class, she noticed "a few Spanish and other uninteresting little people." On June 1, she jotted down in her journal the news of "the German bombardment of Spain. Awful." She was referring to Guernica. On June 2, she noted the contrast between her own opulent mode of travel and those less fortunate: "On one of the third class decks a group of at least thirty people, pitiful individuals, each with a package under the arm, their total belonging."

If we expect a note of sympathy and self-scrutiny from Toni, we are disappointed. "But on closer inspection," she writes haughtily, "these people are poor pitiable little beings [*arme, armselige Menschlein*], and the third class, which is much improved from what it used to be, is still pretty bad, mainly because of the people."

The Mexican city of Veracruz, where Anni and Josef Albers came to meet the Fleischmanns as they disembarked, was, in Toni's view, "a pitiful seaport." They arranged to have their abundant luggage unloaded: great steamer trunks that contained Josef Albers's paints, all his photographs, and a box of glass fragments from his years of work at the Bauhaus, the design school in Germany where he had studied and taught. After clearing customs, they all boarded a train for Mexico City because, as Toni sniffed, "we have little confidence in the Veracruz hotel."

4.

Diego Rivera, the Mexican muralist, helped open Toni's eyes to the beauty of Mexico. Rivera was a close friend of the Alberses, but his political activities—the exiled Russian revolutionary Leon Trotsky was staying in Rivera's heavily guarded Blue House at the time, monitoring the show trials in Moscow—had little interest for them. Toni had admired Rivera's "beautiful frescoes" of Mexican history in the education ministry in Mexico City. "Propaganda here is carried out through art," she noted. She went three times to see the murals. On the drive to the pyramids at Teotihuacán, she looked out the window as though she was viewing a fresco of Rivera's: "The villages consist of the most primitive mud huts, their inhabitants pitiful, Indians in rags, but with wonderful, very hard facial lines."

Josef Albers, Diego Rivera, Anni Albers, Clara Porset

The Alberses, for their part, admired Rivera's formal inge-
nuity, his use of traditional geometrical patterns and of pictorial
motifs drawn from Aztec and Mayan mythology. They relished
his passion for pre-Columbian art. They spent hours admiring
his private collection of artifacts, many of which were dug from
the recently excavated ruins of Tlatilco, later turned into a brick
factory. "We were among the privileged few 'gringos' to see . . .
the Rivera collection at his house in San Angel," Anni wrote,
"and later in his house in Coyoacán. . . . We felt that Rivera had

an oversized appetite for all that came to light and was brought to him by the natives from many parts of the country."

The car trip to Teotihuacán was for viewing the ruins, but it was also a scavenging junket. "Our first small pieces," Anni wrote, "came to us on our visits to prehistoric sites from little boys offering them to us through the car window, just as turkeys and goats were also held up for sale." The search for ancient pottery led them farther into the countryside.

> We went along high cactus fences in village streets silent and empty, but whenever we turned around and looked back, faces would quickly withdraw and hide. We were obviously the sensation of the day. We sat in fields, sandwiches in hand, and wherever we looked, ancient pottery shards protruded.

Among the ceramic heads collected by the Alberses at Teotihuacán, one is particularly striking in its anxious intensity. The head has a large, square forehead and a dark brow extending across the face. The mouth frowns slightly and the nose is broken—cracked, perhaps accidentally, though the effect resembles the broken nose of a boxer. The wide, hollowed-out eyes have a brooding intensity, a dark air of foreboding.

5.

Whenever I look at the photograph of Anni Albers and her parents at Teotihuacán, I want to tell them to turn around on the Avenue of the Dead. I want to grab my great-grandfather Siegfried by the stylish lapels and shout, "Don't go back to Berlin! Are you out of your mind?"

But of course he did go back, confident that his profession, his name (Siegfried, for heaven's sake), and his social status would save him from whatever the upstart Hitler had in mind.

Before leaving Mexico, the Fleischmanns bought serapes for their grandsons Rudolf and Teddy (my father!)—"so they can dress up as American Indians."

6.

Two years later, like something out of Kafka, the Fleischmanns found themselves aboard the same ship, bound for the same port. This time, however, the idyllic voyage assumed the contours of a nightmare. The masked balls and first-class cabins were a thing of the past, another age, almost another universe. This time, the Fleischmanns were refugees, in flight for their lives and subject to the brutalities of bureaucrats and the Gestapo. They had been forced to join the army of "poor pitiable little beings," the pathetic *Menschlein* that Toni had scorned during their first voyage.

Toni reflected on the bitter ironies of this second crossing, a voyage into uncertainty and darkness:

In 1937 I wrote a diary about our first trip to Mexico and I never imagined that I would see that country again. Now, two years later to the day, we begin the same journey on the same boat, the *Orinoco,* but under totally different circumstances. At that time it was a trip to see our children again and through them to see a distant and lovely country. Today it is a departure from our native land, which we must leave forever.

What little they were allowed to pack in their suitcases—a few clothes, some family silver, a limited amount of cash—was now the sum total of their belongings. The rest they had to leave behind in Berlin. On May 28, 1939, they flew to London for final farewells with their daughter Lotte. "My daughter's well-ordered family has been torn apart," Toni noted. She was referring to my father, age thirteen, who would remain in England for the duration of the war.

The Fleischmanns picked up their Mexican visa in London. Before they could board the *Orinoco* in Cherbourg, across the Channel in France, they were told that they would also need a French transit visa. The French visa was then refused because they were booked on a German ship. They imagined the *Orinoco* leaving that day for Mexico as scheduled, with their luggage on board.

But then, a miracle: The *Orinoco,* they learned from a cable, was delayed in Antwerp.

With a hastily obtained Belgian visa, they took a train to Harwich and a boat to Antwerp, only to learn that the delay, a blessing for them, was a death sentence for others. Toni remembered the desperate scene on board, after the ship steamed out of the harbor:

In the evening after the meal, the captain stood up and made a speech. He regretted terribly to have to announce that Cuba had totally blocked entry of emigrants; all his attempts to have Cuba allow entry for the Cuba-destined passengers already on board were fruitless, as were his efforts with the Belgian authorities to accept these emigrants temporarily (hence the long delay in Antwerp), and he was therefore told to return to Cuxhaven to bring these emigrants back. The Gestapo had given assurances that those

returning would suffer no unpleasantness. The ship was already on course for Cuxhaven and we would be there by midday Saturday. The boat would leave again immediately and go directly to Cherbourg. Deathly silence followed this speech and all sat chalk-white with horror, all these people who had left everything, who had given up their native country, now had to start all over again to find a way of getting out, without money, without a home.

A new note of sympathy enters Toni's account: "It was horrifying to have to see the despair on every face without being able to help."

This time, the ocean was eerily calm. Inhospitable Cuba, so charming on the earlier voyage, now seemed sinister: "In the streets at the harbor, quite open and shameless bordellos from whose French windows—long and pulled down—the girls look out and present themselves."

In Veracruz, where Anni and Josef Albers once again waited impatiently for their arrival, there were more bureaucratic barriers. The Mexican passengers were allowed to leave the ship and so were the Spanish refugees, but not the Germans, who learned, to their dismay, that they would have to wait aboard ship until their papers could be carried to Mexico City for approval. Three whole days the Fleischmanns waited, "three unnerving days," while Anni and Josef desperately tried to resolve the situation. When it became clear that the visa that the Fleischmanns had acquired in London was a forgery, perpetrated by confidence men, the hurdles became even higher.

During this ordeal, the Alberses were accompanied by Alex Reed, a favorite student of theirs at Black Mountain College. Alex (also known as Bill) proved invaluable in the negotiations. He ran from the hotel to the ship and from the ship into town,

trying to secure, with bribes paid at each transaction, the neces-
sary permissions and papers. "It isn't just hot as Hell," Josef Al-
bers wrote of the bureaucratic nightmare.

> You also find out that Hell never stops. That there are many
> devils in Hell, and that at first they look just like people.
> Then you find out that Hell is a business. The devils keep
> Hell hot so that you're willing to spend everything in order
> to escape it. Then the damned are delighted that Hell has
> an end, and the devils are delighted that they have money
> and can live on it until more ships come with more sacri-
> fices for Hell.

Another day passed before Reed's bribes had their intended
effect. Toni and Siegfried, anxious and exhausted, were finally
given their passports and allowed to go through customs into
Josef Albers's waiting car. In Mexico City, the altitude made their
heads numb and their limbs listless until they descended a cou-
ple of thousand meters. "Our heads become clearer," Toni noted,
"but with this clarity the awareness of all that has happened to us
engulfs us, and we become depressed. The relinquishing of all
that was ours, the emigrant's distress, and the frightening ques-
tion, what now?"

Diego Rivera's murals looked different to Toni this time
around. Earlier, it was their vivid colors and formal patterns that
had appealed to her, while their political message was lost on her.
Now she could see that Rivera was trying to envision a more just
society, in which the downtrodden Indians could feel at home.
The murals, she wrote,

> depict the whole history of the Indians, their customs, their
> crafts, their festivals, their rituals, and then their frightful

suppression by the Spanish conquerors, Cortés's triumphal march through the country. This propaganda is being shown to the people because the government is endeavoring to lift up the Indian people again, to help their almost vanished crafts flourish again.

7.

On this second sojourn in Mexico, as Toni and her husband waited for official permission to enter the United States, she found it too painful to record her impressions in a travel journal. Instead, she wrote poems, in English, signing them—with a poet's and a *geborene* Ullstein's pride—Toni Ullstein. The poems are rhymed, giving a sense of order to chaotic experience:

I am so lost in this vast and foreign town
I am strolling along the streets, I am depressed, I frown,
I want to meet somebody I know,
Why cannot a familiar face show
Up, from home, and while I look at the shop window with ties
Suddenly somebody cries
Perhaps a cousin?!
Halloh
Oh
But no.

On September 2, 1939, the day after Hitler's troops marched into Poland and ignited, as Toni wrote, "a world conflagration," she took anxious stock of her newly nomadic fate: "We find no rest; the calamity of this war has irresistibly come over all."

8.

At Black Mountain College, Anni Albers developed a classroom exercise that she called, in her wavering English, "starting at the point of zero":

> What intrigued me in regard to teaching was that I think something should be reversed in teaching. We always, in architecture, or whatever you do, you start from what there is today and try to explain it. While I was trying to set a task, put the students on absolute zero, in the desert, in Peru. Nothing is there. What is the first thing you have to think of? And build up? And maybe, for instance, something for fishing, or something for the roof. You gradually develop something, inventions, as you go along. . . . And some of the students . . . like also the idea of not being told a brick is done like this, and we build it like this, but how we arrive at the brick?

"At least once in life," Anni liked to say, "it's good to start at zero."

9.

Though Anni was, as she phrased it, "Jewish in the Hitler sense," the reason the Alberses had left Germany in 1933 was not because of racial laws, which took effect later, but because of the closing of the Bauhaus, the innovative design school where they had first met in 1922. She was twenty-three at the time, from a

family—my family—that was respectable and established in every conceivable way.

Siegfried Fleischmann loved the arts and took them seriously. He haunted the museums in Berlin and later in New York. He encouraged Anni's interests and gave her a room of her own in their spacious apartment at 7 Meinekestrasse in the posh Kurfürstendamm neighborhood. My grandmother Lotte, Anni's younger sister, remembered the layout: "We had eight or nine rooms. There was the music room that was only used for parties. . . . There was a room for Anni's painting."

Lotte and Anni had an Irish governess who taught them to speak fairly good English. Anni also had an art tutor and later took classes with a painter who worked in an Impressionist style. In her early teens, she was drawn to the Expressionist portraits of Oskar Kokoschka, and tried to paint a portrait in a similar vein of her mother. Mother and daughter traveled to Dresden to meet the master. Kokoschka glanced at the portrait and asked, "Why do you paint?" Anni was fifteen or sixteen at the time and, as she put it later, "that was the end of that." She tried an art school in Hamburg for a few weeks—another disaster—and then, by chance, saw a leaflet from the Bauhaus, a new school of design recently opened in Weimar. There was a woodcut of Lyonel Feininger's on the cover, a cathedral in German Expressionist style. "That looks more like it," Anni thought.

10.

Anni abandoned the luxury apartment in Berlin to start from zero at the Bauhaus, with a rented room and a bath available once a week. Anni noted that the Bauhaus, too, was looking for a new beginning.

Anni Albers

Well, the Bauhaus today is thought of always as a school, a very adventurous and interesting one, to which you went and were taught something; that it was a readymade spirit. But when I got there in 1922 that wasn't true at all. It was in a great muddle and there was a great searching going on from all sides.

Though billed as a social experiment where women and men had equal access to instruction, Anni learned that certain workshops were more welcoming to women than others. The glass workshop interested her, but it had room for only one student, and Josef Albers was already enrolled there. She settled, reluctantly, for the weaving workshop. "Fate put into my hands limp threads!" she later wrote. Photographed around 1923, Anni looks contemplative and determined, hands clasped on her knee.

She hated the photograph, claiming that it made her look like Whistler's mother.

Anni Albers, Black-White-Red, *1927*

11.

In 1925, Anni and Josef Albers were married. He was Catholic, the son of a housepainter. After several false starts, he had settled on the Bauhaus as his doorway to modern art. "I was thirty-two," he wrote, and "threw all my old things out the window, [and] started once more from the bottom." While Anni was taking drawing lessons from genteel private tutors, Albers was scrounging around in the Weimar dump. He packed his rucksack with broken glass and made a new kind of art, stained glass for the modern age. He was soon promoted to junior Bauhaus master and quickly established himself as a gifted teacher.

They honeymooned in Italy, where they were struck by the striped marble and brickwork of the cathedrals at Florence and

Sienna. During the years that followed, their abstract designs in weaving and in glass, influenced by Tuscan architecture, followed parallel paths. In her dynamic composition *Black-White-Red,* Anni has gotten the most from her three bedrock colors. The repeated cross motif, black on white and then reversed, may recall the honeymoon amid the striped cathedrals in Italy.

12.

The year 1925, when Anni and Josef Albers were married, was also the year in which the Bauhaus moved from Weimar to its streamlined glass-and-brick building at Dessau, designed by Walter Gropius. The Alberses subscribed to the "form follows function" ethos of the Bauhaus, where all ornament was stripped away and the wastebasket was regarded as the perfect design. Anni's work during these years is almost entirely a series of experiments with different threads. Like other Bauhaus artists, she shared the hope that ideas discovered at the Bauhaus might infiltrate industrial practice and spread to the general public. She showed no sentimentality about crafts or handmade things; she embraced cellophane, rayon, and other artificially manufactured textiles.

Nazis in the local government in Weimar cut funding to the Bauhaus in the fall of 1932. The architect Mies van der Rohe opened a privately funded Bauhaus in Berlin, which lasted for six months. During that time, Anni and Josef lived in a comfortable apartment in the Charlottenburg neighborhood, paid for by Anni's parents. And then, in April 1933, came the definitive end, as the Nazis took over the German government and shut down the Bauhaus.

That summer, the American architect Philip Johnson hap-

pened to visit Berlin and was eager to meet artists from the Bauhaus. He was particularly impressed by some small weavings of Anni's. A few weeks later, back in New York, he was approached by John Andrew Rice, a classics professor who had led a breakaway group of faculty from Rollins College, in Florida, to found Black Mountain College. Rice asked Johnson to recommend an artist to run the academic program there. Johnson, with no hesitation, suggested Josef Albers. Her weavings, as Anni said later, were their passport to America.

13.

So often in the early photographs we see the Alberses in transit, in ships and trains and automobiles, the tragic conveyances of the 1930s. A photograph shows them aboard the *Europa*, arriving in New York harbor on November 24, 1933. He is in formal suit and tie, his thin hair carefully brushed to the side, his wide-awake eyes noticing every detail. He came to America, he said, "to open eyes." She is tall and alert and slightly condescending. With her mink stole wrapped around her neck, her sealskin coat, her transparent veil and her Twenties toque, she herself is eye-opening. They could be waiting to be announced at a formal dinner party or at an art opening in Berlin, rather than heading for an experimental college in the middle of nowhere.

For the local newspaper in North Carolina, they were simply Germans, strangers on a train. GERMANS ON FACULTY AT BLACK MOUNTAIN SCHOOL, the *Asheville Citizen* reported. They were met at the railroad station, just down the line from Asheville, by Ted and Bobby Dreier in their Model A convertible. The "Germans" were driven over dusty back roads into the hills overlooking the town of Black Mountain.

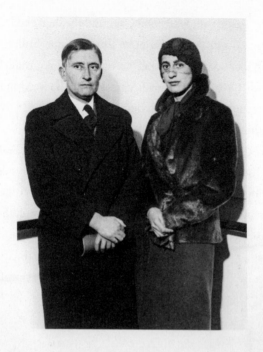

There, like some nostalgic dream of the Old South sum-
moned from the mountain mist, stood Robert E. Lee Hall, a
white mansion with massive Doric columns supporting a broad
porch, with a view out over the valley. This, the Alberses learned,
was the main building of Black Mountain College. This was
where the students lived, where meals were taken, and where
dances were held every Saturday night on the front porch.

Walking up the monumental staircase, Anni was puzzled
to see notices nailed to the marble columns. On closer inspec-
tion, she found that the columns were made of wood. It was a
first lesson that American things were not always what they ap-
peared to be. A few days later, Anni recalled, "there was a big
festival at the college . . . a great event that was Thanksgiving.
And we thought it was really a day to be thankful for."

Josef Albers ran Black Mountain College almost from its
inception in 1933. During his fifteen years there, Albers brought

the avant-garde composer John Cage and the dancer Merce Cunningham to campus; he brought Buckminster Fuller there to build his first geodesic dome; he brought Willem de Kooning and Jacob Lawrence to teach painting at Black Mountain; he himself taught the artists Robert Rauschenberg, Cy Twombly, and Ruth Asawa.

It is often said that the Alberses brought the Bauhaus to Black Mountain, smuggling in their suitcases such fundamental convictions as the fusion of form and function and the honest use of materials. It is true that Anni and Josef drew on their Bauhaus experience. But Josef Albers was a master at the Bauhaus as well as a former student there. Whatever was distinctive in the Bauhaus experience owed a lot to him. As Albers proudly remarked, "I have done more to the Bauhaus than the Bauhaus to me."

<center>14.</center>

The world as found, in its loops and leaves and landscapes, was a way for the Alberses to get a handle on their new surroundings. The lay of the land harbored messages for their alert eyes. Josef discerned the numeral three in an aerial view of the Loop, a highway in the Great Smoky Mountains National Park. With stenciled blue paint he accentuated the 3 and added a 9 for a New Year's postcard.

The fall leaves prompted a round of experimentation for Josef Albers and his students. A section in his classic book *Interaction of Color* is called "Fall leaf studies—an American discovery." "Nowhere in the world," he wrote, "is the autumn foliage as brilliant in color as in the United States." He invited his students to see what happened "when leaves are collected, pressed,

and dried—eventually varnished, even bleached, and sometimes also dyed or painted."

In Albers's collages, oak leaves perform like ecstatic dancers. In one study, leaves hover above a surreal stage like something in Dalí or Magritte. In another, two leaves, one with spiked edges and one with rounded contours, lie like a married couple on beds of colored paper. Yet another features three pairs of dancing oak leaves, each couple made up of one red and one blue leaf locked in embrace. They leap above the green stage, while a drabber corps of six brown leaves dances below them, like their shadows, perhaps, or their real selves.

15.

In Germany, Josef Albers had tended to restrict his palette to two or three urban hues such as red, black, and white. Suddenly, in the hills and mountains of western North Carolina, color gradations were everywhere. *Interaction of Color* sometimes seems, with its lines laid out like poetry, an ode to American colors:

> Usually, we think of an apple as being red.
> This is not the same red as that of a cherry or tomato.
> A lemon is yellow and an orange is like its name.
> Bricks vary from beige to yellow to orange,
> and from ochre to brown to deep violet.
> Foliage appears in innumerable shades of green.

During his time at Black Mountain, Albers concluded that colors, like people, are profoundly relational; colors interact with other colors. His students learned that the same color could be made to look quite different against different grounds, while

two different colors—an even greater surprise—could be made to appear to be identical. His art classes at Black Mountain were built around such juxtapositions, "like making a gloomy raw sienna look as alive and shining as gold by 'working on its neighbors.'" Albers drew moral lessons from this neighborly give and take. "We may consider such calculated juxtaposition as a symbol of community spirit," he wrote, "of 'live and let live,' of 'equal rights for all,' of mutual respect."

Materials, too, were relational. "Nothing," Albers said, "can be one thing but a hundred things." In other words, objects change according to their surroundings, their neighbors. There is no such thing as an object "in itself." Albers invented exercises to show relatedness and contrast and to reveal how materials, like colors, could be deceptive. He was particularly fascinated with brick. How can we "make a brick look like something spongy?" he asked. "How can we make something looking like bread and it is stone?"

16.

Anni Albers was also experimenting at Black Mountain with the world as found, especially during the war years, when expensive art materials were hard to come by. She fashioned jewelry from ordinary household objects, such as faucet washers and paper clips. Although her family in Berlin had lost all their valuable jewelry in the move to America, she herself claimed to prefer cheap ceramic beads made in Mexico to pearls.

Anni's collaborator on these projects was a shy Black Mountain student named Alex Reed, the same young man who had helped in the negotiations to get my great-grandparents, the Fleischmanns, off the boat in Veracruz.

Anni Albers and Alex Reed,
necklace from hardware

With bobby pins hanging from a metal-plated ball-link chain, they made a necklace that looks like something an African warrior might wear into battle. A chain attached with two paper clips to a sink-drain strainer, with more paper clips fanning out from the lower arc, suggested a fusion of silver and feathers out of the American Southwest. Most ravishing of all was a necklace of ordinary aluminum washers strung along golden grosgrain ribbon.

Anni was asked, during the spring of 1942, to describe the work that she and Reed had been doing and to relate it to national defense. "Though our work has nothing to do with defense work," she responded in her lecture "On Jewelry," "there was something right in asking to connect it with it." She added, however, that "for many of us our part can not be that of going into a munitions factory or that of helping those who suffer in this war in a direct way. Many of us are tied to our homes, to our normal circle of action, to our work continuing as usual."

Anni was asking her audience to think more deeply about

what constitutes "our homes," "our normal circle of action," and "our work continuing as usual." War, she argued, was the opposite of the normal and the usual. It was in the context of everyday life that she felt that something new might be accomplished and some opening might be achieved to a more hopeful future.

17.

For Anni Albers, the door to this realm of everyday objects was Mexico. In her 1942 speech, she explained that the jewelry she was making with hardware was inspired by archaeological excavations at the temple of Monte Albán in Mexico, which she and Alex Reed had visited together. "These objects of gold and pearls, of jade, rock-crystal, and shells, made about 1,000 years ago," she remarked, "are of such surprising beauty in unusual combinations of materials that we became aware of the strange limitations in materials commonly used for jewels today."

The Mexican jewelry seemed to Anni to have arisen from experiments in combination and interaction, like those that she and Josef had arranged in the Black Mountain classroom: "Rock-crystal with gold, pearls with simple seashells." Back in North Carolina, Anni and Reed looked for new materials to use:

In the 5 & 10 cents stores we discovered the beauty of washers and bobby-pins. Enchanted we stood before kitchen-sink stoppers and glass insulators, picture books and erasers. The art of Monte Alban had given us the freedom to see things detached from their use, as pure materials, worth being turned into precious objects.

The value of these pieces of jewelry was not in the materials used, which could hardly have been more common, but rather in their "surprise and inventiveness—a spiritual value." Ultimately, this surprise was Anni's contribution to defense work. War, she implied, was a matter of competing over mistaken ideas about what was truly precious and worth fighting for. "If we can more and more free ourselves from values other than spiritual, I believe we are going in a right direction."

18.

I have wondered what working with Anni meant to Alex Reed, a mysterious and tragic figure in Black Mountain lore. An accident on October 8, 1941, near the Lake Eden dam at Black Mountain, made a big impression on Reed. Mark Dreier, the nine-year-old son of Ted and Bobbie Dreier, fellow teachers and close friends of the Alberses, was struck and killed by a truck driven by the college cook.

Reed and his friend Molly Gregory designed and built a simple stone structure, reminiscent of a Quaker meeting house, to the boy's memory. It was known as the Quiet House. Reed gathered the local stone and laid it, cut the wood for the roof, and wove the curtains for the windows. He and Gregory built the simple chairs and benches for the austere interior.

Reed finished building the Quiet House just before he left Black Mountain, in February 1943, to report to Civilian Public Service Camp 32 in West Campton, New Hampshire, run by the American Friends Service Committee. A conscientious objector, Reed had spent the previous summer at a Quaker work camp in Reading, Pennsylvania, and soon joined the Society of

Friends. Like other CPS camps, the West Campton site was remote and the conditions primitive. Reed was put to work as a linesman repairing telephone wires in the pine forests.

Josef Albers sent Reed a copy of the writings of Meister Eckhart, the medieval German mystic, in whose meditations, grounded in plain language and vivid images, Reed found comfort in what he called the idea of obedience. He could see how closely Eckhart's worldview was related to the Quaker concept of turning a conscripted task into a voluntary one by one's own individual assent. He copied a passage from Eckhart: "For the purpose of making a crock a man takes a handful of clay; that is the medium he works in. He gives it a form he has in him, nobler than his material."

By May 1943, many of the workers at Campton were transferred to CPS Camp 37 in the mountainous desert region of Coleville, California. "We are of course miles away from anything," Reed wrote Dreier, "in a hair-raisingly beautiful place." During breaks from serving on lookout duty, fighting fires, and working as a stonemason, Reed studied Chinese and read Arthur Waley's translations of classic Asian literature. Ten years before the Beat movement began to take shape in San Francisco, Alex Reed was already assembling its tenets and tastes. On those rare occasions when he was allowed to leave camp, he explored Chinatown in San Francisco and Los Angeles, looking for the perfect teapot for brewing his smoky Lapsang souchong tea.

Reed spent a few weekends at the English religious thinker Gerald Heard's Trabuco retreat in the Santa Anita Mountains, practicing meditation and listening to talks about human access to higher consciousness. "It seems to me now that different kinds of clay are used in the making of people," he wrote Barbara Dreier in March 1944. Through Heard, he was put in touch with other pacifists with a mystical bent. In Hollywood, he met Christopher Isherwood—"a good clever little man, with a surprisingly

gamin face." As a volunteer for the American Friends Service Committee, Isherwood had been teaching English to German refugees at Haverford, in Pennsylvania.

After the war, Alex Reed studied architecture at Harvard with the Bauhaus masters Gropius and Marcel Breuer and taught design at MIT. He seems to have struggled to find his place in the world; from the Coleville camp he had written of his "un-sureness of where one belongs." Invited by the Dreiers to join them at their estate on Martha's Vineyard, Reed designed his own Asian-style modernist house and garden. A photograph of the interior shows tatami mats, Japanese screens, a bare brick wall, and Reed himself, handsome in the loose-fitting sweater that Anni Albers admired, sipping a cup of tea. The house (since destroyed) was near Harlock's Pond and commanded a sweep-ing view of the water.

Alex Reed died under ambiguous circumstances in 1965. According to the *Vineyard Gazette*, he "drowned in Vineyard Sound when his blue, German-built kayak capsized," but many suspected suicide. Friends established a bird sanctuary in his memory.

19.

After the war, Josef and Anni Albers continued to visit Mexico each summer. They left Black Mountain in 1949, amid tensions concerning the centrality of its arts curriculum. That fall, the Museum of Modern Art in New York devoted an exhibition to Anni's work, the first show the museum had mounted by a weaver. Josef accepted an appointment for one year at Harvard and in 1950 began his long association with Yale. It was also the year—Albers was sixty-two at the time—that he began his

Homage to the Square series. During that same remarkable year, Albers designed a brick wall for installation in Gropius's Harvard Graduate Center, a work that Albers named America.

Brick had fascinated Albers for a very long time. He liked how the uniform, ready-made units, like Anni's washers and paper clips, exacted a certain surrender by the artist, banishing self-indulgent subjectivity. He liked the humbleness of the material, so unshowy and matter-of-fact. He liked that brick could be made to resemble other things—sponges, for example, or bread.

The wall at Harvard, eleven feet tall and eight feet wide, with a fireplace on the opposite side, is built of masonry bricks in regular alternation of stretchers (bricks laid lengthwise) and headers (bricks laid along their width), in the pattern known as the Flemish bond. Albers created a series of recessed vertical patterns by eliminating a width of brick from some of the courses. The resulting impression is that of a wall of bricks pulled slightly apart, as though to reveal something worth seeing on the other side. The pattern is produced not by the bricks themselves but by the shadows caused by recessed brick. The effect recalls the many photographs Albers took of the mazelike walls

Josef Albers, Detail of Stonework, *Mitla, 1937*

at Mitla, where cut stone was laid in intricate patterns to look like textiles.

In an essay about *America,* Albers began with his dissatisfaction with Mexican muralists like Rivera. He felt that their wall paintings weren't truly *murals,* art made of walls, but were actually "enlarged easel paintings" that happened to be placed on walls. Albers decided instead "to make a real mural in which the *murus* (Latin for wall) was respected and preserved to the last degree possible." In a sense, in *America,* Albers was bypassing Rivera and José Orozco and going back to the earlier Mexican builders of Mitla and Monte Albán. He was aiming, he said, to give his brick wall a feeling of "lightness (lack of weight), which counteracts the visual weight of the wall rectangle."

20.

For me, a descendant of so many departures, Anni and Josef Albers seem masters of travel, nomads of the modern world. Their zigzag journey from Berlin to Black Mountain seems like a form of life, adopted and refined. I admire their appetite for change, for risking everything, for picking up their lives and moving them elsewhere. Anni thought deeply about what she called "the nomadic character of things":

> We move more often and always faster from place to place, and we will turn to those things that will least hinder us in moving. Just as our clothes are getting lighter and are increasingly geared to movement, so also will it be with other things that are to accompany us. And if these include a work of art that is to sustain our spirits, it may be that we will take along a woven picture as a portable mural, something that can be rolled up for transport.

"Something that can be rolled up for transport" brings a scroll to mind, perhaps, but it also suggests a magic carpet—or a folded-up serape.

The modern world, in Anni's view, had changed the human sense of scale. Skyscrapers and the monstrous dreams of dictators were typical expressions of the age, but they needn't be the only expression of it. The clay figurines that the Alberses had culled from the fields of Mexico and the jewelry that Anni and Alex Reed made from cheap hardware were reminders that great art does not have to be made of expensive materials on a large scale.

When the time came for departure, for starting again from

zero, such imposing things would have to be left behind. The Alberses' collection of pre-Columbian figurines, by contrast, comprised an art form for nomads. Made in the "modest material of clay," the whole collection, according to Anni, "can be held in two hands."

The Meander

1.

In January 2008, after several earlier plans had fallen through, I finally had a chance to drive out to Black Mountain. The timing was good. I was in Greensboro, visiting my parents, and I had agreed to teach a course that spring on some of the major figures at the college—Josef and Anni Albers, John Cage, Karen Karnes, and Buckminster Fuller—and their impact on American art and society. My older brother Stephen happened to be in Greensboro as well, visiting from his home in Tokyo. He was eager to make the trip with me. The college had been closed for several decades, however. At best, we would be visiting ruins, hoping to find some vestiges of the school, some surviving sign that the landscape was still haunted by those towering presences that had given Black Mountain its legendary status in the history of American education and avant-garde art.

Black Mountain had seemed almost a mythical place during our upbringing, a tether linking our flat Midwestern childhood to the vivid summits of artistic innovation and adventure. A painting by Juppi, as Josef Albers was known in our family, had hung in our dining room when my brothers and I were growing up in Indiana. It was a bold, Mexico-inspired abstraction in red and black from the early 1940s. Our father's sister, Renate, had

attended Black Mountain, living with the Alberses. Some of the
refugees from Black Mountain, after it fell apart during the
1950s, had ended up at the Quaker college in Indiana where our
father taught chemistry. I remembered Ray Trayer, who ran the
farm there after leaving Black Mountain. As a child, I associated
him with the cottage cheese we picked up at the farm, which I
mistakenly thought was "college cheese."

We had even visited the Alberses once, in 1960, at their
simple, split-level house in New Haven. My mother had brought
along some of her own paintings, ambitious abstractions com-
pleted under the tutelage of an Austrian teacher, which appeared
stained into the canvas rather than painted onto it. The paint-
ings that she showed to Josef Albers that day were suggestive
of orange-tinged clouds at dawn, swirling water, uneasy dreams.
They had nothing in common with his clean-edged abstractions,
in which all the drama resulted from where two distinct and
carefully applied colors touched. For Albers, everything in a
work of art should be the result of deliberate and conscious
decisions.

On such social occasions, Anni, ridiculously, played the du-
tiful housewife, wheeling in the tea and German cookies on a
Bauhaus tea cart. Then she sat to one side, as though awaiting
orders from the master of the house, who was courtly and flirta-
tious until the paintings themselves were brought in from the
car. Josef Albers disliked anything that reeked of self-expression;
he thought of art as an escape from inner confusion and mere
feeling. Art for him was a way of exploring the world out there,
not the tangle of emotions inside all of us.

My two brothers and I sat on the floor in an adjacent room,
pretending to play with some miniature Bauhaus architectural
bricks, when the great man placed one of our mother's paintings
on the table. "What means this?" Juppi asked, pointing to a wavy
area on one of the paintings. And then, jabbing with his thumb

at another vulnerable motif, "What means this?" The paintings were hurriedly put away.

2.

Stephen and I had decided to drive straight to Asheville, where we could have some lunch, get directions, and orient ourselves. Then we would backtrack to the Lake Eden campus of Black Mountain College. I estimated that it would take us three or four hours, steadily rising all the way to the eastern outskirts of Asheville, where the hamlet of Black Mountain lies on one side of Interstate 40 and the Lake Eden campus on the other. We could spend a few hours of daylight wandering around the place, and still be back in Greensboro by nightfall. Our trip would be a commemorative pilgrimage of sorts. The school had shut down fifty years earlier, in 1957. By that time its student body, never much more than fifty, had dwindled to six, and its financial resources were approximately zero, if not already in the red.

As we drove west, we passed signs for the Biltmore Hotel, a reminder that Asheville has been a resort for vacationing Yankees since at least the 1890s. Modeled on a French château, the 250-room Vanderbilt mansion took an entire community of skilled craftsmen six years to build. The estate, on 125,000 rolling acres laid out by Frederick Law Olmsted, had its own brick factory, using the abundant red clay from the local riverbeds, and a three-mile railroad spur to bring building materials to the construction site.

As we drew closer to Asheville, however, the surroundings didn't look particularly luxurious. Billboards warned against the dangers of methamphetamine abuse and depicted, with nauseatingly explicit photographs, the dental disaster known as meth

mouth. Notched into the hills were more signs of decay: dilapi-
dated towns of abandoned shacks and trailer parks, rife, no doubt,
with secret methamphetamine labs. We stopped for gas at a con-
venience store off the highway. Inside, by the cash register, there
was a rotating display case for knives. I had never seen anything
like them. They weren't hunting knives or kitchen knives; in fact,
they seemed to have no obvious use at all. They seemed more
like fantasy knives—scimitars and halberds—decorated with
sinister swastikas and Masonic devices.

In Asheville, on the handsome main street with its brick
storefronts from the 1890s, we had lunch at an all-you-can-eat
Indian restaurant. Our waitress, a moonlighting actress, told us
that she had the Audrey Hepburn role in a local production of
Wait Until Dark, the gothic thriller about a blind woman and the
thugs who try to retrieve heroin hidden in a doll. The waitress
came from Franklin, North Carolina. I asked her why she had
decided to live in Asheville. "Have you ever been to Franklin?"
she asked. I told her that I planned to do some research in Frank-
lin during the summer, concerning some mysterious deposits of
white clay. She thought I was joking.

Back on the road, with a local map we'd picked up in Ashe-
ville, we zigzagged off the Interstate and into a maze of local
streets down in the valley below Black Mountain. We followed
the map past the forlorn Creole Court trailer park and looked for
a "big fence," the next landmark, where we were instructed to
turn left onto Lake Eden Road. The fence, a concave spider-
web of rusting wire, turned out to enclose a detention center for
delinquent boys.

3.

Another turn and we entered a less sinister world. A well-groomed road lined with stately pines led us to the serene lake, festooned with faded lilies, where the landscape opened and we had a clear view of the low-lying Study Wing, the most familiar Black Mountain College building. In the distance, the black mountain itself rose up from the pines. Amid the January stillness, I had a momentary impression of being in Japan. I remembered something from Henry Miller's visit to the school during the 1940s, when he was crisscrossing the South on his "air-conditioned nightmare" tour. "From the steps of Black Mountain College in North Carolina," Miller wrote, "one has a view of mountains and forests which makes one dream of Asia."

Walking toward the streamlined concrete and fiberglass building, we could make out the two faded murals, ghostly in the winter light, that Jean Charlot had painted on its exterior pylons. A French artist with a Mexican mother, Charlot had been Diego Rivera's assistant in Mexico City during the 1920s. Albers invited him to teach at Black Mountain, where he painted the murals during the summer of 1944. Strange hooded figures in cramped positions represent Learning and Inspiration.

We hadn't bothered to call before, but Jon Brooks, the codirector of Camp Rockmont, a Christian summer camp for boys, welcomed us warmly when we mentioned that we were grandnephews of the Alberses. We signed the visitors' book, a few lines after Allen Ginsberg, who had visited Black Mountain on his own pilgrimage. Brooks led us down the hall, past individual student studios. He pointed out how the wallboards overlapped, so that student carpenters could make mistakes in measurement without compromising the overall design. Then we descended downstairs into the dark, musty room where Anni Albers had

her looms and where pottery wheels now lined the floor like votive presences. This dank underground space, Brooks said, was now called the Anni Albers Studio.

4.

With the dusky afternoon light filtering down the darkened staircase, it suddenly dawned on me, with an emotional impact I hadn't expected, that we were actually standing in the space where Josef and Anni Albers had taught. It was here that Anni led her students to discover what she called, somewhat mysteriously, "the event of a thread." I had sometimes imagined her as a modern Ariadne with her magic thread, leading the way out of the Labyrinth.

Though both Josef and Anni prided themselves on their modernist orientation, there was also a contrary tendency in their work, toward the primitive and the archaic. Their own teaching was a creative fusion of the deep past and the vivid present; it was the more recent European past that they silently skipped over. They were particularly drawn to ancient patterns, which they invited their students to explore. In his book *Search Versus Re-Search*, for example, Josef devoted a whole section to the pattern, one of the oldest in human history, known as the meander or Greek key.

Frequently found on the borders of pottery and textiles, the meander resembles a maze or labyrinth. When European artists during the eighteenth century fell in love with vases dug from the ruins in Herculaneum and Pompeii, they adopted the meander found on the rims and shoulders of many of the vases. For neoclassical potters like Josiah Wedgwood, the meander was almost a trademark, linking their works with antiquity.

The meander pattern

For Josef and Anni Albers, however, the meander was a quintessentially American shape. "Nowhere has it been cultivated more through all periods," Josef noted, "than by the Amerindians from the northern Tlingits to the most southern Araucanians, in building, sculpture, painting, and particularly in weaving and pottery." After their arrival in America, the Alberses came to see the meander as an emblem of their own winding path through the world.

The meander confirmed the Alberses' interest in the ambiguities of human vision. One was never quite sure whether the pattern was made by the line itself or by the surrounding spaces it created. It was both intricate and simple:

> Intricate because of its figure-ground relatedness in which figure and ground are simultaneously and alternately theme and accompaniment, thus guiding and following each other. Simple, when we discover that the underlying unit measures an alternating decrease and increase in the extension of the lines.

With its strenuous economy of means, the meander fulfilled the less-is-more Bauhaus aesthetic. "Virtually only one line is done," Albers wrote, "but the adjacent ground, accompanying its movement, transforms its one voice into two, three, and more voices and echoes." In Anni's beautiful *Red Meander,* the pattern is doubled, as though the serpentine path is shared. Meanwhile, the resulting composition, with its illusion of depth, looks like a maze viewed from above, and the eye restlessly wanders the red and pink passages, looking for entrances and exits.

Anni Albers, Red Meander, *1969*

5.

It was the Roman poet Ovid, in the eighth book of his *Metamor-phoses,* who first compared the famous Labyrinth on the island of Crete to the winding river in Asia Minor named the Meander. Ovid retold the story of Minos, ruler of Crete, and the danger-ous passion that his wife, Pasiphaë, conceived for a white bull from the sea. In order to attract the bull, she had the master craftsman Daedalus construct out of wood a hollow and alluring cow that she could crawl into.

The hybrid offspring of their unnatural coupling, part human and part bull, was named the Minotaur. Daedalus was prevailed upon to hide this family embarrassment in the elaborate twists and turns of the Labyrinth, part prison and part refuge:

Minos resolved to remove this disgrace from his home
and to shut it in a convoluted house, concealed in darkness.
Daedalus, most celebrated and skilled of craftsmen,
constructed the building, adding confusing marks,

which, through the crooked windings of many different paths, led the eyes into uncertainty.

What follows is known as a Homeric simile, a long and winding comparison of the kind found in Greek epic poems:

> Just as the clear-watered Meander frolics in the Phrygian
> fields,
> and slipping about flows back and forth, and running into
> itself
> sees approaching torrents, and, turning now back to its source
> and now to the open sea, drives its unsettled waters on,
> in just the same way, Daedalus filled his maze
> with countless winding paths. Even he was barely able
> to grope his way back to the entrance,
> so mighty was the trickery of his structure.

Tanta est fallacia tecti. Daedalus had at least two more "fallacious" tricks up his sleeve. One was the ball of thread, the famous clew, or clue, that Ariadne, daughter of Minos and Pasiphaë, entrusted to the Athenian hero Theseus, along with a sword, so that he could find his way out of the Labyrinth after killing the Minotaur, Ariadne's own half brother. Theseus and Ariadne then fled the island kingdom of Crete, and Theseus abandoned Ariadne on the island of Naxos. Daedalus decided that he, too, was tired of Crete and, according to Ovid, was "longing to see his native land." So Daedalus outfitted his son Icarus and himself with wings made of feathers and wax and twine and taught him to fly. Hence the epigraph from Ovid that James Joyce appended to *A Portrait of the Artist as a Young Man,* in which the hero is called Stephen Daedalus: *Et ignotas animum dimittit in artes,* "He now turns his mind to unknown arts."

6.

In the story of the Labyrinth, almost everything goes wrong. Icarus, in the ecstasy of flight, flies too close to the Sun, melting the wax that holds his wings together, and tumbles back to Earth. Forgetful (*immemor*) Theseus, who forgets Ariadne on Naxos, also forgets to change the sails on his ship from black to white. This was the agreed-upon signal to inform his father that he has killed the Minotaur. His father, in despair, throws himself from the cliffs to his death.

All that remains, after the violence and the deception, is the pattern itself, the meander designed by Daedalus, the supreme artist of transformation. The pattern first informs the walls of the Labyrinth, then the thread unwound within it, and finally the dance that Theseus performs to celebrate his triumph.

7.

Another artificer, Hephaestus, the Greek god of craftsmen, depicted this dance on the famous shield that he made for Achilles, as Homer describes it in the eighteenth book of the *Iliad:*

> Here Hephaestus, famous and lame, inscribed a dance floor
> that resembled what Daedalus once fashioned for fair-haired
> Ariadne
> in far-stretching Knossos. Youths and much-courted maidens
> dance there,
> hand to wrist. The maidens wear garments of fine linen, while
> the youths

have flowing, well-spun tunics on, with a slight olive-oil
 sheen;
the ladies sport handsome head-dresses, while the young men
carry golden daggers in silver belts.

Again the passage ends with a striking simile:

At times they run about with great facility,
on skilled feet, just as a seated potter, fitting his hands around
 his wheel,
tests whether it will turn.

I love how Homer brings several arts into his description of
Achilles' shield, how effortlessly he moves from Ariadne with the
lovely hair to the dancing girls and then, suddenly, to the potter
testing his wheel with his skilled hands. The potter at the wheel
is for him the ultimate image of balance, consummate precision,
and graceful turning.

8.

Stephen and I lingered at Black Mountain as the shadows length-
ened. We were both reluctant to leave. We wandered along the
barren paths looking for the wooden house where the Alberses
had lived. Then we poked around in the darkening woods and
finally found Alex Reed's Quiet House, now with an added sec-
ond story and a new roof. During these forays on the site of what
had once been a vital and creatively intense community, I was
groping for a metaphor to capture the proceedings. I wanted a
dominant form that would somehow link our own zigzag path
with the artistic concerns of the Alberses. As we began to retrace

our route through the maze of streets near Black Mountain, I realized that the key had been there all along, in the meander pattern so dear to Josef and Anni.

9.

Driving back to Greensboro that night, following the looping highway, I first heard about Ruth Asawa's work. On his way from Tokyo to North Carolina, Stephen told me, he had stopped over in California to visit his two Japanese American daughters, my nieces, who were studying in art schools there. Together, they had gone to see an exhibition of Asawa's work at the de Young Museum in San Francisco. I recognized, as I learned more about her during the days and weeks that followed, that Asawa was an important link to the Alberses, as well as to our own Quaker and Japanese affiliations. Her difficult and triumphant life had an underlying pattern that felt familiar. It became clear to me that Asawa was one of the students at Black Mountain College who had learned the lesson of the meander, in art and in life, from Josef and Anni Albers.

Another child of dislocation, Asawa had grown up in a poor farming community in Southern California, one of seven children of Japanese immigrants. Her father had come from Fukushima prefecture, not far from Tokyo, where he had been an itinerant farmer. He would walk through the streets calling, "Beans and tofu, beans and tofu!" In California, he schooled his children in calligraphy and kendo, a traditional martial art practiced with bamboo swords, with the idea that they would eventually return to Japan.

As a child, Ruth had shown artistic talent; she won a competition in 1939, when she was thirteen, for a drawing of the

Statue of Liberty. After the bombing of Pearl Harbor, Asawa's father was arrested by the FBI and placed in a hard-labor camp in the Southwest. She did not see him, nor did the family hear from him or know of his fate, for six years. The rest of the Asawa family was among the 120,000 Japanese Americans on the West Coast who were ordered to leave their homes and report immediately to detention centers and internment camps for the duration of the war.

The first destination of the Asawa family, in April 1942, was the Santa Anita Racetrack, where they lived in horse stalls, still reeking of Thoroughbreds, for six months. Among the thousands of detainees crowded into the racetrack were several Japanese artists, some of whom had worked as animators at the Disney Studios. They established a makeshift art workshop in a section of the Santa Anita grandstand, and Asawa studied there. "How lucky could a sixteen-year-old be?" she reflected later. The prison had become a sanctuary.

10.

This strange idyll was interrupted when the Asawa family was shipped by train to an internment camp in Arkansas. The children attended school at the camp, where they were required to recite the Pledge of Allegiance. After the words "with liberty and justice for all," Asawa and her friends added, "except for us." Asawa's ability in art was noticed, and she received a scholarship from the Society of Friends, the Quakers, who took a strong interest in the well-being of interned Japanese Americans. She studied at a teachers college in Wisconsin but learned there was no possibility for a Japanese American to teach there.

Drawn by the murals of Diego Rivera and his associates,

Asawa spent the summer of 1945 studying art in Mexico. She watched José Orozco at work and took lessons in fresco painting. She also worked in Mexico with a Cuban-born furniture designer named Clara Porset, who urged her to enroll at Black Mountain College and study with Porset's friend Josef Albers.

Asawa found a new view of life and art at Black Mountain. At first, she planned to study weaving with Anni Albers, who sent her to Josef's design class instead. There she learned about handling materials. "Every material has several voices," she wrote in her notes for one of Albers's classes. "Let's find out different possibilities." She was fascinated by the class exercises in the juxtaposition of materials, finding ways of making one thing resemble a very different thing. "Leather = peanut butter," she wrote in her notebook. The whole ethos of the class, making art out of leaves and other found objects, suggested a morality based on scarcity, sustainability, and the avoidance of waste. One of her favorite maxims from Albers was: "Get 5 cents from 3 cents." Scrawled across a class exercise on the meander pattern, she wrote: "Do one get two." She also liked how Albers used analogies from Taoism and other Asian philosophical traditions.

Summers were particularly vivid at Black Mountain, bringing extraordinary artists and thinkers to the campus. Albers invited two artists to spend the summer of 1946 at the college. One was the African American painter Jacob Lawrence, soon to paint his great series of scenes on the diaspora of black people from the agricultural South to the cities of the North. Albers hired a separate coach for Lawrence and his wife on the train to Asheville so that they would not have to sit in the Jim Crow car. Asawa enjoyed attending the classes of Jean Varda, a charismatic Greek artist who had worked in Paris before the war. Varda talked incessantly of Greek mythology and "the mysteries of the labyrinth."

11.

The years in which Asawa was at Black Mountain, 1946 to 1949, were among the most creatively vital in the history of the school. It was during these years that a fertile transition began to take place, from the European émigrés who had brought the ideas of the Bauhaus, Brecht, and Schoenberg to the campus, to the homegrown Americans who were eager to push such possibilities even further. The composer John Cage and the choreographer Merce Cunningham were barely known when they performed at Black Mountain in 1948, bringing natural movement and ordinary sounds onto the stage. (Only when Cage began introducing chance combinations into his compositions did Albers object.) Buckminster Fuller, who erected his first geodesic dome at Black Mountain, was known as an eccentric designer but little else.

It was immediately clear to Albers that these brilliant young artists were doing things with movement and sound and structure that paralleled his own experiments with color and materials. The aim—a very democratic and American aim—was to eliminate prejudice against certain colors or sounds or kinds of movement, to corral them all into artistic "making," to "find out different possibilities."

Asawa's mature work, as she developed it in San Francisco during the 1950s, was a sustained engagement with procedures begun during the Black Mountain years. She had spent the summer of 1947 in a village outside of Mexico City, sponsored by the American Friends Service Committee. Josef and Anni were also in Mexico that summer on sabbatical, and they traveled with Asawa and looked at their friend Diego Rivera's murals together.

Back in her village, Asawa was fascinated by the wire baskets

Imogen Cunningham,
Ruth Asawa's Wire Sculpture, *1954*

made by local women, who used
them to carry fruits and vegeta-
bles to market. That summer, she
learned from them to knit with
packing wire, a cast-off material
of the kind favored by the Alber-
ses. She discovered ways to make a
continuous line of wire take on thickness, as it was looped and
threaded, and then volume, as the single thread of wire was knit-
ted into a vessel. Another influence was Japanese pottery, with
its long tradition of humble aesthetics; she saw Shōji Hamada,
the great Japanese folk potter, make pots in California during his
1952 tour of the United States.

12.

Already in Josef Albers's classes, Asawa had conceived a passion
for the meander pattern and its shifting rhythms of figure and
ground. Jean Varda had pushed her further, to think of threads
and labyrinths. Now she found in wire thread a way to develop
the meander in three dimensions. Soon she was making the hang-
ing, basketlike forms that she is best known for, as though Ari-
adne's thread had woven the labyrinth. A photograph by Imogen
Cunningham captured Asawa as Ariadne, entangled in her web.

Imogen Cunningham, Ruth Asawa, Sculptor, *1956*

13.

Stephen's remarks about Ruth Asawa had made me want to know more about her. But it was only much later, a year after the visit to Black Mountain, that I was able to experience Ruth Asawa's work firsthand. I first saw her wonderful hanging globes and baskets in San Francisco, during the summer of 2009, in the tower of the de Young Museum in Golden Gate Park. My wife and I had traveled there with our younger son, Nicholas, who was sixteen at the time. I wanted to see as much of Asawa's work as I could during the visit. We saw the flamboyant bronze fountain that she had made as a tribute to San Francisco, with miniature streetcars and bridges, and the bronze plaque with its sculpted frog in the Japanese Garden in Golden Gate Park. It was mainly the wire baskets and globes that I wanted to see,

however, and I was grateful for the generous installation in the de Young tower.

Something strange happened to me that summer in my encounter with Asawa's art, a mushrooming tangle of associations that began with fairy tales and then looped back, like a meandering thread, to the myth of the Minotaur and the Labyrinth.

We had flown across the country in July, on the day that Michael Jackson died. Nicholas had brought along an old copy of tales from the brothers Grimm, to read on the plane. We were particularly fond of a story called "The Mouse, the Bird, and the Sausage," and especially this line from the first paragraph: "Nobody is content in this world: much will have more." But it was rereading "Hansel and Gretel" that stuck with me for the entire trip west. Here is how the story begins:

> Hard by a great forest dwelt a poor wood-cutter with his wife and his two children. The boy was called Hansel and the girl Gretel. He had little to bite and to break, and once when great dearth fell on the land, he could no longer procure even daily bread. Now when he thought over this by night in his bed, and tossed about in his anxiety, he groaned and said to his wife: "What is to become of us? How are we to feed our poor children, when we no longer have anything even for ourselves?" "I'll tell you what, husband," answered the woman, "early to-morrow morning we will take the children out into the forest to where it is the thickest; there we will light a fire for them, and give each of them one more piece of bread, and then we will go to our work and leave them alone. They will not find the way home again, and we shall be rid of them."

The story had always troubled me, with its disturbing theme of abandoned children. Perhaps it evoked my sense of my father's

interrupted life. But during our stay in San Francisco, I couldn't get it out of my mind, and my thoughts about it began to blend with my response to Ruth Asawa's work. I kept thinking about Hansel's path of pebbles, the children's escape route from the forest.

14.

I would wake up early each morning in our small hotel in North Beach, hard by the City Lights Bookstore, and mull over some aspect of the story. I thought about Hansel's trail of pebbles in the moonlight or his father's mysterious motivations in abandoning his children in the forest, and ideas came unbidden to my mind. Sitting in the Caffè Greco, across from our hotel, I began jotting things down in my notebook. "Hansel and Gretel is the story of a father who cannot provide for his children," I wrote in the first entry. "When you cannot feed your children, they are taken away from you. Think of orphanages, foster homes, animal shelters. All of these sanctuaries can seem like prisons or cages, like the Labyrinth."

I hadn't realized how much of the story was centered on food. There isn't enough food to go around, so the children, with "one more piece of bread," must be sacrificed. The birds eat the breadcrumbs that Hansel, the second time they are abandoned, substitutes for pebbles. The children find a house "built of bread and covered with cakes," with windows "of clear sugar," and they start nibbling on the roof and window panes. The old woman who lives in the house fattens up Hansel so that she can eat him.

No less conspicuous in the story and often linked to the incessant eating is the element of trickery, one clever stratagem

following another. The children secretly eavesdrop on their parents' treacherous plans. Hansel sneaks out to get pebbles to mark the way back home. As the children sit by the fire the first night out, they hear what they think is the reassuring striking of their father's ax. "It was not the axe, however, but a branch which he had fastened to a withered tree which the wind was blowing backwards and forwards."

There are more tricks. The old woman's edible house is a deceptive lure to entrap the children. (From my notebook: "The edible house is the bait, like a worm on a hook. The hooked fish was thinking of dinner. But he wasn't planning to *be* dinner.") With a chicken bone masquerading as his finger, Hansel fools the old woman into thinking he's not getting any fatter. And Gretel, clueless until that moment, asks the old woman to show her how to crawl into the hot oven, then slams the door shut.

15.

There are strange parallels between "Hansel and Gretel" and the story of the Minotaur. Both stories involve disorienting mazes, whether labyrinths or forests, inhabited by insatiable monsters. Both involve the sacrifice of children to those monsters, the bond of brother and sister, and the winding path of escape—Ariadne's thread or the path of pebbles. Both stories hint at exile, for the old woman and the Minotaur.

Has anyone stopped to consider the loneliness of the Minotaur? The shame of the family, an exile in his own country, a strange hybrid of man and beast, he roams the walls of his confusing house looking for love. No wonder Picasso identified with him, and based his famous *Guernica* on imagery that he had developed in his paintings and prints of the Minotaur.

But there was something else here as well, some bedrock ambiguity in the whole notion of the Labyrinth.

16.

I had been wondering what Ruth Asawa had learned from her mentors, Anni and Josef Albers, and I felt that I had begun to un-ravel it. My journeys to Black Mountain and San Francisco had deepened my sense of their relationship. I could see how prisons and refuges, danger and safety, kept changing places for these uprooted artists, the one becoming the other, like figure and ground. The racetrack at Santa Anita seemed a perfect example of this. It was the place where Asawa was imprisoned but also the place where she discovered her vocation.

And then I stumbled upon Graphic Tectonics, a series of drawings and prints that Josef Albers made at Harvard in 1941, when he took a leave from Black Mountain. These images look strikingly like mazes. The eye wanders vertically and horizon-tally, and then plunges along diagonals, even as the image itself seems to pulse inward and outward like an accordion.

The print Albers called *Sanctuary* is for me his central visual statement of the double meaning of the maze. It captures the ambiguity of a prison that is also a safe haven, a sanctuary, as the Labyrinth was for the Minotaur, as the racetrack was for Ruth Asawa, as Black Mountain College was for the Alberses. Are those windows staring out from a house, or the dark eyes of some solitary animal?

For Josef and Anni Albers negotiating a new country, Amer-ica must often have seemed like a maze. They had traveled from Berlin at the height of its sophisticated glamour to this back-woods realm of mountains and pines and winding country roads.

Josef Albers, Sanctuary, *1942*

They lived in it and thrived in it by welcoming the ambiguities and by seeing patterns in those figure-ground uncertainties. They handed on their "searches and researches" to their students, threads for escape, threads for weaving more patterns, more sanctuaries, more spellbinding works of art.

On the Divide

1.

The Northeast Kingdom is a sparsely inhabited region of mountains and lakes notched into the upper corner of Vermont, hard by the Connecticut River and the Canadian border. My friend Mark Shapiro and I drove up there—it really felt like up—one cold and overcast January day, with snow expected in the higher elevations. Our plan was to spend some time with the legendary Black Mountain potter Karen Karnes. Mark had done the drive many times before, helping Karnes, now well into her eighties, with the heavy lifting involved in firing her pots, sometimes in his own wood-fired kiln in western Massachusetts, and sometimes in hers. This time around, however, we were hoping that Karnes might give us an up-close sense of what the pottery scene at Black Mountain was like during the 1950s, when Karnes was a potter-in-residence there. We knew that Karnes had been a good friend of John Cage and other Black Mountain luminaries, and we wondered how pottery, so bound up with folk and national traditions, had fit into the avant-garde, try-anything mood of the place.

The highway unspooled like a black thread between the soft snowbanks, and the snow got deeper as we headed due north. Mark pointed out the groves of red pines planted during the

1930s, first by the WPA and then by conscientious objectors confined to work camps during World War II—serried rows of trees as regular as cornfields, now reaching maturity. We followed the Interstate along the Connecticut River as far as we could before branching off toward the silvery sliver of Lake Willoughby—"so long and narrow," as Robert Frost describes it in a poem, "Like a deep piece of some old running river / Cut short off at both ends." According to local legend, a secret underground channel connects Willoughby to Crystal Lake in Barton, a few miles away. We took the exit for the village of Morgan, with a population of not much more than six hundred people, where many of the houses are hidden in the woods.

Mesmerized by snow sifting down through the pine branches, we overshot the unmarked turnoff to Karnes's driveway and, braking hard, skidded in Mark's blue Prius on the slippery pavement. Karnes's longtime partner, an Englishwoman named Ann Stannard, met us at the door of the simple wood cottage set in a meadow with a view out to the mountains in the distance. Soft-spoken, orderly, and attentive, Ann used to throw pots but now spends her time as a Sufi teacher. As Karnes came out to greet us, Ann headed for the kitchen to finish preparations for lunch.

My first impression of Karen Karnes, as we headed down to her studio, was of silence, simplicity, and something deeply rooted. With her back bent by scoliosis and her slightly inscrutable smile, she reminded me of certain Buddhist figures. She answered my glib questions about her life and work with patient attempts at real answers. The large studio was well lit, with big windows looking out to the snowy meadow, and impeccably neat. There were two pottery wheels surrounded by drying shelves, with small objects—seashells, pre-Columbian figures, pebbles—placed on the windowsills for inspiration. We looked at some of her recent work. She resisted verbal interpretation of what was going on in these wood-fired pots, with their

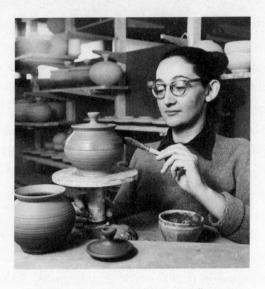

Karen Karnes glazing, Black Mountain College, 1953

heightened blue and orange glazes, their multiple slits and mouths, their bulges and collapses. "Sometimes," she told me, "there are things that don't have words." It seemed almost an article of faith with her.

The conversation continued over lunch—a rich lentil soup served in one of her trademark flame-proof casserole pots. A big yellow painting by her friend Mary Caroline Richards, another potter and Black Mountain teacher, hung by the dining-room table. We touched on many topics that afternoon: the Bauhaus and Black Mountain, Josef Albers, John Cage. I came to realize, as we spoke, that Karnes belonged to a fast-disappearing generation of artists who had lived through an amazing flowering of American art and culture. During that period, she had been both a witness and a participant. Her gnarled and sensitive hands had handled clay for sixty years, and clay had taken her on some unexpected journeys. Through an odd set of circumstances, some planned and some unforeseen, Karnes had become—and still

remained, in my sense of her—the quintessential potter of Black Mountain.

2.

Karen Karnes has lived her life primarily as a solitary studio potter, recognizing no school or tradition but her own and fiercely guarding her privacy. Anyone who makes the pilgrimage to her Vermont studio can gauge the distance she currently maintains from what Thoreau disdainfully called civilized life. And yet throughout her life, Karnes has enthusiastically taken part in various social, artistic, and educational communities. There is something deep in the American grain in the idea of cultivating individuality through community.

American utopian endeavor during the first half of the nineteenth century produced two contrasting experiments, both based on Emerson's notion of self-reliance, and both are relevant to Karnes's career. One was Thoreau's experiment in solitude at Walden Pond, in which he sought, as he put it, "to live deliberately, to front only the essential facts of life." The other was Brook Farm, outside of Boston, in which Hawthorne, Margaret Fuller, and Bronson Alcott took part. Meaningful work was at the heart of both visions. "We sought our profit by mutual aid," Hawthorne wrote, "instead of wresting it by the strong hand from an enemy, or filching it craftily from those less shrewd than ourselves."

Karnes's engagement with work-based experimental communities like Black Mountain was established almost from her birth in New York City in 1925. Her parents were Jewish garment workers from Russia and Poland. During her early child-

hood, the family lived in the Bronx in what Karnes describes as a cooperative colony for families of "really working-class people." It was, she says, a social experiment both architecturally, in the design of houses, and culturally, with its own library, art classes, and Yiddish-language school. Politically, it was "very, very left-wing," she says, with the utopian conviction conveyed to the children, who were given a great deal of freedom, that this was "the way the world was going to be or should be."

After attending the High School of Music and Art, Karnes entered Brooklyn College, where she found in the architect and painter Serge Chermayeff a mentor for life. The Chechen-born Chermayeff had trained in England, where he had developed a strong interest in the relation between architecture and community. At Brooklyn College, he taught a course in design based on the methods of the Bauhaus. It was at Chermayeff's instigation that Karnes spent the summer of 1947 at Black Mountain College, taking a course with Josef Albers. "I was a good student," Karnes told me of her summer at Black Mountain with Albers. "He was hard clay, not soft clay." She made a gesture with her hands like an ax coming down.

At this point, Karnes had not yet discovered clay; what she had encountered was an emerging connection between making art and forging community. She fell in love with a fellow student at Brooklyn College, David Weinrib, whom she married in 1949. When she first moved in with Weinrib, he was designing lamps for a factory in Pennsylvania called Design Technics. It was in this industrial context that Karnes was first introduced to clay. Weinrib brought home "a great lump of clay" for Karnes to work with on the deck of their rented house. Karnes found that she had a talent for designing lamp bases for mass production.

After a year and a half at Design Technics, Karnes and Weinrib traveled to Italy, where they again found themselves in an industrial environment. They had a friend who had worked

in a town near Florence at a ceramics plant there. "He told us if we go there," Karnes recalls, "we can just work at the factory, so that's what kind of inspired us where to go." Weinrib, who suffered from asthma, had conceived of the Italian sojourn as a way to escape the silica dust and glaze fumes of pottery while at the same time acquiring the classical art training that he had missed at Brooklyn College. (He speaks of the irony of drawing from the nude in Florence at the very moment when, back in New York, Franz Kline and Willem de Kooning were reinventing painting.)

But it was in the industrial town of Sesto Fiorentino that Karnes discovered her vocation. She saw students at the factory learning to throw pots at the wheel. "I left very quickly," she says, "and made a wheel in my own house and put it there." She found she had a natural talent at the wheel, and the people at the factory were happy to fire the pots she brought to the kiln on the back of her motorbike. After their return to the United States, the Weinribs moved to Alfred University, which had the premier ceramics program in the country. It was at Alfred that they received the unexpected invitation to come to Black Mountain College.

3.

Despite its ready availability in the riverbeds of western North Carolina, clay had a tenuous existence at Black Mountain. Josef Albers based much of his teaching on the juxtaposition of materials, but he didn't consider clay a suitable material for students to work with. He thought that clay was too malleable, too yielding, too acquiescent to the students' whims and desires. In Anni Albers's phrase, clay didn't offer enough of the "veto of the material." There is something puritanical about this response to

clay, as though it shared some of the characteristics of a loose woman. *La donna è mobile.* But there was a second reason for Albers's dislike. He associated clay with the American craft tradition—"ashtray art," as he disdainfully called it—which he considered a form of recreation or therapy rather than a serious undertaking in artistic experience. (He may also have distrusted the emphasis on folk traditions, which may have recalled for him one unsavory aspect of Nazi ideology.)

It was the poet Charles Olson who brought clay to Black Mountain. Olson, whom Albers had hired to teach literature, took over the leadership of the college in 1949, after the Alberses' departure. Trained at Harvard in American literature, Olson, a giant of a man who was too tall for military service, had written propaganda for the Office of War Information (later folded into the CIA) from 1942 until 1944. He had developed a close friendship with the poet Ezra Pound, imprisoned at St. Elizabeth's Mental Hospital after the war for contributing anti-Semitic propaganda to the Fascist regime in Italy.

Like Pound, Olson was passionately interested in the gestural glyphs and written characters of non-Western cultures. In his landmark manifesto of 1950, "Projective Verse," he had laid out a program for a more immediate poetic language, in an effort to restore it to the physical "push" of breath and voice. During the winter and spring of 1951, Olson traveled to the Yucatán peninsula in Mexico, sending lengthy letters to the poet Robert Creeley, back at Black Mountain, eventually published as *Mayan Letters.* The title was a pun, referring both to the correspondence and to the Mayan hieroglyphs that Olson, believing a poet might succeed where scholars had failed, hoped to decipher.

Olson's *Mayan Letters* are hot with the excitement of a man who is on to something. He contrasted the vital "density" of Mayan writing, in which concrete objects are pictured in inscribed signs, with the abstract and moribund "sieve" that pho-

netic words had become in English. From the window of a third-class bus on a bad coastal road, he glimpsed a promising site for digging; "christamiexcited," he wrote Creeley, in a sort of English-language glyph. He returned from his excavation "with bags of sherds & little heads & feet—all lovely things."

4.

Most strikingly, however, Olson aligned poetry with traditional crafts in "Projective Verse," calling for "the attempt to get back to word as handle." Crafts were central to Olson's emerging vision of what he called the "second heave" of Black Mountain College, after the Alberses' departure. The key to maintaining momentum, in Olson's view, was his "institute model," an array of concentrated studies of which the first would be devoted to crafts. And for Olson, the quintessential craft was pottery.

By late 1951, Olson was determined to identify a significant potter who might be persuaded to teach at the college. In his search, Olson consulted Bernard Leach, author of the influential *A Potter's Book* (1940), the Bauhaus-trained émigré potter Marguerite Wildenhain, and Charles Harder, who ran the ceramics program at Alfred University. By March 1952, Olson felt he knew enough to offer a permanent position to Wildenhain. He explained that he had "taken on this potter post as a sort of personal gauge, why, I can't say, except that it damn well interests me as an act (pots do)." He added that pottery was "tied up severely with my own sense of what is now the push in the old-fashioned arts." Wildenhain was committed to the pottery she was establishing in Northern California, and Leach's candidate, his pupil Warren MacKenzie, was determined to study in Japan.

Leach then informed Olson that he himself was planning a

tour of the United States. He would be traveling with his protégé, the young Japanese potter Shōji Hamada, and with Sōetsu Yanagi, a philosopher steeped in Whitman and William Blake and the leader of the Japanese folk-art movement known as Mingei ("art of the people"). Olson and Leach agreed on a ten-day residency at Black Mountain, combining lectures and pottery demonstrations, to be held in October 1952. Wildenhain agreed to serve as the master of ceremonies for the occasion.

Olson wanted the college to have a head start in pottery for the summer session. Harder wrote to recommend Weinrib and Karnes, specifying that Karnes, who had studied under Harder, "has a placid and calm disposition and a most attractive personality. She can be depended upon to keep the team on a practical course and to get the job done." While Harder suggested the Weinribs as possible candidates for a more permanent position at the college, Olson initially offered them the job for the summer only, to share a position as potters-in-residence.

Fortunately, they didn't have to start from scratch. Paul Williams, the resident architect at Black Mountain, had built the Pot Shop in the meadow at the Lake Eden campus, to the potter Robert Turner's specifications. The son of Quakers, Turner had been a conscientious objector during World War II, working with developmentally disabled students. He had taught at Black Mountain from 1949 to 1951, but finding little support for his endeavors, he had returned to Alfred. It was in Turner's studio, somewhat removed from the main operations of the school, that Karnes and Weinrib set up shop and prepared for the arrival of the distinguished visitors.

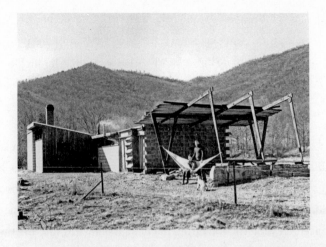

Karnes and Weinrib at the Pot Shop at Black Mountain College

5.

Call it the epiphany on Black Mountain: Three wise men from the East come to the mountaintop to share the good news. On the morning of October 20, 1952, the white-mustached Bernard Leach, born in Hong Kong and steeped in the wisdom of the East (or at least in the pseudo-Asian wisdom of Edwin Arnold and Lafcadio Hearn), gave a lecture, "America: Between East and West." One might think that America would benefit from its geographical centrality, but Leach saw little hope for American craft. What he meant by East and West was really Japanese Mingei and his own pottery at St. Ives, in England, two attempts at a revival of native pottery practices.

Leach's travels in the United States, he wrote, confirmed his "thankfulness" to have been "born in an old culture."

> For the first time I realized how much unconscious support it still gives to the modern craftsman. The sap still flows from a tap root deep in the soil of the past, giving the

sense of form, pattern and color below the level of intellectualization. Americans have the disadvantage of having many roots, but no tap-root, which is almost the equivalent of no root at all. Hence Americans follow many undigested fashions.

Leach's snobbishness extended to North Carolina clay, which he found insufficiently plastic for his needs. Hamada, by contrast, embraced the local clay, welcoming its limitations as additional challenges. It is characteristic of Karnes's independence that what she took from Hamada was an attitude, an ethic. She had no desire to be a Japanese potter. And the big ideas that Yanagi and Leach were selling—the "unknown craftsman," the subsuming of individuality within an old tradition, the avoidance of self-expression, and so on—were already familiar to Karnes through more American channels, namely, her friends John Cage and Merce Cunningham and her teacher Josef Albers. All were, in one way or another, exponents of the impersonal in art.

6.

Karnes witnessed the famous occasion during the summer of 1952 when Cage organized a group performance in the dining hall. He had been reading Zen Buddhist texts along with writings of the medieval German mystic Meister Eckhart. Eckhart wrote that "we are made perfect by what happens to us rather than by what we do," and Cage had begun to envision works of art that were based on chance, on serendipity, on letting things happen. He invited Black Mountain students and teachers to see what happened if they were each assigned an activity and a period of time in which to do it.

Merce Cunningham danced with a dog, Cage stood on a ladder and recited lines from Meister Eckhart, Rauschenberg exhibited his White Paintings, someone played a radio while someone else projected movies upside down on the wall—all to the accompaniment of scratchy Edith Piaf recordings played at double speed. This first "happening" ended with coffee served in cups that had been used as ashtrays during the performance. Soon after he left the campus, inspired by Rauschenberg's paintings of nothing and by Eckhart's injunction to cultivate a mood of silent expectation, Cage composed his epochal "silent piece," titled 4'33", in which a pianist sits at the piano for four minutes and thirty-three seconds without playing a note.

There was another happening the following summer, when the Weinribs invited three American potters to Black Mountain—Peter Voulkos, Daniel Rhodes, and Warren MacKenzie—all of whom were destined for big careers in American pottery. This time, the performance was organized by David Weinrib and centered on Lake Eden at night. M. C. Richards set the mood by reading from a grandiloquent poem that she had written in the style of Milton. Daniel Rhodes describes what happened next:

> At the climax of the poem, a boat appeared on the lake. We were all sitting in the dining room, and a boat appeared out of the darkness and a searchlight shining on it, and in the prow of the boat was Karen Weinrib in the nude draped with vines and flowers.

7.

As the school's finances and student body shrank during the early 1950s, the architect Paul Williams was interested in building a new artists' community, and he shared his plans with M. C. Richards and John Cage. Richards, who taught literature at Black Mountain, had begun studying pottery, first with Turner and then with Karnes. Her book *Centering: In Pottery, Poetry, and the Person* remains one of the classic works on the nature of pottery. Richards wanted pottery to be central to Williams's plan. Karnes and Weinrib were invited to join Richards, Cage, the musician David Tudor, and Paul and Vera Williams at the Gate Hill Co-operative at Stony Point in upstate New York. "The pot shop was the first place built," Karnes remembered, and again it was set off (at Karnes's insistence) from the rest of the community.

What did living with Weinrib, Cage, and other avant-garde experimentalists mean to Karen Karnes as an artist, at a time when American art was undergoing radical change, with the rise of minimalism, performance art, and—Cage's special contribution—the embrace of chance? An anecdote from John Cage gives a sense of the distinctive mood of the place.

"When I first moved to the country," Cage wrote in 1958, "David Tudor, M. C. Richards, the Weinribs, and I all lived in the same small farmhouse. In order to get some privacy I started taking walks in the woods. It was August. I began collecting the mushrooms which were growing more or less everywhere." Cage served a meal of what he assumed to be skunk cabbage, which is edible, to six people at Gate Hill, including a visitor from the Museum of Modern Art. The results were predictable.

> After coffee, poker was proposed. I began winning heavily.
> M. C. Richards left the table. After a while she came back

and whispered in my ear, "Do you feel all right?" I said, "No.
I don't. My throat is burning and I can hardly breathe."

Soon it was clear that he needed to be taken to a hospital. Cage,
who barely survived the ordeal, later learned to distinguish
skunk cabbage from hellebore, which is poisonous.

The tale of the poisonous vegetable is one of the vignettes
in Cage's collection of minute-long stories titled *Indeterminacy*.
It follows his famous account of studying with Schoenberg.
Schoenberg warned that Cage's lack of feeling for harmony
would be "like a wall I could not pass." "In that case," Cage re-
plied, "I will devote my life to beating my head against that
wall." The adjacency of the stories invites a closer interpretation
of the mushrooms, which he decided to continue collecting de-
spite the hellebore mistake. Without reading too much into it,
one can see certain themes: the place of risk in the artistic life
(mushrooms, poker), the Walden-like retreat to the woods and
the balancing proximity of the art world (the unnamed visitor
from MoMA, presumably there to see Weinrib), and the near-
ness of death.

Karnes and Weinrib divorced in 1959, at a time when Wein-
rib had moved away from clay. He became a sculptor in un-
orthodox and colorful materials like resin and fiberglass. At the
same time, his interest in performance art and happenings inten-
sified. In 1960, the year after he left Stony Point, he became part
of a small circle of artist friends in New York City that included
Eva Hesse. Vacationing in Woodstock in 1962, Weinrib, Hesse,
and their friends performed as the Ergo Suits Traveling Group,
using colored sculptures as bizarre costumes.

Karnes's commitment to clay deepened during the 1960s.
Her emerging aesthetic attitude seems to have found confirma-
tion in the self-effacing gestures of Cage and Merce Cunningham
rather than Weinrib's more expressive mode. And yet Weinrib's

openness to sensual materials and to bright color, even to a the-
atrical aspect of pottery, might have revealed a set of possibilities
that could only be fully explored later, during the period when
Karnes had forged an enduring relationship with a new partner,
the potter and Sufi practitioner Ann Stannard.

8.

During their years at Black Mountain, Karnes and Weinrib
had visited Jugtown, the folk pottery in central North Carolina.
Neither Karnes nor Weinrib had much use for American folk
pottery, however, including the rich traditions of North Carolina

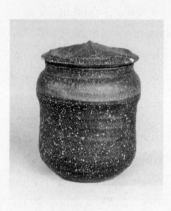

Karen Karnes, Jar, *1969*

clay. But while Weinrib delib-
erately banished craftlike ele-
ments from his ceramics in his
attempt to raise ceramic art to
the level of sculpture, Karnes
pursued a more internal quest.
She followed the inner logic of
the pots she was making, allow-
ing basic elements to take on
new forms and meanings.

Self-expression enters Karnes's
art obliquely, through the han-
dle and the lid. Garth Clark has written of the "single moment
of visual theater" in Karnes's casseroles that "the handle on the
lid is made from a twisted ribbon of pulled clay." Ten years after
she began making casseroles, she encountered salt glazing for
the first time during a sojourn at the crafts community of Pen-
land, in the mountains of North Carolina near Asheville, in
1967. The result was the extraordinary flourishing of stone-

ware jars with faceted lids that remain among her best-known forms.

How do pots like these come to matter to us and find a way into our lives? A passage from T. S. Eliot's play *The Confidential Clerk* suggests a possible answer. The financier Sir Claude regrets having given up a career as a potter and the pleasure of handling clay. Then he reflects on what pots grant access to: not primarily "use," he decides, nor "decoration" but rather an elusive quality he calls "escape into living."

9.

Karnes's late work, after her departure from Gate Hill in 1979, carries the feeling of such an "escape into living." These late pots have their own internal development. Karnes makes a series in one direction, exhausts its possibilities, and never looks back. The catastrophic fire in May 1998 that destroyed her studio and the house she shared with Stannard turned out to be not so much an ending as yet another escape into living. The thin, cylindrical pots displayed in groups of two or three look as if they have survived something—as indeed they have. They speak of transience and evanescence, of that continual metamorphosis that is at the heart of the potter's craft.

In their evocation of permanence and change, Karnes's assemblages remind me of an extraordinary passage in Willa Cather's novel *The Song of the Lark*. The opera singer Thea Kronborg has traveled to the Southwest and visits a site of Indian cliff dwellings, where there are many relics of masonry and pottery. Thea listens to an old German immigrant who has learned a great deal about Pueblo pottery and explains the intimate connection between domestic masonry and pottery:

> After they had made houses for themselves, the next thing
> was to house the precious water.... Their pottery was their
> most direct appeal to water, the envelope and sheath of the
> precious element itself. The strongest Indian need was ex-
> pressed in those graceful jars, fashioned slowly by hand,
> without the aid of a wheel.

Later Thea bathes herself in a pool behind a screen of cot-
tonwoods and has a sudden epiphany about the sources of art:

> The stream and the broken pottery: what was any art but
> an effort to make a sheath, a mould in which to imprison for
> a moment the shining, elusive element which is life itself—
> life hurrying past us and running away, too strong to stop,
> too sweet to lose?

Cather is trying to say something here that is perhaps ulti-
mately inexpressible, something about how art can give us eter-
nal moments—still moments—stolen from the flux of life that
make it all seem worthwhile.

10.

As Mark Shapiro and I were getting ready to leave Morgan, after
a tour of Karnes's big kiln and her small array of selected pots
on display, she presented me with one of her new pots, a strange,
zigzagging cylinder vase I had been admiring. The vase was
pebbled with brown salt glaze on one side and a wonderful pur-
plish hue on the other, where the wood fire had rushed through
the cross-draft kiln. The base was like a funnel or a miniature

space shuttle. The heavy rim seemed more cut than rounded, like an agate geode that had been cut flat and polished.

I cradled the vase on my lap as we drove down through the red pines of central Vermont, with intermittent glimpses of the Connecticut River pockmarked with ice. I had a dawning sense that Black Mountain was something more than a school with a brief lifespan, that it still lived—Albers's "hard clay" and Cage's mushrooming imagination—in this quiet dignified woman of my parents' generation and in the dignified pots she made.

11.

David Weinrib lives with his wife, Jo Ann, in an art-filled apartment that doubles as his studio in the Chelsea neighborhood of Manhattan, a few blocks from the Hudson River. Before I drove down to New York to meet him, I had seen only photographs of Weinrib from the 1950s, when he was bearded and youthful with a full head of hair. His imposing bald head strikes the visitor today, along with his beaklike nose, piercing eyes, and quick, ironic smile. Jo Ann had made coffee and laid out a ceramic slab plate—"some potter in Florida," David murmured—with apricots, nuts, and grapes. Mark Shapiro, with whom I was again traveling, was taping our conversation for use in a retrospective of Karen Karnes's work that he was organizing. While Weinrib was happy to talk about Karnes, he was quick to point out that one of the best-known photographs of Karnes at Black Mountain, sitting demurely on a stone wall by the Pot Shop, is actually half a photograph, with Weinrib's image cropped away.

Weinrib was wearing a white shirt, a white fleece vest, and

tinted aviator glasses; he was comfortable in the kitchen, energetic, gesturing freely, and ready to go at it. I was eager to talk about Black Mountain, which Weinrib described as "a northern college in the South." He said there was "an atmosphere about Black Mountain that just stimulated creativity and ambition." I asked him if his work had changed there, and he said that it had, decisively. He left the pottery wheel behind and made his first slab pots at Black Mountain. The idea, he said, was to "change the idea of pottery," to move it in the direction of sculpture.

We kept talking as we wandered through the apartment, stopping to look at objects and photographs. The apartment immediately felt familiar to me. It reminded me of my mother's studio spaces when I was growing up, with the accumulation of many years' work, various bits and pieces of inspiring bric-a-brac pinned to the walls, and art books balanced on the windowsills. Something about the rooms, especially the rough-hewn wooden stairs leading up to the sleeping loft, reminded me of Japan, where Weinrib had spent a lot of time and where he and Jo Anne had first lived together. She showed me a photograph of her in a kimono, or rather, as David said, "slipping out of it."

I was particularly struck by a pot that Weinrib and Karnes had made in collaboration. It was structured like two principles in dialogue, a rounded form that Karnes had thrown on the wheel and a rectangular form that Weinrib had formed in a mould. I found myself thinking that their marriage must have felt like this at its best; at its worst, I speculated, like two different temperaments coming into collision, a square peg and a round hole. While Weinrib expressed admiration for Karnes as a potter, a "natural" at the wheel with a terrific sense of design, he also hinted that he was more of a free spirit, more of a Sixties temperament. He spoke with distaste of the uptight European émigrés at Black Mountain and the transgressive pleasure of persuading Karnes to appear nude in the pageant on the lake.

*Collaborative pot by Karnes
and Weinrib*

Weinrib and Karnes had struck me from the start as an un-
likely pair, and eventually the contrasts must have become too
stark. But the failure of their marriage seemed less interesting
than the fact of it, during those years at Black Mountain and
right after. The particular temperamental divide at the heart of
their marriage (to the degree that a stranger can discern such a
thing) seemed, in some tantalizing way, to represent the divide
at the heart of Black Mountain. No one has been able to explain
the sheer number of artists and writers and other creative people
whose lives were decisively touched by the creative ferment of
Black Mountain. Perhaps it had something to do with the conflu-
ence of European refugees and American mavericks in search of
safe harbor, finding unexpected common ground in the Appala-
chian outback.

But as I drove back to Massachusetts with Mark Shapiro after
an afternoon with the Weinribs, I felt that this divide at the heart
of Black Mountain might have been more specific, something on
the order of Nietzsche's division of the artistic impulse into
Apollonian and Dionysian tendencies. On one side was every-
thing that Josef and Anni Albers represented: the quiet, orderly,

self-effacing, conscious, and clean-edged exploration of the nature of materials and the principles of design. One could see some of this same spirit in Merce Cunningham's experiments with pure movement, Rauschenberg's White Paintings, or in John Cage's systematically self-erasing explorations of random sounds and silence.

There was a countervailing spirit at Black Mountain, however, and David Weinrib was the perfect embodiment of it. That spirit was anarchic, chaotic, performative, self-expressive. One could see it in Charles Olson's ecstatic outpourings of words and ideas, his epic and exuberant Maximus poems, which seemed the antithesis of Josef Albers's minimalist forays into poetry. One could see it in the action painters at Black Mountain like Franz Kline and Jack Tworkov.

I realized that Black Mountain College, for the twenty-four years of its existence, had drawn its energies from the tensions of this divide. What is remarkable, in retrospect, is not how quickly the experiment died but rather how long it held together for so many vibrant people.

PART III

Cherokee Clay

1.

I had stumbled across pieces of an amazing story over the years, an epic errand into the wilderness that seemed only partly believable, more like a dream than a historical event. The germ of the story was this. The English potter and entrepreneur Josiah Wedgwood, who had built a pottery empire in his native Staffordshire, had sent one of his agents on a dangerous adventure across the Atlantic and into the wildest regions of the Carolina outback, where there were many ways to die. The object of his quest was a glistening white clay, a clay as white as snow. With the right kind of clay, potters in England could make porcelain, the elusive "white gold" of the alchemists, and solve the secret so closely held by Chinese potters for centuries.

The journey in search of white clay had occurred during the months leading up to the American Revolution, when the Carolinas were riven by violent disputes over land, and the keepers of the clay were the proud but increasingly embattled Cherokee people. Wedgwood's agent, an adventurer named Thomas Griffiths, risked shipwreck, murderous thieves, vengeful Indians, and the encroaching winter in the high mountains. But mere survival was not enough. He had agreed to return to England only after securing five tons of white clay.

It seemed like a fairy tale, one of those impossible quests imposed on the third of three sons, who wins the king's daughter if he succeeds but dies if he fails. As I assembled the fragments of the story, I found that the search for Cherokee clay was much richer, braided with more strands, than I had originally imagined. I had pictured a single traveler, but I soon discovered that there had been three successive journeys to the Cherokee towns by three different travelers. One of these journeys involved a distant relative of mine, the Quaker explorer, naturalist, and artist William Bartram. Bartram's account of his own travels inspired, in turn, several key details in Coleridge's opium dream of a poem, "Kubla Khan." Actually, there was a fourth traveler in the mix, because I myself, another third son, was determined to find and see with my own eyes the source of the snow-white clay.

2.

The sun was already descending toward the Great Smoky Mountains when my friend Roy Nydorf and I finally reached the outskirts of Franklin, North Carolina. There wasn't much daylight left to look for Cherokee clay. We had left Roy's stately old farmhouse outside Greensboro early that morning, estimating that it would take us four or five hours driving west on Interstate 40 to reach the mountains. But we had taken a long detour through the Cherokee towns west of Asheville. We had a place near Franklin to spend the night, at my friend Bill Quillian's retreat on Scaly Mountain, above the resort town of Highlands near the Georgia border, so we could afford a leisurely pace. Besides, it was a bright, sunny day in late July, with a gentle breeze, and the landscape opened like a Japanese fan along the highway.

We passed a chain gang on the outskirts of Asheville; Afri-

can American inmates in orange suits collected trash by the high-
way, while two state police officers armed with shotguns kept an
eye on them. We were getting hungry as the mountains came
into view, and we passed an apple orchard, closed, according to
a big, apple-red round sign, until August 1. Roy told me to stop
the car. He climbed the chain-link fence, grabbed a handful of
apples, and was back in a couple of minutes. I was thinking of
the chain gang. The apples were hard and sour.

Roy knew a nice place to get some grilled trout and a glass
of white wine in Sylva, an old town of wood and brick nestled
in the hills. When we placed our lunch order, the waitress ex-
plained that they only served trout for dinner. We looked so
crestfallen that the cook, a dark-haired young Cherokee, called
out from the open kitchen that he would cook us some trout
anyway, and a wonder it was, perfectly grilled and served on a
bed of lettuce with a wedge of lemon. Sylva could have served
as the setting for a movie Western, with a drop-dead-beautiful
white courthouse notched on a hillside over Main Street. Poking
around an antiques store after lunch, we found an old still, not
for sale, with long pipes of burnished copper. The shopkeeper
had worked for the DA's office for many years, and he had come
across a lot of illegal moonshine machinery, but this, he assured
us, was the finest still he had ever seen.

Then, with a map spread out on the dashboard, we headed
for the town of Cherokee, straddling a cleft in the mountains,
where the Indian casino faces the luxury hotel and a fast river
rushes over rocks between them. Roy wanted to show me two
paintings that Sean Ross, a native Cherokee who had studied art
with Roy at Guilford College, had painted and the hotel had
bought for display. We walked into the casino and Roy asked the
hefty, uniformed security guard blocking the way where the cul-
tural center was. "Culture," he said, gesturing toward the single-
minded clients hunched over slot machines. "This here *is* the

culture." He liked the joke so much, he said it again. "Ain't no other culture but this in Cherokee."

Sean's painting of a "Booger Dance," hanging in the sterile hallway of the luxury hotel, suggested another culture altogether. Masked dancers disguised as bears and badgers, representing alien forces among the Cherokee people, loomed from the firelit shadows. The intensity of the scene reminded me of Caravaggio, and Roy told me that Sean had spent a semester studying art in Italy before coming back to Cherokee. From the hotel, we drove to the Cherokee Artists' Collective nearby, where there was a little museum installation. I studied the pottery case for a moment, where there was an explanation of the two methods traditional Cherokee potters use to make vessels: by coiling and by the ball method (taking a ball of clay and hollowing it out with your fingers). The Cherokee pots were unglazed, and their only surface decoration was caused by smoke blackening the surface during low-temperature firing.

Suddenly I recognized one of the pieces in the case. The central pot on display was *my* pot. Or rather, it was exactly the same as the pot that my parents had bought right there in Cherokee, in the Cherokee Artists' Collective, when they were honeymooning in the Smoky Mountains in 1949. The pot was about six inches tall and the same width, with two handles added on each side and circular medallions under each handle that were meant to look like metal rings. Half the pot was blackened by smoke; the other was the gentle persimmon orange of Cherokee pottery. The pot looked burnished, carved, and rubbed. Above the pot was a picture of the potter and her name: Maude Welch.

When I got back to my house in Massachusetts, where the pot sits on my writing desk, I immediately checked the bottom, where I found the inscription: "Made by Maude Welch / Cherokee, NC 8-6-48." I also found an old postcard photograph on-

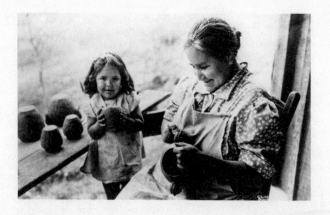

line of Maude Welch burnishing the clay surface of a pot just like mine.

3.

Roy and I had spoken many times about heading for the mountains to look for the fine white clay in Cherokee country, and he had become as obsessed as I was about finding it, whatever it took. I wasn't at all surprised. Roy is a wry and tenacious artist, originally from Long Island, who teaches studio art at Guilford College. An expert printmaker and carver, he was my mother's last art teacher, when she returned in her sixties to the studio, and he also taught some of my friends when I was a student there. Roy spends a lot of time outdoors; he knows the woodland trails around Greensboro; he can show you, down in the Guilford woods where Levi Coffin hid escaped slaves, the biggest poplar tree in North Carolina. He knows which fields are sown with arrowheads, and he has a passionate feel for the specific shapes and colors of the natural world: snakeskin, kelp, antlers, flint.

Roy Nydorf, Leopard Moth 2, *2006*

While I was waiting for Roy to grab his bags for the long drive west, I had admired the new work on the walls of his living room. Several of the pictures were large-scale pastels of moths, with the species identified in hand-printed letters below the image. Roy had chosen the perfect medium for these great-winged creatures. The soft pastel exactly mimicked the powdery feel of a moth's wing.

Roy was at Yale getting his MFA just after Josef Albers had stopped teaching there. One of Roy's teachers, the still-life master William Bailey, liked to imitate Albers's ways in the classroom. "Boy!" Albers would say, before handing down some gruff opinion. As Roy and I drove on toward Franklin and the Smoky Mountains, I told him about how Albers liked to find loops and numbers hidden in aerial views of the mountains, which were just coming into view.

As a child growing up in Indiana, I had a cat called Smoky, half Siamese and black as the night. When I first heard of the Smoky Mountains, as the romantic place where my parents had spent their honeymoon, I thought they must be black as smoke. But it is the white and grayish wreaths of cloud that give these

mountains their name, like smoke signals draped across the pines of the mountain heights.

4.

The only notion I had of where to find the beds of Cherokee clay came from a decade-old online article by an Australian geologist who had never been to North Carolina. The spotty directions seemed more like a map for buried treasure than reliable information. We found route 28 heading north from Franklin, as instructed, and took a left at the next traffic light. But there was no bridge over Iotla Creek from which we could count back one sixth of a mile, per our directions, then ask for Boyd Jones, and find the clay beds. A couple was carrying a pie along the side of the road, so I gave it a try. "It's pronounced 'Iola,'" the man said pedantically. "The 't' is silent." I told him we were looking for white clay. "Clay as in C-L-A-Y?" he asked. No, *as in K-L-E-E,* I almost answered.

Then in the distance, alone and walking right down the middle of the road, an old-timer in overalls made his slow way. Through the opened window I told him our errand. "Used to be a mine down around Rose Creek," he said, "where they dug white clay." He spat a splat of brown tobacco spit onto the hot asphalt and it almost sizzled on the tar. "They say some English fellers dug up some of that clay a long time ago and took it all the way back to England by ship." Yes, I said, yes, that's the clay. Where could we find it? "Go around the mountain and turn by the bridge to Rose Creek and it's right there, where the bait store is at." How far? "Round about three miles."

These directions turned out to be not much better than the

previous ones. What exactly was the mountain we were going around, and why was there no indication of Rose Creek? We got back to Highway 28 no wiser and stopped for the second time at the gas station where I'd asked for directions to Iotla Creek two hours earlier. This time, I helplessly asked for directions to Rose Creek. "It's right up there," said the girl at the cash register, pointing up the highway, "before that bridge. Just take a left on Bennett Road and it's right there." It was. The bait store turned out to be an ambitious operation called Great Smoky Mountain Fish Camp & Safaris. Snug by the side of the Little Tennessee River, a large wooden building was flanked by racks of canoes and kayaks. Down by the river there were a couple of campsites and a viewing platform with a barbecue pit made of stone. A woman and two kids were roasting marshmallows when we arrived. She said the guy who ran the place would be back in a few minutes. We walked toward the wooded ridge above the camp and what we saw took our breath away. Down below was a vast crater of red earth with standing water a few feet deep. A great blue heron picked its way along the edge of the pool while a hummingbird worked the flowers of some underbrush.

All around us was evidence of a vast landscaping project. It was the sheer scale of the operation that took us by surprise. Leading up to the ridge was a spiraling road of red clay, newly bulldozed. Sheets of mica six inches wide were strewn about on the road, like broken glass after an accident. But what really caught our attention were clumps of white clay, smooth to the touch, which disintegrated between our fingers like talcum powder. Cherokee clay! We could see veins of the stuff in the granite bluffs over the river, but to get closer to them we had to descend around the heron's pool and walk along another new roadbed alongside the river. Huge blocks of white quartz placed every ten yards lined the road, like some Roman triumphal way. "Whoever did this had a vision," Roy remarked.

A truck pulled into the driveway, and there was Jerry Anselmo, owner and outfitter of the Great Smoky Mountain Fish Camp & Safari. Jerry was friendly from the start and encouraged us to take plastic bags out to the bluffs to collect as much white clay as we wanted. Some geologists had stopped by from time to time, he told us, but his interest quickened when I mentioned the English potters of the eighteenth century and the Cherokee. "I own Chief Cowhee's village, too," he said, "down in the valley. I've found buckets of Cherokee pottery down there."

Jerry invited us up to his living quarters above the store, and we got a clearer sense of him. He was originally from Mandeville, Louisiana, across Lake Pontchartrain from New Orleans. He'd come to the Smoky Mountains sixteen years earlier. "Then I got kidney cancer," he said, "and that gave me a new view on what life is for." He became interested in Cherokee religion, reading all he could about their life in this river-riven landscape. As we sipped long-necked bottles of beer at Jerry's bar, he dragged out a bucket of Cherokee pottery shards. They were brown or gray, unglazed; whatever color they retained had come from the smoke of the kiln. Each carried a pattern of some kind, scored with a pointed tool: zigzags in parallel or an array of tight spirals, like Van Gogh's *Starry Night*. I was fingering one gray fragment in my hand like a magical talisman. "Take it," Jerry said. "No one will ever care for it more than you do."

Later, when I was back in Greensboro, I tracked down a photograph of Jerry Anselmo's mine as it looked around 1915. The mine itself is down below, in the center of the photograph. The second building, above it, is probably where they packed the kaolin for removal. To the left, a horse or mule pokes its head about the great snowdrift of white clay. I love the gaunt trees like stubble on the horizon, and the drama of the sunlit clouds like more kaolin drifting in the sky. How redolent of the hardscrabble South the postcard is! And I sensed some match between this

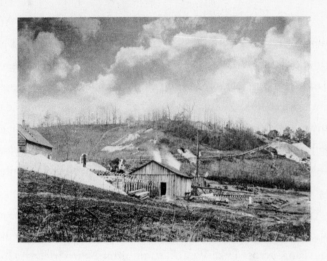

ambitious mining operation and Jerry Anselmo's visionary land-scaping project.

All that exposed red and white dirt made me think of an archaeological dig. It made it easier to summon the waves of people who had taken an interest in these clay beds. With his bucket of pottery shards and his five fish weirs across the Little Tennessee River, some of them built by the vanished Cherokee themselves, Jerry Anselmo was trying to summon the Cherokee ghosts from his land, hoping their spirits could help him find a way through his life. Roy and I were curious about the mining operation that flourished there well into the twentieth century. But most of all, we were looking for traces of earlier travelers, those "English fellers" who, as the old-timer said, "dug up some of that clay a long time ago and took it all the way back to England by ship."

5.

Three adventurous travelers had come this way during the eighteenth century, through some of the most dangerous and unsettled backcountry in the American colonies. One was a potter; one was the agent of a potter; and one, the most remarkable of all, was a writer, artist, and explorer. Two were Philadelphia Quakers. The lure of white clay brought the potters, just as it had brought Roy and me. The aim was to make something beautiful with that white clay, to turn raw material into art. So profound was the draw of the clay that these men were willing to travel thousands of miles, across oceans and mountains, to bring it back home.

The story begins with a young potter named Andrew Duché, a Philadelphia Quaker of Huguenot descent who was born around 1709. Andrew's father, Anthony Duché, was among the first potters in the American colonies to make stoneware pottery. He glazed his jars and jugs with salt thrown into the kiln, and was apparently the first to do so in Philadelphia. Andrew, his third son, joined other ambitious Quakers in their exodus to the South. He may have heard rumors that kaolin, the pure white clay used in porcelain production, was abundantly available in the Savannah River area. With his wife, Mary, he moved to Charleston, South Carolina, during the early 1730s and started a pottery operation there, similar to his father's in Philadelphia, making him the first potter to produce stoneware south of Virginia.

Duché's announcement appeared in the *South Carolina Gazette:*

This is to give notice to all Gentlemen, Planters and others, that they may be supplied with Butter pots, milk-pans

and all other sorts of Earthen ware of this Country made,
by whole sale or retail, at much cheaper rate than can be
imported into this Province from England or any other
Place, by ANDREW DUCHE Potter . . . at his Pot-house
on the Bay.

In Philadelphia, Duché had made stoneware in a heavy Ger-
man or lighter English style, sometimes with decoration in co-
balt blue. But in Charleston he joined a community of artists and
patrons fascinated by all things Chinese, and delicate Chinese
porcelain in particular. By 1737, Duché had moved to New
Windsor, a new settlement on the Savannah River, where there
were deposits of stoneware clay and a fine white clay known by
its Chinese name of kaolin. It was there that, with Yankee inge-
nuity, along with the help of local Indians with whom he traded,
he began experimenting with the arcane secrets of porcelain
production. Archaeologists have found "several curious wheel-
thrown bottles of unglazed white clay with Indian-style punctu-
ated decoration" near New Windsor, and it is thought that these
might be among Duché's early attempts.

The following year, Duché's friend Roger Lacy, the colony's
official agent to the Cherokee Indians, persuaded him to transfer
his base of operations to Savannah. "His next aim is to do some-
thing very curious," Col. William Stephens reported to the Brit-
ish financial backers of the newly founded Georgia colony in
1738. "He is making some trial of other kinds of fine clay; a small
Teacup of which he shewd me, when held against the Light, was
very near transparent." A few months later, Duché claimed, a bit
rashly, to be "the first man in Europe, Africa or America, that
ever found the true material and manner of making porcelain or
China ware."

We can be reasonably certain that Duché had identified at
least part of the secret. But other European potters had gotten

there first. The most that he could claim was to be the first pot-
ter in the English-speaking world to have cracked the mystery
of porcelain.

6.

Much to the frustration of potters in America and Europe, the
secret of porcelain had been known to the Chinese for thousands
of years. Sometime between the sixth and the tenth centuries,
Chinese potters stumbled on two naturally occurring minerals:
the fine, aluminum-rich white clay known as kaolin and another
mineral rich in feldspar known as china stone. Thoroughly
mixed and fired at an extremely high temperature, these materi-
als fused into the extremely hard, glasslike, and translucent ma-
terial we know as porcelain.

As with so many things about China, Western awareness of
fine porcelain goes back to Marco Polo, that shadowy thirteenth-
century adventurer who claimed to have spent seventeen years
in the service of Kubilai Khan, the Mongol ruler of China.
Among the marvels that Polo claimed to have seen abroad was
a handmade *porcellana,* or "little pig," as the delicate cowrie shell
was then called. (The part of the sow that the shell's opening was
thought to resemble was the vulva.) On his return to Venice in
1295, Polo supposedly brought back a fragment of porcelain that
still resides in the Treasury of St. Mark's. The word *china* could
easily have become the name for Chinese exotica like tea or silk;
it ended up as the name for fine porcelain.

The well-guarded secret of Chinese porcelain eluded Eu-
ropean potters until the eighteenth century. The man who really
put china on the map, so to speak, was Augustus II (1670–1733),
elector of Saxony and king of Poland, better known as Augustus

the Strong. Augustus's legendary strength in warfare supposedly gave him his nickname; other sources mention his prowess in bed (he reportedly fathered three hundred children). But what Augustus really loved, loved to the point of obsession, was porcelain. He collected many excellent specimens imported from China, and he once traded six hundred soldiers to the king of Prussia for 151 large Chinese blue and white vases. (That would be four soldiers per vase.) Augustus was determined to discover, at any cost, the secret of porcelain manufacture.

Augustus learned of a clever young alchemist named Johann Friedrich Böttger, locked him up in a laboratory, and impatiently awaited the results. Amid these Rumpelstiltskin-like conditions, Böttger first produced, in 1707, a remarkable red stoneware material, a high-fired clay that could be carved to resemble metal or polished to look like jasper. The inventive Böttger made a coffeepot with a dragon-mouth spout and a dragon-tail handle. But everyone knew that this discovery, however charming, was a stalling tactic.

The following year, the imprisoned alchemist evidently located a source of kaolin and succeeded in producing true porcelain, the lucrative "white gold" of Augustus's dreams. Wasting no time, Augustus set up a porcelain factory in Meissen, on the outskirts of his capital city of Dresden, which continues to manufacture porcelain vessels and figurines to this day. Gradually other potteries in Vienna and France were able to achieve similar results, but reliable sources of kaolin were scarce. That is why English and American potters were willing to dig for it in faraway North Carolina.

7.

A lingering mystery concerning Andrew Duché is why, given the rich deposits of kaolin nearby along the Savannah River, he went so far afield in search of more of the white clay. It may be that his experiments in making porcelain were not quite as successful as he claimed. During the summer of 1741, Duché showed William Stephens "a little Piece, in form of a Tea-Cup, with its Bottom broke out," and Stephens expressed doubt about whether Duché's pots really deserved the "Name of Porcelane." Such uncertainty may have inspired Duché's quest later that year for an even purer source of kaolin.

In any case, we know little about the precise circumstances of Andrew Duché's journey in search of Cherokee clay during the fall of 1741. Duché was in touch with agents who traded with the Cherokee people and who served under the authority of General Oglethorpe, the head of the Georgia colony. These agents must have apprised him of the clay fields to the north and west. Miners in search of precious metals in the mountains would have confirmed the rumors. The frontier was still relatively peaceful; during the following decades, as tensions escalated between the American colonies and the English Crown, it would soon turn violent.

Duché made the journey himself, up to the banks of the Little Tennessee River and into the mountainous regions of North Carolina, to dig the valuable white clay. A German emigrant named John (or Johann) Martin Bolzius, a Lutheran minister for Austrian refugees in the orderly settlement of Ebenezer, Georgia, twenty-five miles up the Savannah River, made two entries in his diary concerning Duché's visit "in search of mines" in October 1741.

Bolzius's diary entries show that Duché, like Marco Polo, had a gift for verbally enhancing his discoveries:

With General Oglethorpe's authorization he (Duché) has traveled amongst the Indians up in the mountains and has seen all sorts of singular things or else learned them from reliable persons. Amongst other things he recounted to me how amongst the Cherokees (a very populous nation, and amicable to England) where upon a cliff the footprints of an entire fleeing people, to wit, many men, women, and children, and all kinds of poultry, birds, and animals may clearly be seen. One also sees the imprint of a fallen man who is trying to rise by supporting himself on both hands; this can be seen because his posterior and his heel are imprinted on the rock as in sand. . . . In the same region there are also some fire-spewing mountains, also a great cave in the cliff from which flows constantly a certain material which turns when it falls to the ground. There are many deep caves, just as in Canaan.

Duché was apparently describing fossils of various kinds, though his account is wonderfully suggestive, with its "imprinted" records of people and animals fleeing and falling. In addition to these marvels, Duché also mentioned a "marble quarry" that he had discovered, "from which he is taking along (to London) samples." This marble, we can now conjecture, was actually kaolin, dug from the deposits near Franklin.

There were no live volcanoes in the region; the "fire-spewing mountains" Duché claimed to have witnessed were probably the Smokies, with their low-lying sheaths of clouds resembling smoke. In any case, Duché was reported to have "an artful Knack of talking," and his travel stories reveal that he was more a poetic fantasist than a reliable reporter of observed facts. He trafficked

in curiosities and marvels: volcanoes in the Appalachians, marble quarries, mysterious caverns, and white gold.

Many years later, Cherokee Indians near Franklin reported that a "Frenchman"—evidently Duché—had "made great holes in their Land, took away their fine White Clay, and gave em only promises for it." We know that the clay that Duché found in the Carolina outback was a remarkably pure kaolin, free of the traces of iron and other minerals that would discolor it when fired at high temperatures.

We find Andrew Duché, the first documented potter to practice his craft in Georgia, at the start of many forking paths. He stands at the origin of the great Southern stoneware tradition; he is among the first in the English-speaking world to embark on the quixotic quest for the secret of making Chinese porcelain; and we find him collaborating, in interesting and still mysterious ways, with American Indian artists.

8.

As it turned out, none of these dramatic discoveries were of much use to Andrew Duché. His early life makes clear that he was bold, improvisational, and brilliant. From urbane Philadelphia, he made a new life for himself in the rough and embryonic towns of the Georgia frontier. He worked closely with local Indians on his experiments, but he was also, apparently, insensitive to the Cherokee people whose clay he carted off. Moreover, he seems to have lacked the business acumen to make a fortune from his discoveries.

Failing to find adequate financial support for his porcelain production in the small towns of Georgia, Duché traveled to England in 1743. There he met with Thomas Frye and Edward

Heylyn, Quaker entrepreneurs who established the Bow Porcelain Factory. On the basis of what Duché told them, Frye and Heylyn applied for a patent to make porcelain with Cherokee clay, or *unaker*—the name derived from the Cherokee word for *white*. Duché seems also to have met at the time with William Cookworthy, a Quaker chemist in Plymouth, who was experimenting with porcelain. Recent chemical analysis of certain porcelain teapots and teacups marked with a blue A, from various British collections, confirms the outlines of this account. Both the expertise and the clay for making high-quality porcelain in Great Britain seem to have come from the American colonies, and specifically from Duché.

Despite all this energetic networking, Duché was destined to be disappointed in his aim to be the leading figure of porcelain manufacture in the English-speaking world. If he inspired potters in Britain, he seems not to have benefited personally from it. During the 1740s, a vein of bitterness entered his dealings with Georgia authorities. He joined the proslavery faction known as the Malcontents, gave up making pottery, and worked as an Indian trader instead; at one point, he sought permission to build a road from Charleston to Keowee, the nearest town in Cherokee country and the first leg of the route to the white clay beds. Duché eventually returned to Philadelphia, where he died in 1778.

9.

Yet another path that Duché helped to inaugurate concerned the innovative use of glazes, specifically what has come to be known as the alkaline ceramic tradition.

There were actually *two* secrets of Chinese porcelain that

intrigued the Georgia and South Carolina potters of Duché's generation: One was the secret of the clay, and one was the secret of the glaze. Southern potters were fascinated by the silky white and green celadon glazes on Chinese porcelain and sought to reproduce them. A history of China by a Frenchman, Jean-Baptiste Du Halde, first published in 1735, included a description of porcelain production using olive-green glazes made from a mixture of lime, plant ash, and powdered flint. Copies of the book were in the Charleston Library, and excerpts were published in the *South Carolina Gazette* in 1744.

It was in Du Halde's history, presumably, that Dr. Abner Landrum, a key figure in the history of early American pottery, first came across recipes for how to make celadon glazes. Landrum (1784–1859) was a farmer and physician, the publisher of a local newspaper called the *Edgefield Hive,* and, with his two brothers, a potter of considerable ambition. Landrum built an extensive pottery village in the Edgefield area, known as Pottersville, across the Savannah River from Augusta; it produced jugs and other household wares during the nineteenth century. The Landrum family had its roots in Randolph County, North Carolina; the Landrums were related to the great potting family of the Cravens, from the Seagrove and Jugtown neighborhood. Landrum's passion for porcelain spread to the naming of his sons after famous ceramic manufacturers, including Wedgwood and Palissey.

Dr. Landrum relentlessly pursued his experiments in matching Chinese celadon glazes. Eventually he found the right combination of lime, leaf ash, and quartz—cheaper materials than the customary salt—to achieve what we now know as the alkaline glazes of North and South Carolina: brilliantly expressive browns and greens that are fully alive today in potteries all over the South.

10.

And yet Dr. Landrum's greatest contribution to Southern pottery may well have been something entirely different, not an innovation in glaze but rather the creative opportunity that he provided for one of his gifted apprentices. In 1859, a slave employed at the Edgefield Pottery inscribed the following words on a great storage jar:

> When Noble Dr. Landrum is dead
> May guardian angels visit his bed.

The potter-poet's name was Dave. As the depth of his achievement has become increasingly known in recent years, Dave has emerged as a towering figure in the history of American ceramics. His idiosyncratic achievement in the writing of poetry also deserves to be more widely known.

One of Dr. Landrum's business partners at Edgefield was his nephew Harvey Drake, who was Dave's first owner. Slaves were employed for much of the heavy work at Pottersville. The young slave known as Dave, born around 1800, learned to turn pots in his teens. His skill was recognized early, and he was soon making storage jars and other vessels of extraordinary dimensions and formal grace. Just as remarkably, Dave learned to read, a forbidden skill for a slave, for it was felt that literate slaves would be more likely to rebel. Dr. Landrum employed Dave at his newspaper, the *Hive*; it seems likely that it was Landrum, later a Unionist, who taught Dave to read and had him set type for him.

Dave was also employed for a time in a brickmaking enterprise. A brick has been discovered at Edgefield with his signature incised into it. It seems reasonable to conclude that Dave practiced his writing skills by writing in brick with a stick.

Dave Drake was a brilliant potter. But he was also a poet. His

storage jars are of a virtuoso grandeur that still fills potters with awe. His most visionary stroke, however, was to combine his two skills in a manner unprecedented for slaves or, for that matter, for anyone in American pottery. Dave inscribed his poems, generally consisting of a single rhymed couplet, directly onto the shoulders of his great jars.

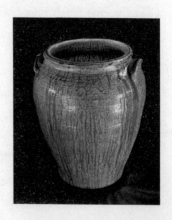

David Drake jar, 1862, inscribed with the words "I made this Jar."

Dave's poems can seem naive in their use of slang, odd rhymes, and high-flown language drawn from the Bible and other sources. But they are no more naive than Emily Dickinson's poems, which also self-consciously adopt folk phrasing and peculiar rhymes. Both poets favor short, incisive, enigmatic lines, like bolts of lightning in a dark night sky.

Many of Dave's poems are self-referential; they refer to the pots and the potter-poet. It is as though Dave is giving the pots voice, speaking through their mouths and lips, as in this inscription from May 1859:

Great & Noble Jar
hold Sheep goat or bear

or this pot made at the height of the Civil War:

I made this Jar all of cross
If you don't repent, you will be lost.

In an early poem of 1840, when Dave was owned by a relative of Landrum's named Lewis Miles, he punned on the double meaning of oven, as both pottery kiln and kitchen stove:

Dave belongs to Mr Miles
wher the oven bakes & the pot biles.

Other poems reach into a wilder, more mysterious register of poetic association, as in this dazzling couplet inscribed on a pot during the summer of 1857:

A pretty little Girl, on a virge
Volcaic mountain, how they burge

The poem speaks of the "volcanic" change in a young woman's desire as she moves from the "verge" of virginity to the "burgeoning" of mature sexuality. Emily Dickinson referred to herself, around the same time, as "Vesuvius at Home." But there is also a deep connection in the poem between sexual transformation and what happens in the volcanic regions of the kiln.

Dave Drake threw pots and wrote poems against a background of incredible violence, personal loss, and, late in life, the chaos of the Civil War. He lost track of his wife and children in the hideous institution of the slave trade, a loss commemorated in one of his most moving poems:

I wonder where is all my relation
Friendship to all—and every nation.

One of the women who worked beside him in the Edgefield pottery was whipped so severely that she committed suicide. And when he was around thirty-five, Dave fell asleep, drunk, on the railroad tracks. A passing train severed one of his legs.

Such tragedies make the big-hearted spirit of Dave's pottery and his poetry even more moving. "Friendship to all—and every nation."

Wedgwood

1.

When Americans hear the name Wedgwood, they tend to think of weddings or official commemorative occasions. A Wedgwood platter is a perfectly appropriate gift for a young couple starting out, just as a baby-blue Wedgwood saucer, with a girl in a swing surrounded by appliqué white flowers, is just right—or used to be—for a girl's first communion or her graduation from high school. Wedgwood comes in more severe patterns as well. Among our own wedding gifts, my wife and I received, from fastidious architect friends, a tea set in the "black basalt" Wedgwood line, unadorned and with a metallic industrial finish prefiguring Bauhaus designs.

But Wedgwood for me, when I was growing up in Indiana, was neither finicky nor austere. The only Wedgwood piece I knew was a weird octagonal bowl, about five inches in diameter, of the most flamboyant design. The bowl was made of bone china, according to the recipe that Josiah Spode first developed for a porcelain strengthened with an admixture of bone ash, and was an iridescent orange on the outside and a variegated purplish-blue within, like mother-of-pearl. It had a gilt rosette in the center and a gilt checkerboard around the exterior rim. Winged dragons circled the outer perimeter, and if you looked

closely, preferably with a magnifying glass, you could make out little Chinese figures riding impishly on their backs. The bottom of the bowl bore the Wedgwood "Portland Vase" trademark, a sketch of the best known of all Wedgwood vessels, also in gold.

The octagonal bowl was a wedding gift for my parents, given to them by an elderly mathematics professor, long retired from Haverford, named Albert Wilson. Wilson had all but adopted my parents during the early years of their marriage. He invited them to occupy his house on College Avenue and retreated to the third floor. When my mother thought that their relationship with the old man had become uncomfortably close and suggested they move out, Wilson moved out instead, and gave my parents all of his furniture, including an Arts and Crafts dining-room table that now graces our living room. He also helped support my parents financially at a time when they were really on their own.

My father's tenure decision at Haverford had been particularly fraught. The chairman of his department, a man of older methods and perhaps anti-Semitic as well, spread the word that my father was delusional, and suffered from a persecution complex. The president of the college called my father in and questioned him in a peculiar way that my father later realized was an amateurish test of his sanity. My father insisted on proceeding

with the promotion process and, with my mother's fierce support, resigned immediately upon being granted tenure.

These frightening events, which foreshadowed in uncanny ways some aspects of my own academic career, inhere for me in the octagonal bowl, a fragile survivor of those precarious years in my parents' early life. The bowl, I have since learned, was designed by an eccentric Wedgwood artist named Daisy Makeig-Jones around 1920 as part of a series called Fairyland Lustre. Makeig-Jones was one of a long line of interesting artists hired by the Wedgwood firm, including, early on, both the poet-painter William Blake and George Stubbs, the painter of horses. Makeig-Jones's fairy world, partly inspired by the illustrations of Edmund Dulac, was a radical departure from the neoclassical designs the firm had become known for. It introduced an element of dream into porcelain production. A triumph of iridescent glazing techniques, the bowl required as many as seven successive firings, with the gilt stenciling applied last. Makeig-Jones made similar designs with hummingbirds and butterflies. Such escapist motifs had a huge vogue in both England and America during the hopeful years after World War I, but they were discontinued during the Depression.

Because of the bowl's outlandish colors and whimsical patterns, I have never thought of Wedgwood as some hyper-English totem of conventional respectability. For me, Wedgwood connotes an exotic realm of dreams, reached by journeys on flying dragons and magic carpets. These associations, as it turns out, are just right for the participation of the famous founder of the firm, Josiah Wedgwood himself, in the quixotic quest for Cherokee clay.

2.

The flurry of excitement in England concerning Cherokee clay could hardly have escaped Wedgwood's attention. He was the greatest of all European potters, but he was also a consummate master of manufacturing techniques and global marketing. A religious dissenter with close ties to influential Quaker merchants in Liverpool and London, Wedgwood had built a ceramics empire in the pottery region of Staffordshire, where his ancestors had made pots since the early seventeenth century. Six straggling villages devoted to making pots, including Wedgwood's native town of Burslem, had sprung up around abundant local deposits of gray and yellow clay. The countryside was pockmarked with pits and piles of drying clay; the skyline consisted of church steeples and bottle-shaped kilns, belching smoke into the heavens like live volcanoes.

Wedgwood's life played out between age-old customs of village craftsmen on the one hand and the explosive energies released by the Industrial Revolution on the other. Always open to improvements and the latest scientific ideas, Wedgwood's instincts for innovation were cultivated among a distinguished group of enterprising friends, including the philosopher-poet Erasmus Darwin, the chemist Joseph Priestley, and the inventor James Watt, who met each month to share ideas on the night of the full moon and called themselves the Lunar Men. These men would be responsible for some of the major discoveries of the age, in steam power, industrial chemistry, and evolutionary biology. It was Wedgwood's quest for something comparably transformative in the field of ceramics that led him to join the romantic—and increasingly dangerous—quest for Cherokee clay.

3.

Josiah Wedgwood was born in 1730, the youngest of seven sur-
viving children. His father, who molded pottery for a living, died
when Josiah was nine. Two years later, Josiah contracted small-
pox, which weakened his right knee and gave him a distinctive
limp. Apprenticed to an older brother, he contracted to learn
"the Art, Mistery, Occupation or Imployment of Throweing and
Handleing" of pots, but found himself unable to kick the treadle
of the pottery wheel with his injured leg.

"Mistery" probably referred to mastery, but it also suggests
the closely guarded secrets of the ancient craft. Hobbled by injury,
Wedgwood developed, by way of compensation, an insatiable in-
terest in new techniques of production and decoration, mystery
in the service of mastery. All potters were experimental chemists
of a kind, learning by trial and error effective ways to prepare and
mix clays, apply glazes, and fire their ware. But Wedgwood was
unusually systematic in his experiments, nearly five thousand of
which he carefully documented during his working life.

Staffordshire potters made two kinds of pots, earthenware
and stoneware. Low-fired earthenware was porous and had to be
fired twice, first to dry it (the "biscuit" firing) and second to re-
ceive the glaze that made it watertight. Stoneware, fired at a
much higher temperature, was made of clay mixed with flint,
which vitrified in the kiln. Salt-glazing was also popular among
Staffordshire potters. A breakthrough came around 1740, with
the development of cream ware, a lustrous glaze over a refined
clay body that bore a close enough resemblance to porcelain to
be used as fashionable tableware. Improvements in cream ware
occupied Wedgwood for many years; in 1765, he was invited to
make a tea set for Queen Charlotte, an extraordinary honor that
made him even better known internationally. He was granted

George Stubbs, portrait of Josiah Wedgwood

permission to call himself Potter to Her Majesty and to rename his cream ware queen's ware.

By the 1760s, Wedgwood ran the most successful pottery operation in the English-speaking world. He marketed his mass-produced cream ware to middle-class families in Europe and the American colonies. But Wedgwood had greater ambitions. He wanted to move from tableware to more expensive and aesthetically exacting luxury products, progressing from what he called merely useful to ornamental vessels. Archaeological finds in Pompeii and Herculaneum fired his imagination. If he could make vases like those extracted from under the layers of volcanic ash and published in luxury editions by Sir William Hamilton, perhaps he could develop a whole new market for pottery.

Wedgwood had monitored the various English experiments with porcelain during the 1740s, when Andrew Duché brought his samples of white clay to show off to potters and chemists. But like other potters in Staffordshire, Wedgwood considered fragile porcelain too costly for mass production. There was simply too

much waste and breakage in the kiln, too much of a gamble for such a limited result. What did interest Wedgwood, however, was the possibility of locating a clay body white enough to imitate Chinese porcelain. A few samples he purchased on the sly, including a lump from South Carolina, "surprised me a great good deal," he reported in 1765. Not only was the clay whiter than any he had seen, but more important, it retained its whiteness even when fired at relatively high temperatures. His subsequent experiments convinced him that the Carolinas might be the source of the vibrant and luminous white clay that he was in search of, allowing him to "turn dirt into *Gold*."

What Wedgwood wanted, above all, was *exclusive* rights to the wondrous white clay. Applying for a patent, he feared, would simply disclose the special properties of the clay to the world. If he could somehow corner access to the sources of the fine clay instead, through a deal with the Cherokee Nation, he could prevent competing potters in the American colonies and in England from using it in their own products. The ornamental pots that he made from the clay could then be advertised as exotic artifacts with Cherokee origins.

4.

Wedgwood's romance with Cherokee clay played out during a particularly intense period of his life. Unease in the American colonies contributed to his impatience to explore and exploit the resources there. He and his fellow Lunar Men admired enterprising Americans like their friend Benjamin Franklin. Despite their distaste for slavery, which Wedgwood in particular abhorred, they tended to sympathize with the upstart colonies against the Crown. Nonetheless, Wedgwood knew that his mar-

kets in America were threatened by any decisive break. In any case, speed was of the essence. What he needed was an agent willing to travel to America who was sufficiently trustworthy to keep his mission secret and sufficiently capable to get the dangerous mission accomplished without spending too much money or time along the way.

After a sustained search, and with some lingering misgivings, Wedgwood settled on Thomas Griffiths for the job. Ralph Griffiths, Thomas's older brother, was the respected founder and editor of the *Monthly Review*. A Staffordshire man, Ralph Griffiths had made a fortune by publishing *Fanny Hill*, and he kept a stylish house in London; among his circle of friends was one of Wedgwood's brothers.

A point in favor of Thomas Griffiths was that he knew the Carolina outback firsthand; he had participated in a financially strapped venture to farm maple sugar in the Piedmont region, using a method that he had supposedly learned from the local Indians. But Wedgwood was afraid that Griffiths might unscrupulously funnel the funds allotted for acquiring white clay into his maple-sugar operation. By the end of May 1767, Wedgwood had received sufficient assurances to go ahead with the plan. He would send Griffiths on his errand into the wilderness, even as he imposed some restrictions to prevent his emissary from "doing too much mischief."

5.

If Andrew Duché's embellished travels sound like something out of Marco Polo, Griffiths's account of his adventures is more like the plainspoken realism of Daniel Defoe. Written to fulfill his obligations to Wedgwood and to justify his expenditures, the

report is blunt and devoid of literary flourish or posturing. The journal reveals what this adventurous young man noticed and what, despite Wedgwood's injunctions to collect botanical and mineral "curiosities" along the way, he overlooked.

Griffiths had no illusions about the risks he was running; what he mainly registered was danger at every turn. On the Atlantic crossing aboard the ship *America,* lookouts scanned the horizon for Algereens, pirates from Algeria. A six-foot shark proved "middling well" for dinner when skinned and boiled. "Nothing Materiall happen'd till our arrival in Chas Town Bay, on the Twenty First of September, being a miserable hot and sickly time." Charleston, South Carolina, was a thriving port of about ten thousand inhabitants when Griffiths stepped off the ship to begin his journey into the interior.

After outfitting himself with such necessities on the trail as a good horse, a saddle and bridle, sufficient tea and coffee, "three quarts of spirits," and a tomahawk, Griffiths "went off for the Cherokee Nation" on October 4, 1767. The first stage of the journey, with a stopover at a rice plantation fifty miles from Charleston, involved nothing more dangerous than treacherous swamps—or holes, as Griffiths called them. But things quickly assumed a darker cast as he rode toward newer settlements to the northwest. The weather turned "very hot and fainty"; Griffiths's horse fell lame; and at an outlying plantation, he found "the People almost all dying of the ague and feaver."

Griffiths moved slowly through the next perilous stages of his itinerary. He was careful to rest his horse. He slept under the trees, spending the night one evening "very near the place where five people had been Rob'd and Murder'd, but two days before, by the Virginia Crackers and Rebells." These, he said, were "a sett of Thieves that were join'd together to Rob Travillers and plunder and destroy the poar defenseless Inhabitants of the New Settlements."

For a man like Griffiths, traveling alone through the woods, there was more to fear from renegade white men than from Indians. The Cherokee War that ended in 1761, with devastating results for the Indians, had opened the way for white settlers, who farmed the land with wheat, indigo, and tobacco, relying heavily on black slaves for manpower. Settlers cleared land where nomadic hunters had once roamed freely, and a new conflict had sprung up in the region, pitting hunters against farmers. The hunters were of varied background: unemployed militiamen, orphans of the Cherokee war, mountain men, and drifters. They stole livestock, sheltered escaped slaves, and had "a reputation for killing and torturing their victims." It was into the heart of this "Cracker War" that Griffiths and his injured horse made their nervous way, through thick woods in which, he noted, it was "a thing very Rare to see either Person or so much as a poar hutt for Twenty or Thirty Miles Ride."

Then came a stroke of luck. Griffiths encountered a friendly trader on the trail. After about six miles of travel together, as the sun was setting, the trader noticed two suspicious men up ahead. Asking to borrow one of the brace of pistols Griffiths carried, the trader advised him to keep his hand "Ready cock'd" with the other.

As my new Companion expected, they [the suspicious men] soon gallop'd up a Deer Track into our Road, with a "how do you do Gentlemen, how far have ye cum this Road? Have you met any horse Men?" and then wish'd us a good Evening; but Soon stop'd and asked if we had heard of any News about the Robers, which we answer'd in the Negative & so on: my Companion then said it was well we were together, and that we had fire arms as he had some knowledge of one fellow, and believed him to be concern'd in the late Murder, which proved too true.

The men went their separate ways. But in Charleston, a few months later, Griffiths witnessed the public hanging of the cracker his companion had identified.

Griffiths stopped at a settlement called Coffee Creek, where "the people were all sick and Lay about the room like Dogs, and only one Bed amongst 'em." Then, he came to the town of Hard Labour, about two hundred miles from Charlestown, which, despite its name, boasted "fine Rich Red Loomy [Loamy] Land famous for Raising Corn, hemp, flax, Cotton," and so on. At Hard Labour, Griffiths had another piece of extraordinary good fortune, without which his errand to secure Cherokee clay would almost certainly have been a failure. He was approached by white intermediaries and asked to escort, as far as the Cherokee towns, "an Indian woman belonging to the Chiefs of the Cherokees." He was informed that she had been held captive by a rival Indian tribe and ransomed through the efforts of John Stuart, superintendent of Indian affairs in the region. Griffiths agreed to the task. Continuing along the heavily wooded trail, he escorted the woman safely to the Indian town of Old Keowee, the gateway to Cherokee country. Several Cherokee chiefs happened to be gathered there to choose representatives for a peace conference in New York. Griffiths realized that this was a perfect opportunity for him to make arrangements for acquiring Cherokee clay.

Griffiths ate, drank, and smoked with these "Strainge Copper Collour'd Gentry," as he called them. He waited patiently for the right moment to state his purpose. Portraying himself as an idle adventurer who had come to their land "in search of anything that curiosity might Lead me to," he mentioned, as though in passing, his interest in collecting some of their "white Earth."

It must have seemed a harmless enough request under the circumstances. But to Griffiths's dismay, an interpreter was called for, and there was a great deal of debate about the wisdom of allowing permission to dig white clay.

This they granted, after a long hesitation, and severall de-
bates among themselves; the Young Warier [warrior] &
one more seem'd to consent with Some Reluctance; saying
they had been trubled with some young Men long before,
who made great holes in ther Land, took away their fine
White Clay, and gave 'em only Promises for it: however as
I came from their father [the superintendent of Indian af-
fairs] and had behaved like a True Brother, in taking care
to conduct their Squaw safe home, they did not care to
disappoint me for that time.

The Cherokee chiefs were used to deception by white people
and understandably wary of negotiations. They were dismayed
by Duché's high-handed behavior twenty-five years earlier,
when he made "great holes" in their land and broke his promises
for payment. But they were also moved by Griffiths's brotherly
deed in bringing the captive woman safely home.

In granting the request, the Cherokee chiefs stipulated that
the agreement was for this occasion only. If more clay was to be
taken later, they insisted, additional arrangements would have to
be made, "for they did not know what use that Mountain might
be to them, or their Children." They also asked whether the clay
"would make fine punch Bowls, as they had been told." If so,
"they hop'd I wo'd let 'em drink out of one."

Deal in hand, Griffiths still had a long way to travel before
reaching the white clay beds in the mountains. He made his way
along the Savannah River, from one Cherokee settlement to an-
other, through what he called "very daingerous" country. "I was
a little in fear," he wrote, "of every Leafe that Rattled." In one of
the villages, he encountered the woman he had brought back
from captivity—"my old Consort the Queen." He was told that
she had been subjected to a purification rite "according to the

Indian Custom," and "was obliged to undergoe Eight days Con-
finement in the Town house . . . and after that to be strip'd, dip'd,
well wash'd, and so Conducted home to her Husband."

Mindful of potential dangers lurking at every turn of the
trail, Griffiths had little time to appreciate his natural surround-
ings. Only once did he take the trouble to notice the many kinds
of trees around him: "fine white and black oak, ash, Maple, Hick-
ory, Birch and many Lofty Pines." As Griffiths made his way into
the mountains the weather turned nasty, with "Cold and heavy
rain or Sleet from five in the morning till nine at night." There
was "scarce Life in either me or my poar horse," he noted, but
every day brought him closer to his destination.

Finally, on November 1, he had made his way to Cowee Vil-
lage on the Little Tennessee River, where he knew the white
clay was waiting nearby. He rested for a few days at Cowee and
outfitted himself with tools, blankets, and a slave to help him
with the considerable labor of digging and preparing the white
clay. He also secured the services of a local Indian trader named
Patrick Galahan to guide him to the clay beds. And there, to his
dismay, the real work began.

6.

Three full days of backbreaking labor were needed to clear away
the twelve or fifteen tons of rubbish that had piled up in the pit,
evidence that clay had been dug there before. On the fourth day,
the pit was finally clean and the white clay "appeared fine." But
just at that promising moment, with the long-sought treasure
seemingly in hand, several Cherokee chiefs suddenly appeared
on the scene and took Griffiths prisoner as a trespasser on their

land. With the help of an interpreter and four hours of patient negotiation, the misunderstandings were resolved, and the hard labor resumed.

Four days later, Griffiths finally had a ton of fine white clay ready to load on the packhorses. But again, luck was against him. The weather took a sudden change for the worse, with disastrous results.

> Such heavy Rains fell in the night, that a perfect Torent flow'd from the upper Mountains with such Rapidity, that not only fill'd my pitt, but melted, stain'd and spoil'd near all I had dug and even beat thro our wigwam and put out our fire, so that we were nearly peris'd [perished] with wet and cold; this weather proved of bad consequence another way, as it wash'd the Strattums of Red earth that Run Skirting thro the pitt, which stain'd and spoil'd a vast deal of white clay.

When Griffiths reports that the red earth has overrun the white clay and spoiled it, we can feel the symbolic aptness, as though red men and white men do not mix harmoniously.

Like Sisyphus, Griffiths resumed his seemingly endless task, clearing, digging, and drying the white clay yet again. To palliate the Indians, he invited them to share rum and music with him. By December 18, working steadily, he finally had prepared the five tons of clean clay that he had promised to bring back to Wedgwood. He arranged to have horses sent to the pit for loading.

Griffiths had never experienced such cold; twice, in the morning, he found the river frozen over despite the strong current, and "the pott Ready to freeze on a Slow fire." While waiting for the packhorses to arrive, he took a few days to "fossil and Botanise," another request from Wedgwood. Not surprisingly,

given the season, the results of his frigid excursions were "very short of my expectation."

Two days before Christmas, Griffiths finally left "this cold and Mountainous Country," and retraced his steps over hundreds of miles of slippery paths. The valuable clay was transported first on horseback and then, from Fort George, by wagon. He reached Charleston in early February. There he watched "severall Thieves executed that were Lurking about the Woods I had Travill'd thro" and, "a far pleasanter Sight," a good horse race. His precious cargo of white clay was loaded onto a ship; man and clay survived another rough passage to London, where the clay was transported by land to Josiah Wedgwood's pottery, along with a shocking bill of £500.

7.

Soon after Griffiths's return, Wedgwood's bad leg, weakened by smallpox and aggravated by a coach accident, was giving him so much trouble that he could no longer walk. On the advice of doctors, he decided to have the leg amputated. On May 31, 1768, fully conscious and numbed only with laudanum, Wedgwood sat in his chair and watched as two surgeons applied a tourniquet and sawed off his leg above the knee.

By the fall, with his peg leg in place, Wedgwood was sufficiently healed to go vase hunting with his friend Matthew Boulton. They visited private collections and public museums, looking for ancient models for their own productions. The idea they were developing together was a synthesis of metalwork, in which Boulton specialized, and ceramics. Boulton would supply silver or gilded "mounts" for Wedgwood's vases, thus creating a new

kind of ornamental *objet de luxe.* Porcelain was too fragile for the heavy ornaments, and Wedgwood continued his search for clay bodies, dramatically white or, alternatively, dramatically black for his "classic" vases.

In June, 1769, another of Wedgwood's dreams came to fruition when he opened a new factory that he named Etruria. It was there that he manufactured "Etruscan" vases and urns in an austere black stoneware that he called basalt, in forms derived from ancient Greek patterns. On June 13, the day of the official opening, Wedgwood sat at the wheel, with his business partner Thomas Bentley turning the treadle, and threw six perfect vases in the distinctive black clay body that he had developed. Wedgwood was in advance of public taste in the ways that he chastened rococo curves and flourishes in favor of the more restrained style that came to be known as neoclassical. A growing Quaker clientele was particularly drawn to the unglazed surfaces and simple geometric forms, and Wedgwood's black "basalt" came to be known as Quaker ware.

The 1760s had marked the height of the aristocratic craze in Britain for collecting fine ceramics, as "vase mania" swept the country houses. Upscale collectors like Horace Walpole filled "china rooms" with their prized acquisitions, and Wedgwood's ornamental vases fit right in. For Walpole and his fellow collectors, a whole worldview was summed up in the two meanings of *curiosity.* On the one hand, a curiosity was a rare object—something odd, exotic, recherché—to be placed with comparable treasures in a "cabinet of curiosities." Anything connected with American Indians or ancient Etruscans was curious in this sense. But Wedgwood's intellectual circle was also fueled by curiosity in the other sense: an insatiable hunger to find out how things really worked, in nature or in the new world of industry and manufacture.

By around 1770, the upper-class demand for fine china seemed saturated. Wedgwood realized that he needed to create a new market as well as new products.

He determined that something new was needed to capture the imagination of the middle class. Producing vessels for use, especially for serving food and drink, was a steady and lucrative market, but Wedgwood wanted these "middling" people to acquire luxury objects as well. During the summer of 1772, he wrote to Bentley:

> The Great People have had their Vases in their Palaces long enough for them to be seen & admir'd by the *Middling Class* of People, which Class we know are vastly, I had almost said infinitely, superior in number, to the Great, & though a *great price* was I believe, at first necessary to make the Vases esteemed *Ornaments for Palaces,* that reason no longer exists.

To entice new buyers, Wedgwood needed new clay. It was as simple as that.

8.

In late 1774, Wedgwood had a breakthrough: He finally discovered a use for his dearly acquired white Cherokee clay. He used it to manufacture his biggest innovation since his popular cream ware: a blue-tinted stoneware that he named jasper ware. In his promotional materials for jasper ware, Wedgwood stressed its origins in the Cherokee lands of Carolina. The exotic origins of the clay enhanced its market appeal. Just as his earlier vases had

drawn on archaeological excavations in Greece and Italy, jasper ware summoned images of American Indians in the great forests of the New World.

At the same time, the prohibitive expense of acquiring more Cherokee clay made its future use at Etruria uncertain. The outbreak of the American Revolution made further excursions to Cherokee country impossible. This presented a conundrum. As Wedgwood steadily exhausted his store of Cherokee clay on his popular jasper ware, he knew that he would not be able to replenish his supply from the same distant source.

Then came the news that William Cookworthy, the Quaker potter and scientist whom Andrew Duché had visited thirty years earlier, had discovered abundant kaolin deposits in Cornwall, on the southwest coast of England. Cookworthy and his partner, another Quaker named Richard Champion, sought to corner the market for the clay and use it for porcelain production. With stiff resistance from Wedgwood and other Staffordshire potters, Cookworthy managed to acquire a patent for using Cornwall clay in porcelain but not in earthenware, a significant qualification.

And so it was that in May 1775, Thomas Griffiths, the adventurer and clay-hunter who had braved incredible danger to bring his precious cargo safely home to Wedgwood, made a final journey in search of white clay. This time he did not have to cross an ocean to do it, and his wary employer, walking carefully on his peg-leg, accompanied him on the westward excursion. Wedgwood contemplated the prospect from the rocks of Land's End in Cornwall and gazed "with a kind of silent awe, veneration, & astonishment" at the Atlantic Ocean. "It was with a transport of awe," Wedgwood wrote, "that I now set my face homewards towards Etruria." It was the end of Wedgwood's ten-year romance with Cherokee clay.

Xanadu

1.

John and William Bartram, father and son, were brilliant naturalists, writers, and explorers. William, in addition, was an artist of
genius. Brought up in the Quaker faith, in the Quaker city of
Philadelphia, they worked for several years as a team, discovering new species of plants and exploring little-known regions. And
yet they were strikingly different in temperament. John Bartram
was in many ways a typical man of the Enlightenment, in a city
that welcomed such views. Eighteenth-century Philadelphia,
with its tolerant Quaker governance in religious matters, was an
incubator of wide-ranging scientific and artistic creativity. Bartram's friends and associates included the statesman-scientist
Benjamin Franklin, the artist-physician Benjamin West, the museum founder, naturalist, and artist Charles Willson Peale. These
were versatile men who excelled in multiple fields and recognized no limits to their undertakings.

John Bartram's universe ran like orderly clockwork, with
human projects in accord with an intelligible divine plan. He
made a good living by traveling into the wilderness of Florida and
Georgia and collecting new specimens of plants, which he then
sold to aristocratic clients in England. It was a business arrangement, not without its dangers, but John Bartram had learned to

minimize the risks of his profession. He expected his son William to follow the same industrious principles. In one sense, he was vastly disappointed, for William's genius turned out to be of a highly idiosyncratic kind.

William Bartram was brought up in the Enlightenment world of clarity, fixed hierarchy, industry, and order. Almost from the start, however, he fit uneasily into this grid. Compared to his father's friends, with their orderly ambitions and systematic undertakings, young William Bartram was waywardness embodied. His world was a world of accident. He made a lifelong practice of wandering from the beaten path; his best discoveries always came after slips and falls of various kinds. His accidents were lucky and his falls fortunate; serendipity could have been his motto.

Here is a typical passage from William's account of travels in western Georgia, when he literally stumbled upon a new variety of wild rose:

> Before we left the waters of Broad River, having encamped in the evening on one of its considerable branches, and left my companions, to retire, as usual, on botanical researches, on ascending a steep rocky hill, I accidentally discovered a new species of caryophyllata (geum odoratissimum); on reaching to a shrub my foot slipped, and, in recovering myself, I tore up some of the plants, whose roots filled the air with animating scents of cloves and spicy perfumes.

The passage could almost be taken as a microcosm of William Bartram's life: He leaves his companions and enters the woods alone; he climbs a steep hill; he slips; he recovers his balance to find in his hand, by accident, a new discovery, which fills the air with its pungent perfume.

Melancholy and prone to depression, William's psychologi-

cal world was as vulnerable to unexpected slips and falls as the
exterior world. During one of his rambles, he reflected on how
accidents can interfere with the best-laid plans:

> Thus in the moral system, which we have planned for our
> conduct, as a ladder whereby to mount to the summit of
> terrestrial glory and happiness, and from whence we per-
> haps meditated our flight to heaven itself, at the very mo-
> ment when we vainly imagine ourselves to have attained its
> point, some unforeseen accident intervenes, and surprises
> us; the chain is violently shaken, we quit our hold and fall:
> the well contrived system at once becomes a chaos; every
> idea of happiness recedes; the splendor of glory darkens,
> and at length totally disappears; every pleasing object is
> defaced, all is deranged, and the flattering scene passes
> quite away; a gloomy cloud pervades the understanding.

For young William Bartram, the inner weather of moods and
melancholy was as unpredictable as the outer. A hint of alien-
ation steals into all his undertakings. He was, in crucial ways,
more a member of the coming Romantic generation, that inter-
national movement dedicated to feeling and spontaneity and a
deep-felt correspondence between the promptings of the natu-
ral world and the human heart. Bartram's Philadelphia contem-
poraries admired his writings and drawings, complaining only
of a want of accuracy here and there, and of an unfortunate
penchant for inventive exaggeration. But it was a younger cohort,
including the English Romantic poets Coleridge and Words-
worth, who found a kindred spirit in Bartram. These writers
found in Bartram's *Travels,* his meandering masterpiece of keen-
eyed observation and emotional response, a map of a brave new
world of imagination and reality.

2.

William Bartram was born in 1739, along with his twin sister, Elizabeth. Their mother was Ann Mendenhall, daughter of Benjamin Mendenhall, a Quaker wheelwright—a craftsman who made and repaired wheels—who immigrated from England around 1686. Just four years earlier, the first wave of persecuted Quakers had responded to William Penn's invitation to establish a colony of religious tolerance in the New World. Both Benjamin and his older sister Margery Mendenhall (1655–1742) made the journey to Philadelphia. My mother happens to be a direct descendant of Margery, which makes William Bartram and me distant cousins.

The Bartrams lived in a stone house on the banks of the Schuylkill, with broad, carefully planted grounds leading down to the banks of the river. The French traveler Crèvecoeur visited John Bartram's estate in 1765, marveling at its well-ordered tranquility. "The whole store of nature's kind luxuriance seemed to have been exhausted on these beautiful meadows," he wrote of land reclaimed from the river. "Thence we rambled through his fields, where the right-angular fences, the heaps of pitched stones, the flourishing clover, announced the best husbandry as well as the most assiduous attention."

Apprenticeship was the accepted method of embarking on a respectable career in the colonial cities. In his youth, William Bartram turned down apprenticeships in printing with Franklin and in medicine with Alexander Garden, the Georgia-based botanist after whom the gardenia is named. He trained instead with a shopkeeper in Philadelphia before joining the Quaker diaspora to newly opened lands in North Carolina. He borrowed money from his father in 1761 to establish himself as a merchant

on the Cape Fear River, on the road between the coastal settlement of Wilmington and the inland town of Fayetteville.

William was a disaster as a merchant. In 1765, he shut down his business and joined his father, newly appointed by George III as the Royal Botanist for the American colonies, on a ten-month plant-collecting expedition into Florida and Georgia. In October, the Bartrams strayed from the path again and discovered a beautiful flowering tea plant they named, after Benjamin Franklin, *Franklinia alatamaha*. The plant is now extinct in the wild.

William was so taken with Florida that he decided, against his father's wishes, to stay there and try to make a living as a planter of rice and indigo, another disaster. By 1767, he was back in Philadelphia, working as a day laborer. At the age of twenty-eight, with no clear financial prospects, he had become a concern to his family. Three years later, under pressure from creditors—one of whom was so frustrated by William's insolvency that he threatened him with physical injury—William abruptly fled to his old haunts in North Carolina. "Poor Billy hath had ye greatest misfortunes in trade that could be & gone thro ye most grievous disappointments," John Bartram wrote, "and is now absconded I know not whither."

And then, by one of those fortuitous events, those confluences of human and natural coincidence that shaped his eccentric life, William received an extraordinary invitation, from a remarkable man named John Fothergill, which put his life on a different course altogether.

3.

During his feverish quest for Cherokee clay, Josiah Wedgwood had consulted this same Dr. Fothergill, a brilliant Quaker physician in London, whose interests included botany, art, and global trade. As Wedgwood's biographer writes:

> The Doctor, who took great interest in scientific subjects, seems to have advised with him on this matter of foreign clays, and to have thought, as did merchants and many others who had already imported them in small quantities, that unless they were restricted to the manufacture of highly-prized porcelain, the difficulties and expense connected with their transit from so remote a region would render them too dear [expensive] to be available, to any remunerative extent, to either the importer or potter.

Quakers were banned from English universities, but Dr. Fothergill had received excellent medical training in Edinburgh. The first British physician to identify diphtheria, he became the leading doctor in London; he would probably have been named the King's Physician if Quakers were not excluded from that position as well. Fothergill had close ties to the American colonies; his father and brother were Quaker missionaries there. "The two Fothergills, John and Samuel," according to the Quaker historian Rufus Jones, "were highly endowed, broad in their intellectual outlook, refined and gentle in breeding, possessed of the best culture of their time." Samuel Fothergill was sharply critical, after a visit in 1754, of Quaker ownership of slaves in North Carolina. "Friends have been a lively people here," he wrote, "but Negro-purchasing comes more and more in use among them."

By the time that Wedgwood consulted with him about Cherokee clay, John Fothergill knew a great deal about the Southern colonies. A new passion made him eager to know much more. For in addition to his many other interests, Dr. Fothergill had become a gardener and amateur botanist. In 1762, he bought a large estate in Essex, where he gradually assembled the most extensive botanical garden of his time, with hothouses and greenhouses that held more than 3,400 distinct species of exotic plants from around the world. He was in touch with the Swedish botanist Linnaeus concerning the classification of previously unknown plants, and he was keen to add to his remarkable collection.

To find new plants, someone had to be willing to go into the wilderness and brave the dangers of the American outback. Among Fothergill's close friends in the American colonies was a prominent Quaker merchant and scientist named Peter Collinson. It was Collinson who had first inspired Fothergill's enthusiasm for collecting American plants. Collinson had hired John Bartram to collect specimens, and the two had developed a lively trade in plants between the two continents, becoming close friends along the way. Collinson, in turn, had introduced Dr. Fothergill to John Bartram. When Collinson died, in 1768, Fothergill remarked that he was "the means of introducing more new and beautiful plants into Britain than any man of his time."

Just before his death, Collinson had shown Fothergill some drawings executed by young William Bartram. Fothergill was impressed and wished for more. "I called upon my Friend [Collinson] one morning this summer," he wrote John Bartram, "when he showed me some exquisite drawings of thy son's. He proposed that I should engage thy son to make drawings of all your land tortoises. I wish he would be kind enough to undertake this for me."

"To make drawings of all your land tortoises": The more one learns about William Bartram, the more fitting this first commis-

sion seems. It combines two features that one finds in so many of William's undertakings: ambitious sweep and peculiar, even hallucinatory specificity.

4.

The offer could not have come at a better time, for it was against a backdrop of debt, failure, and flight that Dr. Fothergill's interest in William Bartram's drawings opened up a new future for a young man in crisis. Bartram successfully completed the series on tortoises. And then, in 1772, from his new base of operations in Charleston, South Carolina, William requested support from Fothergill for an ambitious plant-hunting excursion through Florida, a plan to which Fothergill agreed.

And that was the beginning of William Bartram's epic travels, which extended to four solid years of wandering in the wilderness. At the end of those four years, Bartram was transformed; more Natty Bumppo than a typical Philadelphia Quaker, he became a man of the woods, at home with deer and rattlesnakes and on respectful terms with the native Indian population. After returning briefly to Philadelphia to outfit himself for his travels, Bartram boarded ship for Charleston, arriving in late March 1773, and then sailed to Savannah to finalize his plans.

Bartram alerted the local authorities on Indian affairs about his intentions to travel into Cherokee country. His timing was excellent. In June, up the Savannah River in the settlement of Augusta, there was to be a gathering of the chiefs of the Cherokee and Creek peoples. They were to meet with colonial agents concerning outstanding debts and other points of disagreement and conflict. The meeting would allow Bartram to seek arrangements with the Indians for safe passage within Cherokee country.

William Bartram, Great Soft-Shelled Tortoise

During the intervening weeks, as he waited for spring and the meeting at Augusta, Bartram whiled away the time exploring the sea islands of the Georgia coast. Crossing a narrow shoal from the mainland, he spent a whole day scrutinizing one of these islands and was particularly entranced by huge heaps of shells on the level sands, which he assumed were either brought there by Indians or created by the movement of the tides. Then Bartram looked more closely.

I observed, amongst the shells of the conical mounds, fragments of earthen vessels, and of other utensils, the manufacture of the ancients: about the center of one of them, the rim of an earthen pot appeared amongst the shells and

earth, which I carefully removed, and drew it out, almost whole: this pot was curiously wrought all over the outside, representing basket work, and was undoubtedly esteemed a very ingenious performance, by the people, at the age of its construction.

Visual ambiguity of this kind, an earthenware pot masquerading as a woven basket, appealed to Bartram the artist.

5.

As William Bartram set out along the Savannah River, bound for Augusta, his journey into the interior played out against two opposing landscapes. One was the volatile political situation, resulting from the breakdown of colonial rule and the fraudulent land deals that white settlers had made with the indigenous Indians. The other was the timeless natural landscape of the backcountry. Bartram, the Quaker naturalist, averted his eyes from the political conflict and acutely observed—as though salvation lay there—the burgeoning spring carnival of azaleas, mountain laurel, and trailing arbutus.

The meeting at Augusta ran its predictably ugly course. By the mideighteenth century, the Indians had come to depend on English traders and their products. Exchanging deerskins for rum, the Indians, as Bartram noticed, had lost their skills in traditional arts and crafts, no longer making the sorts of pots he had found on the coastal islands. At Augusta, the Indians' mounting debt, mainly for liquor purchased from unscrupulous traders, was forgiven in exchange for land, "the merchants of Georgia

demanding," as Bartram noted dryly, "at least two millions of acres of land from the Indians, as a discharge of their debts."

The Cherokee representatives at the Congress were already an endangered and demoralized remnant. Soundly defeated in the Cherokee War of 1760, when Lord Jeffrey Amherst dispatched British troops to pacify the region, they had little bargaining power and were reduced to supplicants instead. The warlike Creeks belittled them; the whites cheated them. The Cherokee delegation itself was riven into factions. The older chief known as the Little Carpenter, or Attakullakulla, favored accommodation with the whites; he himself had traveled to Great Britain and knew what his people were up against. The charismatic Dragging Canoe, younger and more intransigent, fiercely opposed the deal.

Despite Dragging Canoe's objections, a treaty was eventually signed, and Bartram was invited to accompany the team of surveyors delegated to mark the boundaries of the newly acquired land. He proceeded to join what he scornfully called the caravan, which consisted of

> surveyors, astronomers, artisans, chain-carriers, markers, guides, and hunters, besides a very respectable number of gentlemen, who joined us, in order to speculate in the lands, together with ten or twelve Indians, altogether to the number of eighty or ninety men, all or most of us well mounted on horseback, besides twenty or thirty packhorses, loaded with provisions, tents, and camp equipage.

This obscene parade was hardly the manner in which Bartram wanted to travel; he was relieved when the surveying party divided into three groups, and his team proceeded to the Quaker village of Wrightsborough, thirty miles from Augusta on the

Little River. Nearby, Bartram was delighted to find a "sublime forest" of black oak rising "like superb columns." The oaks measured "eight, nine, ten, and eleven feet diameter five feet above the ground," and tapered "forty or fifty feet to the limbs."

Equally impressive to Bartram's eyes, and an uncanny parallel to the towering columns of trees, was a site of ancient Indian monuments along the river, displaying great geometrical sophistication, and offering a poignant contrast to the humiliated Indians at Augusta:

> I observed a stupendous conical pyramid, or artificial mount of earth, vast tetragon terraces, and a large sunken area, of a cubical form, encompassed with banks of earth; and certain traces of a larger Indian town, the work of a powerful nation, whose period of grandeur perhaps long preceded the discovery of this continent.

6.

After four more days of travel, Bartram's party reached the Buffalo Lick, three or four acres of dazzling white clay at the foot of the Great Ridge, and one of the boundaries of the land ceded by the treaty. The sight was a breathtaking expanse of natural sculpture. Bartram was so curious about the nature of the clay that he actually tasted it.

> The earth, from the superficies to an unknown depth, is an almost white or cinereous colored tenacious fattish clay, which all kinds of cattle lick into great caves, pursuing the delicious vein. It is the common opinion of the inhabitants, that this clay is impregnated with saline vapors, arising

from fossil salts deep in the earth; but I could discover nothing saline in its taste, but I imagined an insipid sweetness. Horned cattle, horses, and deer are immoderately fond of it, insomuch that their excrement, which almost totally covers the earth to some distance round this place, appears to be perfect clay; which, when dried by the sun and air, is almost as hard as brick.

Bartram was right that this was not a salt lick. The sweet taste of the clay and the abundant excrement on the scene indicate that Bartram's Buffalo Lick was in fact, as the geologist Louis De Vorsey notes, "an exposed bed of the mineral popularly known as primary kaolin and served the buffalo and other animals much as Kaopectate serves humans with stomach upsets." Animals consumed the kaolin to reduce the acidity of their diets and to loosen their bowels. Although he was unaware of its significance, Bartram had discovered a trove of high-quality kaolin. This clay was suitable for porcelain production and was situated much closer to Charleston than the Cherokee deposits that Duché and Griffiths had tracked down in the distant mountains.

The surveying parties concluded their work amid mounting indignation from the Cherokees regarding the exact boundaries established by the humiliating treaty. Tensions soon erupted into violence. Two young Indians who had participated in the surveying work happened to ask for water at a settlement of white homesteaders. The settlers brutally murdered the Indians, as though in confirmation of Dragging Canoe's skepticism.

After this incident, there was widespread fear of a new Indian war. Bartram's plans to explore the Cherokee towns north and west of Augusta, deep in the Smoky Mountains, had to be postponed indefinitely. He returned reluctantly to Savannah, making plans to travel into east Florida instead, because the Indians there, he was told, "were not openly concerned in the mischief."

7.

During his two years in Florida, William Bartram became a collector of visions as well as plants. He bought a canoe and explored the area along the St. Johns River, with traders and Indians serving as his guides in this idyllic landscape. He learned to bring a startling specificity to his descriptions, drawing on his deep knowledge of natural history, his acute sympathy for wild animals, and his wide reading. He became a connoisseur of cormorants and rattlesnakes, hummingbirds and horseshoe crabs. Contemplating the snakelike contortions of the cormorant, he wrote that "if this bird had been an inhabitant of the Tiber in Ovid's days, it would have furnished him with a subject for some beautiful and entertaining metamorphoses."

Bartram was particularly dazzled by the underground rivers in Florida. Traveling along the upper St. Johns, amid orange groves and huge magnolias, he came across an astonishing sight:

> The enchanting and amazing crystal fountain, which incessantly threw up, from dark, rocky caverns below, tons of water every minute, forming a bason, capacious enough for large shallops to ride in, and a creek of four or five feet depth of water, and near twenty yards over, which meanders six miles through green meadows, pouring its limpid waters into the great Lake George, where they seem to remain pure and unmixed. About twenty yards from the upper edge of the bason, and directly opposite to the mouth or outlet of the creek, is a continual and amazing ebullition, where the waters are thrown up in such abundance and amazing force, as to jet and swell up two or three feet above the common surface: white sand and small

particles of shells are thrown up with the waters, near to
the top, when they diverge from the center, subside with
the expanding flood, and gently sink again.

Three times in this sexually charged passage Bartram resorted
to the adjective "amazing," as though helpless to describe what
he had seen.

As Bartram peered down into the "absolutely diaphanous"
waters of the basin, he saw "innumerable bands of fish" that,
under ordinary circumstances, would be expected to feed on
each other: "the devouring garfish, inimical trout, and all the
varieties of gilded painted bream; the barbed catfish, dreaded
sting-ray," with the "voracious crocodile stretched along at full
length" by the pool. He was stunned to see "no signs of enmity,
no attempt to devour each other; the different bands seem peace-
ably and complaisantly to move a little aside, as it were to make
room for others to pass by."

For Bartram, this "paradise of fish" constituted a utopian
vision of nature before the fall, a peaceable kingdom that might
inspire humans to "make room for others." At the same time, he
realized that the "amazing and delightful scene" was to some ex-
tent an optical illusion. The water was so clear that bands of fish
at different depths seemed to occupy the same plane.

But the very transparency of the water, in Bartram's view,
contributed to the peaceful scene. All predatory fish, as Bartram
explained, "take their prey by surprise," by hiding in weeds or
shadows. "But here is no covert, no ambush; here the trout freely
passes by the very nose of the alligator," he noted, and "what is
really surprising is, that the consciousness of each other's safety,
or some other latent cause, should so absolutely alter their con-
duct, for here is not the least attempt made to injure or disturb
one another." Of course, Bartram knew perfectly well that these
marauding fish needed to find their prey somewhere, but he

allowed himself to be seduced by the deeper meaning of the scene. The implication was that in a guileless world without hiding places, and with mutual transparency, peaceful relations among neighboring groups might actually be possible.

In Florida, Bartram made significant forays into Indian territory, asking his Creek and Seminole guides about their use of medicinal plants. As he traveled on foot and by canoe, he recorded what he saw in both words and drawings for his patron, Dr. John Fothergill. He drew a pair of huge alligators cavorting in the waves, snorting and writhing like Chinese dragons. He drew a sinkhole, opening like a sinister beckoning hand in the center of the landscape, with another alligator sidling toward it. He drew the Savanna crane, a "stately bird" about six feet in length, with a wingspan of eight or nine feet, and then he ate it: "We had this fowl dressed for supper and it made excellent soup." He drew fish and birds and snakes and seashells.

These drawings, fusing pinpoint accuracy with visionary intensity, are portraits of woodland creatures; one feels that Bartram, in his Quaker way, has befriended them. As one lets one's eye drift to the penciled-in backgrounds, one finds a parallel world in miniature: tiny deer with antlers spread, tiny ships with sails unfurling in the breeze, even tiny towns springing up above distant horizons.

8.

Ever since the gathering of tribes at Augusta, William Bartram had hoped to return to the Cherokee lands in the Carolina outback. During the spring of 1775, relations with the local Indians were sufficiently peaceful for Bartram to retrace his previous journey to Augusta and push his travels farther, toward the re-

mote Cherokee encampments deep in the Smoky Mountains, which were known as the Overhill towns.

Bartram started down the same trail that Duché and Griffiths had followed. This time, with no "caravan" to impede him, he traveled alone. Following the Little Tennessee River, he reached the Cherokee village of Cowee, where he stayed in the house of the same guide that Griffiths had employed, the experienced trader Patrick Galahan, whom he described as "an ancient respectable man . . . esteemed and beloved by the Indians for his humanity."

A younger trader in the area slyly offered to show Bartram "some curious scenes amongst the hills," and led him to a former Indian settlement. On their return, they ascended a ridge and were met with an astonishing sight:

> A vast expanse of green meadows and strawberry fields; a meandering river gliding through, saluting in its various turnings the swelling, green, turfy knolls, embellished with parterres of flowers and fruitful strawberry beds; flocks of turkeys strolling about them; herds of deer prancing in the meads or bounding over the hills; companies of young, innocent Cherokee virgins, some busy gathering the rich fragrant fruit, others having already filled their baskets, lay reclined under the shade of floriferous and fragrant native bowers . . . disclosing their beauties to the fluttering breeze, and bathing their limbs in the cool fleeting streams; whilst other parties more gay and libertine, were yet collecting strawberries, or wantonly chasing their companions, tantalizing them, staining their lips and cheeks with the rich fruit.

This "sylvan scene of primitive innocence" was, in Bartram's view, "perhaps too enticing for hearty young men long to con-

tinue idle spectators." Seeking to play "a more active part in their delicious sports," they cautiously approached the girls.

> Now, although we meant no other than an innocent frolic with this gay assembly of hamadryades, we shall leave to the person of feeling and sensibility to form an idea to what lengths our passions might have hurried us, thus warmed and excited, had it not been for the vigilance and care of some envious matrons who lay in ambush, and espying us, gave the alarm.

The young satyrs eventually caught up with the nymphs, at which point the girls, "incarnated with the modest maiden blush, and with native innocence and cheerfulness, presented their little baskets, merrily telling us their fruit was ripe and sound." What happened next Bartram leaves to our imagination.

9.

Amid such distractions, Bartram still had his eye resolutely on the Overhill towns to the west. He had engaged a guide and "protector" to the region, but the man failed to show. Ignoring the advice of local traders, who warned that the Overhill Indians had lately been in an "ill humor" toward the whites, Bartram determined to travel alone. It was with an ecstatic, devil-may-care attitude that he headed deep into the mountains. He felt as though he had been "expelled from the society of men, and constrained to roam in the mountains and wilderness, there to herd and feed with the wild beasts of the forests."

In the strange and almost manic mood in which he traveled, Bartram's meetings with Cherokee warriors in the woods as-

sumed a dreamlike quality, as though he had entered a peaceable kingdom like the bands of fish in the crystal fountain. As he crossed a branch of the Tennessee River, a band of Indians suddenly materialized out of the dark trees. Bartram recognized the Cherokee supreme chief Little Carpenter himself and his armed entourage. "I turned off from the path to make way, in token of respect," Bartram wrote. He introduced himself, explaining that "I was of the tribe of white men, of Pennsylvania, who esteem themselves brothers and friends to the red men." The warriors accepted this friendly overture and allowed Bartram to continue on his solitary way.

As though to keep his bearings in these volatile surroundings, Bartram catalogued the plants as he traveled upward, like an exotic mantra: "Panax ginseng, Angelica lucida, Convallaria majalis, Lalesia, Stewartia, Styrax." Reaching the summit of the most elevated peak, he "beheld with rapture and astonishment a sublimely awful scene of power and magnificence, a world of mountains piled upon mountains."

Bartram's descent down the western side of the mountain slope was gentle for a few miles; then it abruptly plunged downward. As so often in Bartram's narrative, it was with the temporary loss of his footing that he made his discoveries:

> My changeable path suddenly turned round an obtuse point of a ridge, and descended precipitately down a steep rocky hill for a mile or more, which was very troublesome, being incommoded with shattered fragments of the mountains, and in other places with boggy sinks, occasioned by oozy springs and rills stagnate sinking in micaceous earth: some of these steep soft rocky banks or precipices seem to be continually crumbling to earth; and in these moldering cliffs I discovered veins or strata of most pure and clear white earth, having a faint bluish or pearl color gleam,

somewhat exhibiting the appearance of the little cliffs or wavy crests of new fallen snowdrifts: we likewise observe in these dissolving rocky cliffs, veins of isinglass (Mica S. vitrum Muscoviticum), some of the flakes or laminae incredibly large, entire and transparent, and would serve the purpose of lights for windows very well, or for lanthorns.

Bartram appended a footnote to this serpentine sentence: "Mica nitida: specimens of this earth have been exported to England, for the purpose of making Porcelain or China ware." Bartram had literally stumbled upon the great clay pits where Duché and Griffiths had ended their own journeys in quest of Cherokee clay.

After his slippery, sliding discovery of the veins of Cherokee clay, with visions of new-fallen snow and well-lit windows, Bartram's buoyant mood abruptly changed. It was as though he were waking from a dream. The vegetation, as though in response to his suddenly barren inner landscape, lost its profuse variety.

Leaving the great forest I mounted the high hills, descending them again on the other side, and so on repeatedly for several miles, without observing any variation in the natural productions . . . and perceiving the slow progress of vegetation in this mountainous, high country; and, upon serious consideration, it appearing very plainly that I could not, with entire safety, range the Overhill settlements until the treaty was over, which would not come on till late June, I suddenly came to a resolution to defer these researches at this time, and leave them for the employment of another season.

The wavering sentence, with its peculiar dips and turns and its curious evasion of feeling, raises more questions than it an-

swers. Had Little Carpenter somehow warned Bartram to go no farther? Had the vegetation really become so dull just a few days after some of Bartram's most ecstatic evocations of botanical plenitude? Had he already achieved his goal in entering the wilderness and had his vision? In any case, as Bartram concludes without further explanation, "next day I turned about." He returned to Galahan's house near Cowee, where he inspected the Indian mounds there, before retracing the long route back to Georgia, arriving in Charleston in June 1775.

And there, like Rip Van Winkle awaking from a dream, he learned some surprising news. The Revolutionary War had begun in April, with the battles in Lexington and Concord, just as Bartram was heading into the hills on his solitary journey.

10.

During the fall of 1786, while perched precariously in a cypress tree in his father's garden by the Schuylkill River outside Philadelphia, William Bartram lost his footing and fell twenty feet to the hard ground below, breaking his leg in several places and effectively putting an end to his travels. Now visitors came to him, as George Washington did the following summer, along with James Madison and Alexander Hamilton, who were attending the Constitutional Convention in Philadelphia. The publication of his *Travels,* in 1791, sealed his reputation as the greatest naturalist of his time.

When the purchase of western lands from Napoléon extended the borders of the United States far beyond the limits of Bartram's earlier excursions, President Jefferson asked Bartram to serve as adviser in natural history to the explorers Lewis and Clark. Citing his age and physical disabilities, Bartram politely

declined. Living quietly in the stone mansion built by his father, with his menagerie of domestic and wild animals, he continued to reflect on his travels. He was amused by the behavior of his clever pet crow, Tom, who "enjoyed great pleasure and amusement in seeing me write, and would attempt to take the pen out of my hand, and my spectacles from my nose."

A late addition to the *Travels* was a short section called "Observations on the Creek and Cherokee Indians," prompted by questions submitted in 1788 by a young Philadelphia naturalist called Benjamin Smith Barton. Still recovering from his fall, Bartram was also suffering from eye problems so acute that, as he told Barton, "I have been obliged to write the greater part of this with my eyes shut, and that with pain."

A question about Indian art elicited a particularly intense run of paragraphs from Bartram. Barton, with typical European prejudices, had wondered whether Indian paintings preserved "the memory of events," and whether they used "signs or symbols to denote attributes or qualities of various kinds." In other words, were Indian paintings merely representational, or did they convey abstract ideas such as courage or virtue?

Bartram, in his vivid and almost hallucinatory memory of Indian paintings he had seen, on walls and human bodies and buffalo hides, sidestepped Barton's question, with its hierarchical assumptions about the superiority of abstract concepts over mimetic depiction. Suddenly, the art of the Creek Indians rose up in his memory as vividly as on the first day he saw it:

> The paintings which I observed among the Creeks were commonly on the clay-plastered walls of their houses . . . they were, I think, hieroglyphics, or mystical writings, for the same use and purpose as those mentioned by historians, to be found on the obelisks, pyramids, and other monuments of the ancient Egyptians, and much after the same

style and taste, much caricatured and picturesque; and though I never saw an instance of the *chiaro-oscuro*, yet the outlines are bold, natural, and turned or designed to convey some meaning, passion, or admonition, and thus may be said to speak to those who can read them. The walls are plastered very smooth with red clay; then the figures or symbols are drawn with white clay, paste, or *chalk*; and if the walls are plastered with clay of a whitish or stone color, then the figures are drawn with red, brown, or bluish chalk or paste.

Bartram remembered how all kinds of trees and flowers and animals were depicted, along with human figures in various attitudes, "some very ludicrous and even obscene; even the *privates* of men are sometimes represented, but never an instance of indelicacy in a female figure." Bartram added that the most beautiful paintings he had seen among the Creek people were tattooed on the skin of the chiefs. Whole scenes played out across the torsos and limbs of warriors: "a sketch of a landscape, representing an engagement or battle with their enemy, or some creature of the chase," a deer, perhaps, or a wild turkey. Such paintings, in Bartram's view, were "admirably well executed, and seem to be inimitable."

11.

Bartram's *Travels* had a volcanic impact on the English Romantic poets. Samuel Taylor Coleridge, with his far-ranging appetite for other worlds, the more exotic the better, was enthralled by the book. "This is not a Book of Travels, properly speaking," he wrote, "but a series of poems, chiefly descriptive, *occasioned*

by the Objects, which the Traveler observed.—It is a *delicious* Book; & like all *delicious* Things, you must take but a *little* of it at a time."

For Coleridge, Bartram's intense descriptions of plants and soil became poetic metaphors for his own experiences and for people he knew, such as his close friend, poetic collaborator, and walking companion, William Wordsworth. While reading Bartram's *Travels*, he wrote, he "could not help transcribing the following lines as a sort of allegory, or connected simile and metaphor of Wordsworth's intellect and genius":

> The soil is a deep, rich, dark mould, on a deep stratum of tenacious clay; and that on a foundation of rocks, which often break through both strata, lifting their back above the surface. The trees which chiefly grow here are the gigantic, black oak; the magnolia magniflora; fraxinus excelsior; plantane; and a few stately tulip trees.

At Coleridge's urging, Wordsworth read Bartram with kindred excitement, and was enthralled by the description of strawberry fields and Indian nymphs, which he worked seamlessly into his narrative poem "Ruth," about a young and vulnerable Englishwoman. She is mesmerized, tragically, as it turns out, by an adventurous young man who has recently returned from America, full of stories about wondrous plants that "hourly change their blossoms."

> He told of girls, a happy rout!
> Who quit their fold with dance and shout,
> Their pleasant Indian town,
> To gather strawberries all day long;
> Returning with a choral song
> When daylight is gone down.

But it was Coleridge's great poetic fragment "Kubla Khan" that drew most directly and profoundly from Bartram's *Travels*. Kubilai Khan was the Mongol ruler of China who founded the Yuan dynasty, beginning in the thirteenth century, and presided over an immense empire. In his opening lines, Coleridge summoned Kubilai's pleasure palace at his summer quarters of Xanadu, as described by Marco Polo and other visitors.

> In Xanadu did Kubla Khan
> A stately pleasure-dome decree:
> Where Alph, the sacred river, ran
> Through caverns measureless to man
> Down to a sunless sea.
> So twice five miles of fertile ground
> With walls and towers were girdled round:
> And there were gardens bright with sinuous rills,
> Where blossomed many an incense-bearing tree;
> And here were forests ancient as the hills,
> Enfolding sunny spots of greenery.

Coleridge claimed that the poem came to him in an opium dream after he fell asleep reading about early China and that he was hurriedly writing the lines down, as though from dictation, when a stranger, "a person from Porlock," interrupted him, leaving the poem a fragment.

But in fact, "Kubla Khan" arrived in Coleridge's consciousness festooned with delicious passages from Bartram's *Travels*. Bartram's underground river in Florida, which "meanders six miles through green meadows" before jetting into a "crystal fountain," flowed directly into Coleridge's poem:

> And from this chasm, with ceaseless turmoil seething,
> As if this earth in fast thick pants were breathing,

A mighty fountain momently was forced:
Amid whose swift half-intermitted burst
Huge fragments vaulted like rebounding hail,
Or chaffy grain beneath the thresher's flail:
And 'mid these dancing rocks at once and ever
It flung up momently the sacred river.
Five miles meandering with a mazy motion
Through wood and dale the sacred river ran,
Then reached the caverns measureless to man,
And sank in tumult to a lifeless ocean. . . .

It is interesting to speculate on the subtle chemical reaction by which Samuel Purchas's narrative of travels in sixteenth-century China, which Coleridge was reading as he fell asleep, combined with Bartram's meandering river and crystal fountain, with opium as the catalyst. The notion of pleasure was presumably at the heart of this transformation, the "delicious" quality that Coleridge found in Bartram. For Coleridge, Bartram was almost as potent a drug as opium.

12.

When William Bartram made his solitary journey to the Overhill towns of the Cherokee people, he was traveling the same route as his clay-mad predecessors, the potter Andrew Duché and Josiah Wedgwood's agent Thomas Griffiths. It was Bartram, in turn, who bequeathed the imaginative richness of the Southern landscape to Coleridge and Wordsworth. Perhaps fittingly—for such is the strange circularity of this exchange—Coleridge was a close friend of Josiah Wedgwood's son Thomas (a fellow opium addict) and received a generous annuity from the Wedgwood

family. It is pleasing to imagine that Cherokee clay, dug from the Carolina outback and worked into the recipe for the popular jasper ware, helped fund the composition of "Kubla Kahn." They were, one might say, dug from the same source.

Coleridge and Wedgwood, in their differing ways, were both digging for China in Carolina. Coleridge, with Bartram's travels on his mind, made poetry from the story of the great Mongol ruler in China; Wedgwood, with his Cherokee clay, made his exquisite pottery reminiscent of fine china. Bartram, searching for specimens for his patron, John Fothergill, was also digging for China—as he identified exotic tea plants and ginseng in the American forests.

A metaphor might be drawn from the gardens of Fothergill and the potteries of Wedgwood. Exotic plants like ginseng and porcelain clays for making china were dug from the rich earth of North America and transported to England, where they thrived in new surroundings and inspired new artistic creation. Similarly, Bartram's *Travels* served as a rich repository of metaphors for later writers, "transplanted" to new literary uses. Just as there was a global trade in plants and materials, there was a parallel trade in verbal structures and ideas. And every once in a while, a restless genius came along—a Bartram, a Wedgwood, a Coleridge—who wandered from the familiar trail, risking falls and failure, and fused these new possibilities in unexpected ways, leaving lasting art for posterity.

Epilogue:
Arrangement in Gray and Black

1.

When I visit my mother at Friends Homes, I drive my rental car from the new airport in Greensboro onto the new, almost deserted beltway, and then down New Garden Road and into the Whittier Wing parking lot, directly across the street from Guilford College, the Quaker college from which both my mother and I graduated. Each time that I visit, I think that maybe this will be the last time that I will see her. An air of permanent convalescence hangs over the hallways of the Whittier Wing, where nurses from Senegal and Jamaica hover around the clock. Everyone here is recovering from something—my mother from the insertion of an artificial heart-valve and the series of terrible strokes, like terrible monthly beatings, that followed. A maple leaf adorns the doors of residents in danger of falling. There is a red leaf on my mother's door. She is deciduous.

Actually, she doesn't have far to fall, for she rarely leaves her bed, except when she is wheeled to the bathroom, a painfully complicated procedure, or the dining room. Propped up on her pillows, her stern Scots-Irish face with slightly stiffened neck in profile, always in profile, my mother could almost have been posing for me. Sitting with my mother during these recumbent

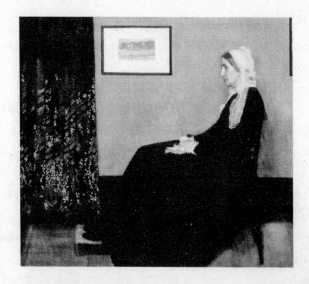

months, as she lies on her hospital bed in Whittier, I am often reminded of James McNeill Whistler's famous portrait of his mother.

2.

One thing that draws me to the painting is that Whistler's mother looks so much like a Quaker. In old prints depicting Quaker meetings, the men in wide-brim hats sit on plain benches facing the women in plain bonnets, all in profile. Two of these prints adorned the entrance to the little side room—a rustic reconstruction of an eighteenth-century meetinghouse—of Clear Creek Meeting in Richmond, Indiana, which I attended as a child. This room, outfitted with ancient, high benches, was never used for meetings; a modern space nearby served that purpose. Instead, it became a sort of playroom or refuge for children playing hide and seek or "Quaker meeting" (in which we sat in silence and

tried to make each other laugh) during the long hour of stony silence next door, where the adults sat in silence, not laughing, not even smiling.

In her black widow's garb, as I say, Whistler's mother looks just like a Quakeress. At first, I assumed this link of Whistler's mother with Quakerism was a private association of mine, based on my Quaker childhood and my failing, falling mother, but it turns out to be quite widespread. Sarah Walden, the expert conservator who restored the painting for the Musée d'Orsay in Paris, where it hangs alongside Manet's *Déjeuner sur l'herbe,* writes of "the Quaker-like simplicity we think of as the natural habitat of Anna Whistler." (I like that phrase "natural habitat," as though Whistler's mother were an endangered shore bird, glimpsed in the wild.)

Whistler's portrait of his mother is officially called *Arrangement in Grey and Black: Portrait of the Painter's Mother.* It is generally assumed to be the best-known painting by an American artist. The painting is so familiar that it is difficult to really look at it. In Don DeLillo's *Underworld,* there is an artist named Klara who keeps a print of Whistler's mother on her wall "because she thought it was generally unlooked at." In DeLillo's novel, Klara likes how Whistler's mother sits "so Quaker-prim and still."

3.

Whistler's mother refused to pose on Sundays, but when she posed, she prayed. "It was a Mother's unceasing prayer while being the painter's model," Anna Whistler later wrote, that "gave the expression which makes the attractive charm." Soon after the portrait was completed during the early fall of 1871, Whistler and his mother spent a weekend at the home of William

Cleverly Alexander. Alexander was a banker in London, a passionate collector (like Whistler) of Chinese porcelain, and a Quaker. Anna Whistler was impressed when the seven Alexander children joined the servants each morning for silent worship in the Quaker manner. "Their home life is quite according to your ideas & mine," she wrote to a friend.

When Whistler painted a portrait of one of the seven children, Cecily, he made her look anything but Quaker-like; she resembles instead a little Spanish dancer out of Velázquez—insouciant, flamboyant, dappled with butterflies. Cecily's plain gray wraps are flung carelessly on a chair in the background, as though they are the wrinkled Quaker chrysalis from which she has emerged, vibrantly sleek and fully fledged.

4.

The Symbolist writer Joris-Karl Huysmans called *Arrangement in Grey and Black* a painting of convalescence. Whistler's mother had been quite ill during the Civil War. In 1863, trying to escape the war and her disease, she lived for a time in the Round Hill Hotel in Northampton, Massachusetts, taking the famous "water cure" there, drinking lots of water, taking many baths, and so on. (From Hartford, Harriet Beecher Stowe came to Northampton to take the cure, and Henry James came, too, for his constipation, and so did Emily Dickinson's mother, from nearby Amherst.)

Whistler's mother was sick again from May to June 1870 and was still unwell in December, six months before Whistler began to paint her portrait. "It may be," as scholar Margaret MacDonald observes, "that Whistler, deeply concerned for her, wished to record his mother's appearance before it was too late." Whistler originally planned to portray his mother standing up—he was

already famous for painting portraits in this format—but after two or three days it became clear that Anna hardly had sufficient energy for sitting.

All this suggests that Whistler *planned* to paint his mother's portrait, that this was his next project, so to speak. The truth is that the painting was begun almost by accident. The female model whom Whistler had hired, for a painting that was giving him a great deal of trouble, failed to show up for her sitting.

On impulse, Whistler decided to paint his mother instead. "If the youthful Maggie had not failed Jemie as a model for 'The girl in blue on the sea shore,'" Anna Whistler wrote her sister, "he would have had no time for my Portrait." Necessity is the mother of invention—and so, in this case, was the presence of an actual mother. "Disappointments," Anna added, "are often the Lord's means of blessing."

5.

As I try to satisfy my own curiosity about this marvelous painting, I think I know what's really happening here. My own confused feelings while sitting with my mother in her residential wing in Friends Homes have started to grow, like a gently spreading moss, onto Whistler's portrait of his mother. Everything about the painting recalls aspects of my mother, and everything about my mother takes up residence in different aspects of the painting. Whistler's portrait of his mother is the *culture* on which I am growing my own memories of my mother. Is this a defense mechanism, a way of not quite looking at what my mother has become? Of course it is. But it's also a way—my way—of looking at her.

6.

When I last saw my mother, she whispered to me conspiratori-ally, "Christopher is coming to see me this week."

"But I am Christopher," I said.

She turned her head sideways and squinted up at me, skep-tically. "Are you *little* Christopher?" she asked.

7.

Whistler's mother, Anna McNeill Whistler, was born in 1804 in Wilmington, North Carolina, a two-hour drive from my mother's birthplace of Raleigh. She married the railroad engineer Major George Washington Whistler, in Lowell, Massachusetts, in 1831. Born in Indiana, he was a widower with three children; she had been his dead wife's best friend.

8.

Whistler's father invented a new kind of steam whistle for use on trains.

I told my son Nicholas about the steam whistle invented by Whistler. Nicholas asked, reasonably enough, "Was the whistle named for him?"

9.

Whistler was ambivalent about his birthplace. When he was asked how he had come to be born in Lowell, he replied, "I wanted to be near my mother."

Whistler would have preferred to have been born in St. Petersburg, Russia, where his father was hired in 1842 to oversee the construction of the railroad to Moscow. It was in St. Petersburg that Whistler had his first formal training in drawing.

During the celebrated trial many years later in which Whistler sued John Ruskin for libel, Whistler claimed that he had been born in Russia. When it was pointed out to him that, after all, he was actually born in Lowell, Massachusetts, Whistler replied haughtily: "I shall be born when and where I want, and I do not choose to be born in Lowell."

Whistler's father died of cholera in Russia in 1849, and Anna and her two sons, James and William, settled in Connecticut. They also lived briefly in Springfield, Massachusetts. Whistler's mother dressed in deep mourning for the rest of her life. In 1851, James entered the United States Military Academy at West Point.

10.

In his 2008 Jefferson Lecture in the Humanities, John Updike asked himself, "What is American about American art?" and—connecting the dots from Copley to Winslow Homer and after—suggested that American artists share "a bias toward the empirical" and seek to capture "the clarity of things."

But there is a countertradition in American art, a sort of Velvet Revolution, and its roots can be traced back to two

hotheads expelled from West Point. Edgar Allan Poe, booted from the academy in 1831, wrote influential manifestos in favor of art for art's sake and argued that "tone" and "suggestiveness— some undercurrent, however indefinite of meaning"—were at the heart of artistic effect. The poet and art critic Charles Baudelaire translated Poe's writings into French; Poe's influence on elite French writers and painters was considerable.

Whistler studied Poe's books avidly in the West Point library before being kicked out in 1854 for flunking a chemistry test. He traveled to France with the ambition of becoming a painter and made close friendships with the artists Henri Fantin-Latour and Alphonse Legros, while also meeting Courbet, Manet, and Baudelaire. Legros specialized in painting women in traditional, Quaker-like religious garb. Fantin-Latour painted Whistler along with Baudelaire and Manet in his group portrait *Homage to Delacroix.* In 1859, recognizing that England might prove a fertile market for artists, Whistler shifted his base of operations to London.

11.

Whistler met a striking young Irishwoman named Joanna Elizabeth Hiffernan in 1861; by the end of the year, when he took her to Paris and showed her off to his painter friends, she was both his model and his mistress. Courbet was particularly taken with her long coppery red hair and portrayed her in *La belle Irlandaise* (1865–66).

Whether Jo also posed for Courbet's *The Origin of the World* (1866), as has often been suggested, remains in doubt. The *Origin,* which has a shadowy past and has hung at the Musée d'Orsay only since 1995, belonged for a long time to the French psycho-

analyst Jacques Lacan. It portrays a woman's torso viewed from below, with a white garment pulled above her exposed breasts. The focus of attention is squarely on the woman's lovingly painted vagina and her pubic hair, hence "the origin of the world."

It is tempting to interpret Whistler's *Mother* as a rejoinder to Courbet's painting.

Whistler's portrait of his mother might be called "The Origin of *My* World."

12.

Anna Whistler moved to London to escape the horrors of the Civil War. In 1863, she boarded a ship in Wilmington, North Carolina, the last seaport to remain in Confederate hands, and ran the Union blockade, eluding Union raiders and arriving safely in London a few weeks later. When Whistler's mother moved in, Jo Hiffernan moved out. It was as simple as that.

13.

It is easy to think of Whistler's portrait of his mother as an "easy" painting, a fairly straightforward rendition of how his beloved mother looked while sitting in his studio. Actually, the painting was the result of several bold experiments that Whistler had been pursuing in his work for several restless years.

After his false start, during his early months in Paris, laying on thick brushstrokes with his friend Courbet, Whistler overhauled his style completely in London during the 1860s. It was then that he painted his first blue and black tinged "moonlights,"

dreamy marine scenes that he later renamed nocturnes, seeking an analogy with musical composition.

Whistler painted the first of these dramatic scenes when he was looking out on the harbor in Valparaiso, Chile, where he made a mysterious journey in 1866. Recently discovered documents make it fairly clear that Whistler was a well-paid gunrunner for Chilean nationalists who had declared war on Spain.

"Paint should not be applied thick," Whistler told a friend. "It should be like breath on the surface of a pane of glass." The aim in such paintings, contrary to the personal touch of Impressionism, was to abolish any evidence of the hand or the active brush. "A picture is finished," Whistler maintained, "when all trace of the means used to bring about the end has disappeared." The colors in such pictures seem to have condensed on the surface or to have seeped through like a spreading stain from the back of the canvas.

For some critics, the labor was a little too invisible; in 1877, Ruskin accused Whistler of "willful imposture" in his nocturnes, and of charging high prices "for flinging a pot of paint in the public's face." Whistler sued for libel but won only a token victory; forced to cover the cost of the trial himself, he went bankrupt in the process, selling his London house and his cherished collection of Asian porcelain.

14.

Whistler's portrait of his mother is the culmination of his almost decadelong obsession with Asian pottery. When Anna Whistler moved into her son's house in Chelsea in 1863, she was amazed by the profusion of Chinese and Japanese things there. "Are you an admirer of old China?" she wrote a friend. "This artistic abode

of my son is ornamented by a very rare collection of Japanese and Chinese [porcelain], he considers the paintings upon them the finest specimens of Art and his companions (Artists) who resort here for an evening of relaxation occasionally get enthusiastic as they handle and examine the curious subjects portrayed."

In searching for a counteraesthetic to the painterly realism of Courbet, Whistler fell in love with Chinese and Japanese porcelain. He admired both the colors of blue and white porcelain, as it was called, and the delicate and expressive figures, borrowed from Chinese plays and popular novels, painted on the glazed surfaces. On a collecting trip to Amsterdam in 1863, he began amassing his own extraordinary collection of Asian porcelain, and he inspired others to take up the collecting mania. "It was Whistler absolutely who invented Blue and White," the dealer Murray Marks wrote.

To put it differently, it was Whistler who shifted elite British taste from eighteenth-century Wedgwood and Sèvres "china" back to the real thing.

In an ambitious and sometimes bizarre series of paintings, Whistler tried to apply the lessons he had learned from these pots. In *Purple and Rose: The Lange Lijzen of the Six Marks* (1864), Jo Hiffernan dressed up as a Chinese artisan with brush in hand, putting a finishing touch on an already glazed and fired blue and white porcelain vase. She is surrounded, as in a dealer's shop, by other examples of Chinese porcelain, and we are meant to feel that she herself is almost made of porcelain—one of the *lange lijzen*, Dutch for "lanky people," that are portrayed on the vases that surround her.

La princesse du pays de la porcelaine (1864–1865) takes the fantasy even further, with Jo in indigo kimono and orange wrapper, holding a Japanese fan and framed by a Japanese screen of birds and flowers—"the princess from the country of porcelain."

This ravishing painting was the centerpiece of Whistler's

swooningly beautiful Peacock Room, now in the Freer Gallery in Washington, D.C. Whistler designed the room for a wealthy shipowner named Frederick Leyland. It was a dining room, but it was also a walk-in porcelain cabinet. The walls of green and gold have regularly placed niches for the display of blue and white Chinese porcelain. Murals of gold and blue peacocks and golden wave patterns complete the elaborate design.

15.

The first artist was a potter, or so Whistler imagined in his famous "Ten O'Clock Lecture," delivered on February 20, 1885, at ten o'clock in the evening.

> In the beginning, man went forth each day—some to do battle—some to the chase—others again to dig and to delve in the field—all that they might gain, and live—or lose and die—until there was found among them, one, differing from the rest—whose pursuits attracted him not—and so he staid by the tents, with the women, and traced strange devices, with a burnt stick, upon a gourd.

This man, according to Whistler, was "the *first* artist," soon joined by "others—of like nature—chosen by the Gods—and so they worked together—and soon they fashioned, from the moistened earth, forms resembling the gourd—and, with the power of creation, the heirloom of the artist, presently they went beyond the slovenly suggestion of Nature—and the first vase was born, in beautiful proportion."

Whistler's own art began with pottery as well.

16.

And then there is the matter of indigo.

In Whistler's portrait of his mother, an indigo kimono hangs like a curtain on the left-hand side of the painting. This indigo curtain is more than exotic decor. You might say that the whole painting is somehow framed in indigo, bathed in indigo. The nocturnes and the portrait of his mother are from Whistler's indigo period, just as Picasso had a blue period.

Indigo, that purplish-blue pigment that comes from Japan and the American South, is another link between Whistler's mother and my own. Indigo happens to be my mother's favorite Japanese dye. On our first trip to Japan, in 1971, one hundred years after Whistler painted his mother, my mother studied Japanese fabric-dying techniques. She worked with the National Treasure artist Kesuke Serizawa. She learned to work with indigo dye.

I asked her why she liked indigo so much. "Because it's so beautiful," she answered, "beautiful and natural."

17.

Arrangement in Grey and Black, yes, but there is a third major color in the painting: blue. The indigo kimono completes a background of blue and gray. Was Whistler trying to avoid any association, in the title of his painting, with the colors of the American Civil War? His mother, of course, looks like a Civil War widow. His brother, William, had served as a battlefield surgeon for the Confederate forces. Was Whistler himself a Confederate sympathizer?

It might be more accurate to say that he instinctively sided with the underdog. He traveled to Chile to support Chilean separatists. When Henry Adams dined with John La Farge and Whistler, Whistler spoke incessantly in favor of the Boers against the British. And Whistler was a close friend of the Irish separatist John O'Leary.

18.

In DeLillo's *Underworld,* the artist named Klara has Whistler's portrait of his mother on her wall "because the picture was so clashingly modern." It is worth trying to specify what this "clash" consists of. There seems to be some fundamental, bedrock ambiguity in Whistler's portrait of his mother.

Whistler was interested in visual ambiguity. In his first major painting, *Symphony in White* (1861), also known as "The White Girl," he had painted Jo Hiffernan as a melancholy woman dressed in white and holding a white lily. After taking in all this whiteness, the viewer suddenly notices that the white girl is standing on a bearskin rug. Just beyond her slippers, the bear's feral face rears up, with ears erect, eyes wide open, and open mouth, showing his teeth. What is the relation between the demure girl and the ferocious bear?

The ambiguity in *Arrangement in Grey and Black: Portrait of the Painter's Mother* is of a different order. Its doubleness is captured in its double title. Looked at one way, it is a formal "arrangement" in gray and black, drawing on Japan and Whistler's infatuation with blue and white porcelain. Looked at another way, it is a nostalgic evocation of a specifically American motherhood.

These jarring oppositions were highlighted in 1932, the

worst year of the Depression, when Alfred Barr, director of the
Museum of Modern Art, hit upon the idea of borrowing Whis-
tler's *Mother* from the Louvre as a way to boost sagging atten-
dance and moribund fundraising. At MoMA, the painting would
appear as a modernist icon, or so Barr assumed. But after its star
turn in New York, the painting continued on a triumphal tour
of great American cities, with a long stop at the Chicago World's
Fair. Along the way, it was interpreted as a tribute to American
motherhood, culminating in a three-cent postage stamp issued
on Mother's Day, in 1934, in honor of mothers of America. On
the stamp, Anna Whistler's footstool is replaced by an earthen-
ware vase full of flowers.

19.

My uncle Alec, my mother's younger brother, dead now from
Alzheimer's disease, had a house in Wilmington, North Caro-
lina, on Wrightsville Beach, raised on stilts as protection from
flood tides caused by hurricanes. My mother loved to stay there.
It was always her dream to live near the ocean, to eat freshly

caught fish, and to take long walks on the sand. She seemed completely at home in Wilmington, the birthplace of Whistler's mother. I know that she would give up anything—*anything*—to get up from the bed where she is now lying, walk through the door with the falling leaf on it, and walk on the sand at Wrightsville Beach.

When I stayed in the house in Wilmington, I had a different fantasy. I wanted to be the man with the metal detector who walked up and down the beach early each morning, his awkward apparatus swinging from side to side. Like a robin listening for a worm, he would stop periodically and dig down into the sand with a sharp stick. I imagined the riches uncovered in this way: doubloons, silver dollars, wedding rings.

He was a dowser of sorts, as I saw him, a feng shui artist, divining his place in the world and seeking an auspicious alignment of earth and stars. The zigzag path he traced over the sand was determined by unseen forces underground, the chance pattern of previous visitors and voyagers. From these soundings in the sand, I could imagine him piecing together a fragmented narrative of sorts, reaching back to Sir Walter Raleigh, perhaps, and forward to the most recent bride on her honeymoon, who had rashly removed her wedding ring for an impromptu frolic in the waves.

I can see, now, that some such divination has been my purpose in this book all along. My pen has been my metal detector, and I have been digging, as patiently as I can, for evidence of my family's passages, in art and in love, as they pursued their own lives across many generations, living and surviving. A snuffbox, a stamp album, a rust-colored pitcher, a handful of white clay—these things carry their stories with them.

A mysterious passage on the questing and magnetic tendencies of human beings by the seventeenth-century poet Henry Vaughan comes back to me unbidden:

He knocks at all doors, strays and roams,

Nay hath not so much wit as some stones have

Which in the darkest nights point to their homes,

By some hid sense their Maker gave;

Man is the shuttle, to whose winding quest

 And passage through these looms

God ordered motion, but ordained no rest.

20.

The poet Stéphane Mallarmé translated Whistler's "Ten O'Clock Lecture" into French. He also helped to facilitate the sale of Whistler's *Mother*, in 1891, to the public Musée du Luxembourg. From there, it eventually entered the Louvre, as Whistler had always hoped, and then, much later, the Musée d'Orsay, its current home.

Whistler, like his famous painting, moved back to Paris in 1892. He died of a stroke in 1903.

21.

The Irish painter John Butler Yeats, father of the poet William Butler Yeats, helped to bring some of Whistler's paintings to Dublin for an exhibition.

"Imagine," he said to his son, "making your old mother an arrangement in grey."

ACKNOWLEDGMENTS

I'd like to thank the potters first. My friend and traveling partner, Mark Shapiro, a potter based in western Massachusetts, introduced me to the master potters Mark Hewitt and Karen Karnes, pushing this book in fresh directions. I also accompanied Shapiro to the crafts community of Penland, up above Asheville, where I was warmly welcomed by the director, Jean McLaughlin, and visited Cynthia Bringle, Paulus Berenson, Michael Kline, and other potters in the area.

In the North Carolina Piedmont, Vernon and Pam Owens have always been friendly and welcoming at Jugtown. The brilliant and generous scholar Charles "Terry" Zug III instructed me on the stunning beauty of nineteenth-century North Carolina jugs. Two knowledgeable collectors of North Carolina pottery, Tommy Edwards in Pittsboro and Bobby Kadis in Raleigh, were kind and generous with their knowledge.

Nancy Selvage, director of the Ceramics Program at Harvard, invited me to speak there at a symposium on "Japanese Ceramics: Cultural Roots and Contemporary Expressions," on November 7, 2004. It was on that occasion that I first used the title and three-part structure of "Red Brick, Black Mountain, White Clay." Three potters at the symposium were wonderfully

supportive of what I was up to: Edmund de Waal, Julian Stair, and Rob Barnard. The Virginia potter and tile maker Joan Gardiner and the writer John Rolfe Gardiner were encouragingly curious about where this book might take me.

Back home in Massachusetts, the potter Bill Sax answered many questions about firing techniques and the changing pottery scene at Alfred University. Lisa Uyehara has deepened my understanding of the World War II resettlement camps for U.S. citizens of Japanese ancestry. Frank Murphy, a passionate scholar of literature and of pottery, followed every twist and turn of my research.

Second comes my family. My uncle John Wesley Thomas has chronicled the Thomas family connections, brick and tobacco, in rich detail. Bruno Benfey in Montreal has done the deep research on the Benfey genealogy. My father, Ted Benfey, has helped fill in the blanks while entering into the imaginative reconstruction of our family networks. I am deeply indebted to his support of this undertaking from the start. Since my mother, Rachel, is in many ways the central figure of my book, I can hardly thank her enough.

My brothers, Philip and Stephen, have done everything I've asked and more, hosting me in Chapel Hill and Tokyo, traveling with me, and accompanying me through great swaths of the story I tell in this book. Their imprint is everywhere. Elisabeth Benfey gave me a beautiful Jugtown tray, once housed in her own house, when it belonged to Juliana Busbee's cousin. Punk Howard, my mother's youngest sister, is a close friend and confidante, and shares my love for Jugtown pottery. Renate Wilkins, my father's older sister, has shared with me her memories of Black Mountain College and the Alberses. During the late stages of this book, it has been a special pleasure to reconnect with my sister, Karen Boyd, of Winston-Salem.

Editors, many of whom are named in my "A Note on Sources," have encouraged my forays into ceramics and family lore. They include Robert Silvers at the *New York Review of Books* and Sasha Weiss at the *New York Review Blog;* Leon Wieseltier at *The New Republic;* Ann Hulbert at *Slate;* Nancy Novogrod and Margot Guralnick at *Travel+Leisure;* and Chuck Grench at the University of North Carolina Press.

Melanie Jackson is the ideal agent and literary adviser, as everyone who has the privilege to work with her knows. Ann Godoff strikes just the right balance as a brilliant editor, knowing the book and its needs much better than the author does. I'd like to thank her shrewd and smart assistant, Ben Platt, for minding the thousand details while keeping the big picture.

I can't thank all the friends who made this book a better book. Let these names stand for them all: Sven Birkerts, friend and guide; Seamus Heaney, beloved teacher, who sent me a postcard of a bricklayer by August Sander at just the right time; Stanley Cavell, who pointed out key differences between the immigrant experience of German Jews and other refugees from Europe; Jed Perl, who urged me not to wait in writing this book; Roy Nydorf and Terry Hammond; Donal O'Shea; Eric Poggenpohl and Wendy Woodson, who tracked down Alex Reed's memorial on Martha's Vineyard; Karen Remmler and Holger Teschke; Mel and Priscilla Zuck; Nicholas Fox Weber and Brenda Danilowitz, friends and generous helpers at the Josef and Anni Albers Foundation; Kim Cumber at the State Archives in Raleigh; James Gehrt and others who helpfully provided illustrations; my supportive poker buddies, artists all—Nick Bromell, Eric Poggenpohl, Jim Gipe, James Steinberg, Kirt Snyder, and Don Hamerman.

My own family has sustained and supported me. Mickey Rathbun read every page and knew the right time for us to move

to a modernist house on the edge of the old Amherst Brickyard, the perfect place for taking up the thread of our lives together. Tommy and Nicholas, sons and friends—what better company could a father have?

Chris Benfey
The Brickyard, Amherst
July 4, 2011

IMAGE CREDITS

A NOTE ON SOURCES

CHAPTER ONE: THE BAMBOO GROVE

For biographical information on Sergei Thomas, see Caroline N. Jacob, *Builders of the Quaker Road: 1652–1952* (Chicago: Henry Regnery, 1953), ch. 22. On New Garden, see Henry Cadbury, "The Church in the Wilderness: North Carolina Quakerism as Seen by Visitors" (1948), a published lecture delivered at North Carolina Yearly Meeting. The French traveler Crèvecoeur also describes New Garden in the seventh of his *Letters from an American Farmer* (Oxford: Oxford University Press, 1997). I have consulted various accounts of arrangements made in World War II for conscientious objectors, including Gordon Zahn, *War, Conscience, and Dissent* (New York: Hawthorn, 1967).

CHAPTER TWO: JUGTOWN

On varieties of clay, I have borrowed freely from Suzanne Staubach's *Clay: The History and Evolution of Humankind's Relationship with Earth's Most Primal Element* (New York: Berkley, 2005). I rely on Jean Crawford's *Jugtown Pottery: History and Design* (Winston-Salem: John F. Blair, 1964) for the history of Jugtown, supplemented by the useful essays in *New Ways for Old Jugs: Tradition and Innovation at the Jugtown Pottery,* edited by Douglas DeNatale, Jane Przybysz, and Jill R. Severn (Columbia: McKissick Museum/University of South Carolina, 1994). The standard history of North Carolina folk potters is Charles G. Zug III's indispensable *Turners and Burners: The Folk Potters of North Carolina* (Chapel Hill: University of North Carolina Press, 1986), from which many of the quotations in this chapter come. I also benefited from personal conversations with Terry Zug. Much of the biographical information on Mark Hewitt is drawn from *The Potter's Eye: Art and Tradition in North Carolina Pottery* (Chapel Hill: University of North Carolina Press, 2005), by Mark Hewitt and Nancy Sweezy, complemented by many conversations with Hewitt. I have also learned from Dave Korzon, "Studio Potter Mark Hewitt: Moving the Earth a Little Closer to Heaven," in the *Village Rambler* magazine (March/April 2005). The quotation from Ben Owen is from "Reflections of a Potter," *The State of the Arts* (April 1969), 1, quoted in Hewitt, *The Potter's Eye,* 135. I have changed the name of the family with whom I worked in the Tamba region of Japan. See Daniel Rhodes, *Tamba Pottery: The Timeless Art of a Japanese Village* (Tokyo: Kodansha, 1970).

A version of my account of Mark Hewitt firing his groundhog kiln appeared as "Under Fire: Mark Hewitt's 'Big-Assed Pots,'" in the blog of the *New York Review of Books* (September 8, 2010).

CHAPTER THREE: THE SNUFFBOX

The story of O. Theodor Benfey's spiral version of the periodic table can be found in his article "The Biography of a Periodic Spiral," *Bulletin of the History of Chemistry* 34, no. 2 (2009). On Chinese awareness of the regular solids, see O. Theodor Benfey, "Dodecahedral Geometry in a T'ang Era Incense Burner Preserved in the Shosoin," *Proceedings of the 14th International Congress of the History of Science* (Tokyo: 1975), 273–77. On the Sanskrit scholar Theodor Benfey's continuing relevance to research on the migration of folk tales, see Jan Ziolkowski's *Fairy Tales from Before Fairy Tales* (Ann Arbor: University of Michigan Press, 2007). On Henry Sidgwick's involvement with the Benfey family in Göttingen, see Bart Schultz, *Henry Sidgwick, Eye of the Universe: An Intellectual Biography* (Cambridge, UK: Cambridge University Press, 2004), 416–19. I have also drawn on Meta Benfey's privately published biography of her father, *Theodor Benfey* (1909), and Bruno Benfey's research on our family. For the concept of serendipity from Walpole to the present, see Robert K. Merton and Elinor Barber, *The Travels and Adventures of Serendipity* (Princeton, NJ: Princeton University Press, 2004). A version of sections 3, 7, and 8 of this chapter appeared as "Our Berlin," *Travel and Leisure* (October 2002).

CHAPTER FOUR: MEXICO

The translation of Toni Ullstein Fleischmann's journal is by my father, O. Theodor Benfey. On Mexican art in the Albers collection, see Karl Taube, *The Albers Collection of Pre-Columbian Art* (New York: Hudson Hill, 1988). I wish to thank Nicholas Fox Weber and Brenda Danilowitz from the Josef and Anni Albers Foundation for sending me a copy of the letter of Josef Albers to Barbara Dreier, June 25, 1939, as well as for many other courtesies. For Anni's concept of starting from zero, see Nicholas Fox Weber and Pandora Tabatabai Asbaghi, *Anni Albers* (New York: Guggenheim Museum, 1999), 174–75. Nicholas Fox Weber's chapters on Joseph and Anni Albers in *The Bauhaus Group: Six Masters of Modernism* (New York: Knopf, 2009) proved invaluable to me for details of their careers in Germany and the United States. See especially pages 288, 340 (on Anni as Whistler's mother), and 354. For the connection between *Black-White-Red* and Florentine architecture, see Weber, *Bauhaus Group*, 392–93. For Gropius on educating women, see his letter to Annie Weil, February 23, 1920, Weimar State Archives no. 259, 48; quoted in Weber and Asbaghi, *Anni Albers*, 156. For Anni's "limp threads," see Sigrid Wortmann Weltge, interview with Anni Albers, February 21, 1987; quoted in Weber and Asbaghi, *Anni Albers*, 156. For what Albers did to the Bauhaus, see Mervin Lane, *Black Mountain College: Sprouted Seeds: An Anthology of Personal Accounts* (Knoxville, TN: University of Tennessee Press, 1990), 33. On making sienna look like gold, see Martin Duberman, *Black Mountain: An Exploration in Community* (New York: Dutton, 1972), 56. I owe a great deal to this pioneering history of Black Mountain. On materials as relational, see *Josef Albers: A Retrospective* (New York: Guggenheim Museum, 1988), 53. On making jewelry in wartime, see Anni Albers, *Selected Writings on Design* (Middletown, CT: Wesleyan University Press, 2001). For the passage from Meister Eckhart, see Alexander Reed's letter to Barbara Dreier, March 1, 1944, Dreier Papers, North Carolina State Archives, Raleigh, NC. All other quotations from Reed are from this collection. Albers gave Reed a copy of Franz Pfeiffer's edition of Eckhart, the only translation available at the time. Information about the Quiet House is from the Web site of the Black Mountain College Project, www.bmcproject.org. Additional biographical information about Reed and other Black Mountain artists can be found in Mary Emma Harris, *The Arts of Black Mountain College* (Cambridge, MA:

MIT Press, 1987), 254. Nicholas Fox Weber, in conversation, mentioned Anni's admiration for Reed's sweaters. Josef Albers's statement on his brick mural at Harvard can be found in Eleanor Bitterman's *Art in Modern Architecture* (New York: Reinhold, 1952), 148–49. I first saw the mural in the delightful company of the English potter and curator Edmund de Waal, when we were both lecturing on Japanese pottery at Harvard.

CHAPTER FIVE: THE MEANDER

Information about Ruth Asawa's life and work is drawn from Daniell Cornell, *The Sculpture of Ruth Asawa: Contours in the Air* (Berkeley: University of California Press, 2006). See especially pp. 13 (pledge of allegiance), 45 (Varda), and 56 and 60 (studying with Albers). The translations from Ovid and Homer are by my son Thomas Benfey. Plutarch wrote that Theseus celebrated his triumph by performing the Crane Dance. Whether Homer is describing the same dance is not clear. Daedalus's dancing floor may have metamorphosed, in the imaginations of successive poets, into the labyrinth. The labyrinthine palace at Knossos might also have been the prototype.

CHAPTER SIX: ON THE DIVIDE

Another version of sections 2–9 of this chapter, with textual citations, appeared in Mark Shapiro, ed., *A Chosen Path: The Ceramic Art of Karen Karnes* (Chapel Hill: University of North Carolina Press, 2010), 13-26. For biographical information on Karnes, I have relied on Mark Shapiro's "Oral History Interview with Karen Karnes, 2005 August 9–10," Nanette L. Laitman Documentation Project for Craft and Decorative Arts in America, Archives of American Art, Smithsonian Institution, www.aaa .si.edu/collections/interviews/oral-history-interview-karen-karnes-12096. Another version of sections 3–5, with a sustained comparison of Josef Albers and Charles Olson as leaders of Black Mountain, can be found in my essay "Letters from Black Mountain" in *Starting at Zero: Black Mountain College 1933–57*, edited by Caroline Collier and Michael Harrison (Cambridge and Bristol, UK: Kettle's Yard and Arnolfini, 2006), 23–37. For information on Robert Turner, see Martha Drexler Lynn, *Clay Today* (San Francisco: Chronicle Books, 1990), 152. Gate Hill originally included seven people: Paul and Vera Williams, John Cage and David Tudor, M. C. Richards, David Weinrib, and Karen Karnes. Mary Emma Harris interviewed Karnes at Stony Point in April 1972, when only Tudor and Karnes from the original community were still living there. Olson's correspondence with Leach, Wildenhain, and Harder is in the Black Mountain Collection, North Carolina State Archives, Raleigh. Leach's remarks on American pottery come from *Craft Horizons*, as quoted in Edmund de Waal, *20th Century Ceramics* (London: Thames and Hudson, 2003), 154. Mary Harris's interview with Rhodes is in the Black Mountain Collection, North Carolina State Archives, Raleigh. Meister Eckhart is frequently invoked in John Cage's *Silence* (Middletown, CT: Wesleyan University Press, 1961), but I found the link with 4'33" in James Pritchett's *The Music of John Cage* (Cambridge, UK: Cambridge University Press, 1996). Richard Sennett writes about distinctions between art and craft in *The Craftsman* (New Haven, CT: Yale University Press, 2008). In a chapter called "Metamorphosis: The Potter's Tale," Sennett observes: "Clay, that most philosophical of materials, shows three quite different ways in which its craftsmen could guide the metamorphosis of their craft" (125). The three ways, all provoking what Sennett calls "material consciousness," are the internal evolution of a generic form, changes due to various kinds of mixture and synthesis, and what Sennett calls "domain shift," the leap from one practice to a quite different activity (127). Mary Emma Harris describes Cage's "happening" in *The Arts at Black Mountain*, 226–27.

CHAPTER SEVEN: CHEROKEE CLAY

For information on Duché's career and the history of the Edgefield pottery, I have relied on John A. Burrison's *Brothers in Clay: The Story of Georgia Folk Pottery* (Athens: University of Georgia Press, 1983). For the quotations from Duché and for documentation of his early career in Georgia, including his experiments in making porcelain, see Cinda K. Baldwin, *Great and Noble Jar: Traditional Stoneware of South Carolina* (Athens, GA: University of Georgia Press, 1995), 7. Duché's religious affiliation is not entirely clear, though some scholars claim that he was a Quaker. A version of section 6, with illustrations and more detail, was published in the online magazine *Slate* (April 2, 2008) as "Seven Mysteries of China." On Marco Polo and porcelain, see Howard Coutts, *The Art of Ceramics: European Ceramic Design 1500–1830* (New Haven, CT: Yale University Press, 2001), 63. For Australian geologist W. Ross Ramsay's analysis of Bolzius's report, see "Macon Clay Used in Fine China," *Smoky Mountain News,* November 14, 2001, www.smokymountainnews.com/issues/11_01/11_14_01/mtn_voices_macon_clay.shtml#top. The reference to Duché as a Frenchman in Cherokee lands comes from Thomas Griffiths's report to Josiah Wedgwood, as discussed in chapter 8. Mark Hewitt has a well-informed account of the Georgia potters' fascination with Chinese ceramics in *The Potter's Eye,* 107–8. On Duché and porcelain production in England, see the well-researched account by W. Ross Ramsay, Judith A. Hansen, and E. Gael Ramsay, "An 'A-Marked' Porcelain Covered Bowl, Cherokee Clay, and Colonial America's Contribution to the English Porcelain Industry," in Robert Hunter, ed., *Ceramics in America 2004* (Hanover, NH: Chipstone Foundation, 2004), 61–77. My account of the potter Dave and his poetry is drawn freely from Leonard Todd's *Carolina Clay: The Life and Legend of the Slave Potter Dave.* Todd notes the pun on *oven* in the couplet about Mr. Miles. Mark Hewitt also has a characteristically vivid account of Dave's achievement in *The Potter's Eye.*

CHAPTER EIGHT: WEDGWOOD

The Web site of the Wedgwood Museum (www.wedgwoodmuseum.org.uk) has information on the career of Daisy Makeig-Jones. On Wedgwood's life and career, see Jenny Uglow's wonderful book *The Lunar Men: Five Friends Whose Curiosity Changed the World* (New York: Farrar, Straus & Giroux, 2003), especially ch. 5, 46–56. For his experiments with cream ware, see 87. On the American market for British pottery, see James Deetz, *In Small Things Forgotten: An Archaeology of Early American Life* (New York: Anchor, 1996), 83. Chapter 3, "All the Earthenware Plain and Flowered," is about pottery in America. Brian Dolan has an excellent chapter on the search for Cherokee clay in *Wedgwood: The First Tycoon* (New York: Viking, 2004), 233–37. For turning dirt into gold, see 162–63. Dolan notes Wedgwood's use of exoticism in marketing his jasper ware (238). William L. Anderson's "Cherokee Clay, from Duché to Wedgwood: The Journal of Thomas Griffiths, 1767–1768," *North Carolina Historical Review,* October 1986, includes the full text of Thomas Griffiths's journal, along with a well-researched and incisive commentary on such matters as Griffiths and maple sugar (p. 490) and Wedgwood's distrust of Griffiths (p. 490). Joel Fry, a scholar affiliated with Bartram's Gardens in Philadelphia, suggested to me that Griffiths's experiments with the manufacture of maple sugar were directed toward finding an alternative to sugarcane and thus perhaps were antislavery in spirit. Details of Griffiths's encounters with crackers and Indians are from Anderson, 495–505. Anderson points out that Griffiths's journal is one of the first instances in which the word *Cracker* (capitalized therein) appears (500). On Patrick Galahan as guide for both Griffiths and Bartram, see Edward J. Cashin, *William Bartram and the American Revolution on the Southern Frontier* (Columbia, SC: University of South Carolina Press, 2000). For Wedgwood's Etruria, see Uglow, *Lunar Men,* 196. On the taste for Quaker ware, see Coutts, *Art of Ceramics,* 181. See also Eliza

Meteyard, *The Life of Josiah Wedgwood* (London: Hurst & Blackett, 1865–1866), vol. 2, 131–32: "The pale tint, the fine glaze, and the beauty, yet simplicity of forms, were most consonant to their [Quakers'] feelings." On the European vogue for vases, see *Vasemania: Neoclassical Form and Ornament in Europe,* ed. Stefanie Walker (New Haven, CT: Yale University Press, 2004). Wedgwood on the "Great People" and the "Middling Class" is quoted in Dolan, 240. For Wedgwood looking out on the Atlantic, see Uglow, *Lunar Men,* 263.

CHAPTER NINE: XANADU

The main source for this chapter is William Bartram's *Travels and Other Writings,* which I quote in the Library of America edition (New York, 1996), ed. Thomas P. Slaughter. Bartram's account of his first journey into Georgia is on 30 (for the shell heaps) and 52–66; his journey in Florida, 150–52; and his second journey, when he reached the Overhill towns, 291–98. On his pet crow, see 574, and on the art of the Creeks and Cherokees, 532–34. For details of the lives of John and William Bartram, I have relied on Slaughter's chronology in the Library of America edition, and on Slaughter's biography of the Bartrams, *The Natures of John and William Bartram* (New York: Random House, 1998). For Bartram's relations with Fothergill and for the nature of his achievement in visual art, I also rely on Judith Magee, *The Art and Science of William Bartram* (University Park, PA: Pennsylvania State University Press, 2007), especially 80–85 and 103–9. On Fothergill and Wedgwood, see Eliza Meteyard, *Life of Wedgwood,* vol. 2, 7–8. On John and Samuel Fothergill as Quaker missionaries, see Rufus Jones, *The Quakers in the American Colonies* (1911; New York: Norton, 1966), 127, 322. For Crèvecoeur's visit with John Bartram, see the eleventh of his *Letters from an American Farmer.* For identification of William Bartram's field of kaolin, see Louis De Vorsey, "Bartram's Buffalo Lick," bartramtrail.org/pages/articles.html. For Coleridge on the "delicious" qualities of Bartram's writings, see *Collected Works of Samuel Taylor Coleridge,* vol. 12, *Marginalia,* part 1, ed. George Whalley (Princeton, NJ: Princeton University Press, 1980), 227, n. 1. Coleridge's description of Wordsworth's intellect is from the *Biographia Literaria,* edited by James Engell and W. Jackson Bate (Princeton, NJ: Princeton University Press, 1983), 155. John Livingston Lowes points out in *The Road to Xanadu* (Boston: Houghton Mifflin, 1927; Princeton, NJ: Princeton University Press, 1986), 453, that Coleridge misremembered the name *Magnolia grandiflora,* erroneously transcribed as magnolia magniflora.

EPILOGUE: ARRANGEMENT IN GRAY AND BLACK

On Whistler's *Arrangement in Grey and Black,* from the expert in charge of conserving the painting, see Sarah Walden, *Whistler and His Mother: An Unexpected Relationship* (Lincoln: University of Nebraska Press, 2003). See 16 (Huysmans's remark about convalescence), 52 (on its Quaker-like simplicity), and 67 (Baudelaire's remark). Part 6 of Don DeLillo's *Underworld* (New York: Scribner, 1997) is titled "Arrangement in Grey and Black." For "Quaker-prim," see 748. For details of how the painting was made, including Anna Whistler's account, see Margaret F. MacDonald, ed., *Whistler's Mother: An American Icon* (Farnham, UK: Lund Humphries, 2003), 26. On painting Anna before it was too late, see 31. On Whistler and the Alexander family, see Linda Merrill, *The Peacock Room: A Cultural Biography* (New Haven, CT: Yale University Press, 1998),151. I developed the ideas in section 10 in an essay for *Slate* (July 9, 2008) called "Whistler's Velvet Revolution." For Whistler's joke about being born near his mother, see Elizabeth Robins Pennell and Joseph Pennell, *The Life of James McNeill Whistler* (Philadelphia: Lippincott, 1908). On Courbet and Whistler, see Merrill, *Peacock Room,* 43–44. I have relied on this rich book for the history and design of Whistler's magnificent porcelain cabinet of a room.

INDEX